D0039650

WELCOME TO PARADISE, NOW GO TO HELL

A True Story of Violence, Corruption, and the Soul of Surfing

CHAS SMITH

DEY ST.
AN IMPRINT OF
WILLIAM MORROW *PUBLISHERS*

WELCOME TO PARADISE, NOW GO TO HELL. Copyright © 2013 by Chas Smith. All rights reserved. Printed in the United States of America. No part of this book may be used or reproduced in any manner whatsoever without written permission except in the case of brief quotations embodied in critical articles and reviews. For information, address HarperCollins Publishers, 195 Broadway, New York, NY 10007.

HarperCollins books may be purchased for educational, business, or sales promotional use. For information, please e-mail the Special Markets Department at SPsales@harpercollins.com.

A hardcover edition of this book was published in 2013 by It Books, an imprint of HarperCollins Publishers.

FIRST IT BOOKS PAPERBACK PUBLISHED 2014.

Designed by Lorie Pagnozzi

Library of Congress Cataloging-in-Publication Data has been applied for.

ISBN 978-0-06-220253-6

20 21 22 OV/LSC 11 10

TO MY CIRCE ROSE
(AND MY MICK FANNING)

CONTENTS

1

There is a gun pressed to my temple. And I have a horrible haircut. I don't know which is worse, having my head shattered by a bullet or living another moment with this truly awful *coiffure en dégradé*. Why did I do this to myself? Why did I ask the stylist to make me look like Ellen DeGeneres circa 2004?

The gun, pressing, is a handgun because a Kalashnikov, the sort of rifle all Arabs love, would not fit in the backseat of this Mercedes sedan. Or, rather, it would fit but not comfortably enough alongside me and my best friend, Josh, with our T-shirts pulled over our heads as makeshift blindfolds, three captors, a driver, another man riding in the passenger seat, and all their beards. I am also wearing horrible jeans. They were already bad, a sort of way-too-light acid wash but then they got caught in my motor scooter chain, the one I was riding not fifteen minutes earlier when we were captured, and now they are too-light acid-washed bell-bottoms. What was I thinking? And why was I riding a motor scooter instead of a proper Peter Fonda–worthy motorcycle? Why had I failed so badly, stylistically?

This outcome, this getting captured at gunpoint, had certainly been in the cards for the last five years and had probably really been in the cards since I was ten years old. That was when the idea of adventure, of living a cinematic life, grabbed my heart and refused to

ever let it go. I remember the exact moment very clearly. I remember sitting in Uncle Dave's faux Tudor-style San Diego home and him turning off the lights, then flipping the slide projector on. I remember the warm *whirrrrrrrr* of the projector fan and the first image that danced on his wall. It showed an oddly bearded Uncle Dave— he was normally clean-shaven—standing in a dirty moonscape with a slight smirk on his face. He was flanked by two exotic men, tall with much bushier black beards and bandoliers crossing their chests, clutching ancient-looking rifles. They did not smirk. Their faces were resolute. In front of the group there was a mule with an oversized load strapped to its back. The mule was expressionless. Uncle Dave, watching my wide-eyed reaction, said, "Those men are called mujahideen. They are freedom fighters who are trying to push the Soviet Union out of their country. In this picture we are in Pakistan about to cross the Khyber Pass into Afghanistan." "What is on the mule?" I asked. Dave, wearing the same slight smirk as in the image, replied, "Stinger missiles."

Uncle Dave never admitted to being in the CIA, or working for the government in any capacity for that matter. He ran a Christian nonprofit that, theoretically, brought medicine and food into war zones. This, in fact, was the only image I ever saw of him with military apparatus, aside from the picture of him shaking Ollie North's hand in his sitting room, but this image was all I needed. It was a revelation. My favorite movies ever were *Indiana Jones and the Raiders of the Lost Ark* and *Lawrence of Arabia* and Uncle Dave made me believe that it was completely possible to actually *be* Indiana Jones or T. E. Lawrence.

To make matters even more awesomely adventurous, his two sons surfed. I lived on the Oregon coast, which is not surf country, but San Diego is and cousins Danny and Mikey surfed every day. They

were the surf archetype—sun-kissed, with bleach-blonde hair tips, always in the latest surf gear. I would stand on the beach, during family visits, and marvel at their skill. Cousin Dan gave me a surf-board, one sunshiny day, and I was hooked. There is something magical about surfing. Dreamy, floaty, sexy, fairytale-ish. Magical. Sliding across the ocean powered by nature herself. Getting a gor-geous tan. Delicious babes on the sand. I brought surfing back to the Oregon coast, even though the water was freezing and the rain was endless and there were no tans or hot sand babes, because when I surfed, I felt California cool. Surf and adventure became my iden-tity. I had fallen forever in love with both of them.

The years passed but the ideal of living a cinematic life did not fade. I went to university in Orange County, California, so I could surf before class. I spent semesters in Cairo, learning Arabic, and at Oxford, because T. E. Lawrence had gone there. I became obsessed with fashion, realizing that the cinematic life demands amazing cos-tume design. Looking good—next level good—always opens doors. It opens them in New York City and in Damascus, Syria. Why do you reckon Indiana Jones cared so much about his hat? Why do you reckon T. E. Lawrence always had perfectly coifed hair? Fashion is the highest art and so I delved into *Esquire* and *Vanity Fair* and even *Women's Wear Daily*, taking notes and crafting an overall aesthetic that matched what I wanted to be.

And then jumbo jets crashed into the Twin Towers. I was lying in bed when my mother called and told me to turn on the television. She was crying, like the rest of America, and trying desperately to understand how this could be happening. Was this terrorism? Who could hate us so badly? I didn't have answers and contin-ued watching the coverage all day. It was such a tragedy, and as it became clearer that it was a terrorist act perpetrated by a man

named Osama bin Laden who came from Yemen, I stopped caring about the tragedy itself and started to wonder about Yemen.

Yemen was on the Indian Ocean and the more I looked at maps the more I figured it must have surf. Some of the best waves in the world are found in the Indian Ocean, but no one had ever surfed mainland Yemen. So I drove over to my best friend Josh's house, whom I had met hitchhiking in rural cartel country Mexico, and we looked at more maps together and concluded, yes, it must have surf.

Six months later we landed in Sana'a, Yemen, and spent the next three months driving up and down the coast, surfing. We found waves. We were chased by Al-Qaeda. We shot old Kalashnikovs in the desert and laughed. We lived a wild adventure and wrote about it for *Surfer* and *Australia's Surfing Life* magazines. It was my first taste of surf journalism though it was not a normal taste. It was not palm trees and cocktails in a setting sun, which is what I assumed surf journalism was. It was desert and bullets.

The stories were well received by the surf community, but even better by hip culture magazines so, before we knew it, we had abandoned surf writing and were doing more wild adventure stories in Lebanon, Syria, and Colombia for the likes of Brooklyn's *Vice* magazine. I would pitch the most outlandish ideas possible, like finding corrupt gangsters in Damascus or searching for the roots of grime music and its relation to piracy along the Somali coast. Somehow the magazines would bite and then we would go and make it all happen. It was a great ride, always with Josh and always on edge.

Television eventually came calling and Fremantle Media, makers of *American Idol*, signed us to an option deal. They wanted to develop a show based on our travels but their ideas were dumb. We'd sit in endless meetings listening to producers blather on and on about how cool it would be for us to go to the Timbuktu Music Fes-

tival or Lima, Peru, for its exotic cuisine. Eco/foodie/aural travel is never cool.

And then Israel invaded Lebanon in response to Hezbollah rocket attacks and the kidnapping of Israeli soldiers. Just like after 9/11, this aggression was the impetus for a creative response. Josh and I told Fremantle to fuck off and Al Gore's Current TV assigned us to cover the war for them. We covered it as we thought wars should be covered, treating all of Lebanon like a giant playground, renting the finest car we could, eating steak dinners in Beirut's tony Christian neighborhoods, and generally watching the city burn to the ground. This real, declared war felt wholly surreal. It felt like life might end at any moment and there was the requisite sadness but there was also a party atmosphere. We lived it up.

We had spent much previous time here so we knew where to party, how to get around, and how to get deep into trouble. Hezbollah controlled a sizeable chunk of central Beirut called the Dahieh, which was very off-limits to Westerners of any sort and especially reporters. Yet one cloudless day as Josh and I were riding our unfortunate motor scooters we heard bombs raining down on the Dahieh and we knew we had to go in. We were speeding through a rubble-strewn street toward a plume of smoke when another bomb exploded a block away. It blew us off our scooters, catching my awful jeans in the chain, and broke our ears. We sorted ourselves out, restarted our scooters, and tried to race away but got shot at by either Palestinian or Hezbollah militia and then got grabbed by a mob of dirty youth who handed us over to official Hezbollah. That was that. My whole cinematic adventure rushing toward a fitting but bummer end.

And now I am in the back of their Mercedes sedan with a gun pressed to my temple and pouring with sweat. My T-shirt is soaking wet and all I can hear is rapid-fire Arabic, which I am piecing

together one out of every ten words. My ears are still ringing. The gun is pressed so firmly to my temple that every sudden jerk of the Mercedes makes it dig in farther and the sweat is dripping off the end of my nose.

I am fucked. Josh is fucked. We are fucked. My hair is shit. My jeans are too. I always think I look good, but right at this moment I am having a life-flashing-before-eyes epiphany. I look like shit. I should have worn trimmer jeans. I really should have.

The Mercedes screeches to a halt and I hear car doors opening and feel the pressure of the gun releasing, momentarily, and the captor who was sitting on my lap, I think, or at least on top of me, getting up and off and dragging me with him, barking Arabic. "*Imshi! Imshi!*" *Imshi* means "walk" but it is derogatory in the Egyptian Arabic that I'm familiar with. The kind of dismissive word used to wave away a bothersome street urchin. And apparently I am not walking quickly enough because I feel a boot kick my ass so hard that I see stars. I have never been kicked that hard before. My ears are still ringing from the bomb. How exactly are they going to kill me? Will they torture me first? Will I be a headless YouTube celebrity?

I hear metal roller doors being opened and I am pushed forward into a darker room that is also cooler and I hear many more Arabic voices, some confused, some angry, and they are shouting to each other. I am marched down stairs—"Imshi! Imshi!"—and hear a heavy key in metal and the hinges creak as the door is pulled open and I am kicked inside a room darker still and the metal slams behind me, too quickly for the hinges to creak again, the heavy key working backward, locking, and then I hear nothing but my own breath.

I am breathing heavily.

Heavily.

Fuck.

I don't know if Josh and I are together anymore. I don't know if he has been left in the car to be taken somewhere else. I am afraid to take the T-shirt off of my head. I don't know if we are slated to die alone or together. It doesn't matter, I suppose. We will die and our families will cry. Whatever. I hate my wife.

Breathing.

I don't hear anything except my own breathing and so after a sweaty eternity, I take my T-shirt slowly off of my head and when my eyes adjust to the dark of my cell I see a bloodstained mattress in the corner. I see the silhouette of Josh, T-shirt still on head, sitting next to it. I whisper at him. He whispers back and then makes a joke that our shirts had stretched out so much that they now look like dresses. They are our Hezbollah dresses and we are going to go to the Hezbollah dance. Outside, our guards yell at us in Arabic to shut up and that George Bush is a dog. Josh laughs. I laugh too but inside my heart I think, "Fuck me. No more failed-state journalism. No more sleeping in the dirt, under rocks in the dirt while bombs are dropping. No more getting chased by Al-Qaeda. No more Somali pirates. No more Hezbollah. No no no no more. If I get out of here I am going to go back to the softest thing ever and this time I am going to do it properly. I am going to party and drink and stay out late with cute girls and surf and drink and look at palm trees swaying in the setting sun and feel salt water on my skin. I am going to have the best tan. I am going to get a very good haircut. I am going to get new jeans. I am going to write fluff. It will still be a cinematic, adventurous life but more *Tequila Sunrise* and less *Lord of War*. I am going to become a surf journalist. I am going to become a surf journalist. I am going to become a surf journalist."

The North Shore, Oahu, December 2009

There is a giant forearm around my neck. It is smooth. Not bodybuilder smooth, not shaved, but hairless and hot and pressing heavy on my trachea. It smells like yesterday's beer turned into today's sweat and Spam. It smells like the North Shore of Oahu. Like Hawaii.

And what is the image of Hawaii that flickers across the tourist mind when sitting in Cleveland, Ohio, or Muncie, Indiana, or even a good place like San Diego, California? It is of paradise. It is of perfection. It is of a dreamy island where the normal struggles of life, like cable bills and a gutted IRA, are washed away in a golden-hued sunset and mai tai buzz. It is of coconut scent and relaxation. Getting off the plane in a garish floral shirt while a diminutive brown woman says "aloha" accompanied by ukulele covers of Elvis Presley's "Loving You." The temperature is a perfect eighty degrees, even, with just the right touch of humidity. Chaise lounge today. Snorkeling tomorrow. Maybe a luau. Maybe a hula. Maybe "mele kalikimaka" is the thing to say. A vacation that never ever ever ends. Greens, blues, splashes of tropical-flower red, splashes of piña colada white. No one imagines getting killed. No one imagines Spam.

Another giant forearm has both my arms wrapped behind my

back and the meaty paw at its end is squeezing my bicep. Really digging into it. I am in what ultimate fighters call an arm bar. And no matter my preference, I'll be going where I'm taken.

I look around, awkwardly due to my physical predicament, and revelers are giving me drunken stares and I might detect sympathy in one or two of them but I also definitely detect condescension. "Asshole's been asking for it all along" condescension. Fuckers. They all enjoyed the spectacle while it was happening. They've been enjoying my particular spectacle for three years.

The house I'm being danced through is packed with revelers because a celebration is in full drunken swing. Mick Fanning, dull professional surfer sponsored by the dull brand Rip Curl, has just won his first World Title this afternoon at the famous Banzai Pipeline right in front of the house. The most famous wave in the world. Mick is an Australian with a penchant for drink. He even has an alter ego that comes out, with enough alcohol, named Eugene. And even though a drunken alter ego with a name sounds interesting it is not. Nothing about him is interesting. Not his short, cropped blonde hair. Not his bland chipped-tooth smile. Not his broad Australian accent. Nothing.

The whole set design of the home is so totally ideally island, reflecting the surrounding area. It is beachfront, has an open floor plan and island-modern furniture and oversized faux palm frond fans spinning languidly just like the tourist mind in Muncie, Indiana, imagines. Inside it is hot and humid, so hot, and smells like beer, sweat, and Spam or maybe that is just what I am smelling because of my currently intimate relationship with this hairless arm.

And I am being danced for sure. Between choke hold and arm bar I have to do a deconstructed Lindy Hop to keep moving. So I keep

Lindy Hopping and keep looking and revelers keep condescending. I am wearing very skinny jeans and they make the dance slightly more difficult.

I hear his voice too close to my ear, the voice of North Shore authority filled with Hawaiian slang. "Ho, brah. You lucky you no git one false-crack but you gonna learn some respeck outside."

His voice is high. I'm always surprised by how so many North Shore Hawaiians are huge and scary but have voices like young girls. "You gonna git respeck, brah." I keep hopping until we hit the back door.

It opens, revealing a rickety staircase leading down to a small walkway fronted by a plumeria hedge. The air outside feels different compared to the air inside. It is cooler and a breeze is pushing off of the Pacific but it also feels more sinister. The voice keeps on now that we are outside but gets louder and is not directed at me but at unseen forces floating somewhere nearby. "Hooooooo! Come, boys! Come, braddahs!" it is calling, for reinforcements.

We both stumble down the steps and fall against the hedge and a few white flowers fall innocently to the ground and his voice has grown still louder and higher. He is a mountain of a man. He is hot. Everything is hot. Everything is wrong. I don't see the reinforcements yet but I do see a wooden fence in front of me. I assume they are outside. Waiting. Big. As big as the one grabbing me right now or bigger. Mokes. A "moke" is any Hawaiian who fits a particular stereotype. Usually fat, always angry, speaks pidgin, drives a giant pickup truck. Sometimes it is a term of endearment. Mostly it is a call to arms. If I was to shout, "Let go of my neck, you fucking moke!" it would be a call to arms. My head would get popped off. I can hear the pound of surf so near it almost drowns out the hooting in my ear. "HOOOOOO-Eeee!" But my focus is on the hooting.

The choke is getting tighter. Hawaiians love to choke people out. It is their trademark, their heritage.

Two days earlier, in the water at a wave called Rocky Point that breaks half a mile from my current situation, I had witnessed Cheeseburger choke out an unsuspecting mainlander. Rocky Point is as seemingly tropical perfect as anything on Oahu. White sand beach. Palm trees. Warm, blue water. It is beautiful but its beauty is only skin deep because its heart beats trouble.

Cheeseburger is Hawaiian and looks like someone's chubby little brother but his heart also beats trouble. A mainlander kid, from Florida, maybe eighteen, floated next to him in the cluster of madness waiting turns to take a wave. There is a pecking order for who gets to go when. This is true of all surf spots the world over but nowhere is it enforced as severely as it is in Hawaii. And in Hawaii all Hawaiians are at the top.

So Cheeseburger and this kid were floating when over the horizon steamed a perfect wave all feathery and inviting. Cheeseburger started to paddle and this kid started to paddle. They were shoulder to shoulder, both head-down, both digging. Cheeseburger began to shout in his own Hawaiian slang, "Hooo! Gooo-een! Goooo-een!" and when Cheeseburger says "Gooo-een" it is impossible to differentiate if he is saying, "Hey, you paddling next to me. Go in (to the wave)." Or if he is saying, "I'm going." Impossible. The mainlander must have assumed the former, popping to his feet and racing down the feathery inviting line. Surfing tropical perfection all alone. Cheeseburger also popped to his feet but ended up getting hit in the head with the lip of the wave and wiping out grandly.

When they were both back in the lineup, sitting on their boards, Cheeseburger started screaming at him and the kid raised his arms in a confused defense. Cheeseburger couldn't care less, leaned over,

grabbed him by the white neck, and began the Hawaiian ritual. Choking him out. The kid sputtered and waved his still confused arms like a spastic ballerina as his face turned bright red. His eyes went crazy with terror and no one moved a muscle. Cheeseburger eventually let him go after squeezing to his heart's content and the kid paddled to the beach as fast as he could. Cheeseburger howled with laughter, and everyone else out that day thought it was very funny.

But right now nobody is laughing, especially not me, and the wooden fence is getting closer and so is my fate. "HOOOOOOO-Eeee!"

Suddenly, and without warning, I am flung into open space. The forearms around my neck and bicep release with the addition of a hefty shove. So hefty that I am spun around and momentarily face my oppressor. He is taller than six feet and must weigh three hundred pounds. His black XXXL tank top features the numbers "808" in ghetto-scrawl white. Hawaii's area code. I am unable to discern the finer of his features but can see a glimmer off his large golden chain and, right before slamming into the wood, can make out his slippahs and the fat, brown feet inhabiting them.

I slam. And expect the wood to be firm against my own skinny frame but instead feel it disappear behind me. The fence is actually a gate and one that opens outward.

Ha!

Hahahahahahahaha!

I stumble but don't fall and regain, if not my composure, then at least my footing, on the Kamehameha Highway. The Kamehameha, or Kam, is the main road that runs parallel to the Pacific along the entire North Shore. Highway is a generous name. It is a two-lane, potholed symbol of neglect sometimes buried beneath landslides.

My oppressor is staring at me openmouthed. His "808" flutters

in the breeze. He is also surprised that the fence is an outward-opening gate.

I was flung so far that he can't grab me even though he is reaching, grasping, and I scoot backward farther from those hairless arms. I see three mountainous shadows in the island foliage. The reinforcements. And they might be openmouthed too but it is dark everywhere except all around me. I am standing underneath a yellow streetlight. I am bathed in glory. I am an impressionist painting. "Haole Who Has Momentarily Escaped His Destiny No. 4."

I continue to scoot backward and feel a jig of freedom coming on. Not my forced-march Lindy Hop of a few moments ago. But a jerky and spontaneous shimmy. I shimmy in the road, grooving free, while the mountainous shadows hoot and lurch forward.

"HOOOOOOOOOO-EEEEeeeee! What da fuck! What da fuck!"

And like that, I am gone. Into the tropical night. I jog to where my car is parked, not for a moment glancing backward. My car is a white convertible Mitsubishi Spyder, top down, resting underneath an oversized banyan tree. Top down on a parked car is rare. Thievery is epidemic on Oahu's North Shore and cars are regularly destroyed for a dollar bill left in plain sight. But I feel top down is counterintuitive. There must be nothing worth stealing if no precaution is taken. And so I jump in without opening the door. Right through where the top would be. Right like Magnum, P.I., and turn the key. It purrs to life.

Gravel sprays everywhere while fishtailing onto the almost empty Kamehameha. I still haven't glanced backward. They are there somewhere, the mountainous shadows, and maybe they are trying to find their own rusted Jeep Wranglers or jacked-up Ford F-150s or motor scooters, or maybe they have given up on smashing this particular haole tonight. The only notable damage I can find is to

my Helmut Lang button-up, which has been violently torn. I have also left my shoes in the house. Stinky, cream-colored Vans that had been smashed in the heel since I refuse to ever wear them properly. And terribly stinky since I don't ever wear them with socks.

I hear the pound of surf off to the right before I crank the stereo. Top 40 pours into the tropical night. My hair, now like Christian Slater's and not like Ellen DeGeneres's, blows back. I love Top 40 here. I love my white convertible, Helmut Lang shirt, skinny jeans, and all sorts of contrivance. It is my version of "island dandy" and it is purposefully at odds with everything Oahu's North Shore stands for. The image of Hawaii? Paradise? Relaxation? No worries? It is all a lie. The North Shore, very much against its idyllic stereotype, stands for rough brutality but I don't do rough brutality, stylistically. I do easy breezy. I do dandy. Yet I cannot help causing problems. I have learned that about myself. I cannot stop even when I want to. Even when I need to.

The slivered moon is low and semi-haze-obscured, and palm, banyan, hibiscus, plumeria speed past as I drive west toward Hale'iwa. It is overgrown and dirty. Not brown dirty but red dirty. Volcanic dirty. The one grocery store, Foodland, rushes past on the left and then I am hugging the curves near Waimea Bay. Hot. Humid. Alive. Dirty. Good jeans. Great hair. Thrilled.

I had become a fabulous surf journalist. I had fulfilled the promise I made to myself inside a dark Beirut dungeon. And I have received more death threats, more choke outs, more problems, more trouble than I ever had going to the Hezbollah dance. Or running from Somali pirates or drinking tea with Palestinian rebels or ducking Al-Qaeda shoot-outs. And though it may seem that being kidnapped in the Middle East is much more bone-chilling than being strangled by a Hawaiian on Oahu's North Shore, I am here to say

that it is not. Being kidnapped, shot at, chased, tracked, followed by terrorists in Africa and the Middle East is certainly unnerving but it also feels fantastical. It feels otherworldly because when the mob gathers, when the bullets start flying, everything turns into a strange dream and the adrenaline pops and aye-aye-aye! Lights, cameras, action! The film set is from *Syriana* and the extras are too. And when the intensity is over, when the scene wraps, I get back on an Emirates flight bound for Los Angeles, California, and lounge in the peaceful sunshine near a blue swimming pool.

The North Shore is as much of a film set as the Middle East or Africa, only it is *From Here to Eternity*, not *Syriana*. But the scene never wraps. The intensity never ends. There is no escape because the angered Hawaiian will not give up. Even as my white convertible Mitsubishi Spyder zooms away I know I am not forgotten. I am not forgotten for the moment and I am not forgotten when I am back on a Hawaiian Air flight bound for Los Angeles, California. The Hawaiian lives on an island, true, but that island is still the United States of America. And he will find me, eventually, and he will physically destroy me.

There is simply no remove on the North Shore. Anyone related to the surf world, including a fabulous surf journalist, is fair game in this war. It crawls inside in a way that nothing I have ever experienced does. It is so completely "other" even though it is also completely "American" and thus "me." The Middle East is only "other" but the North Shore is not and this otherization of one's own self is horrifying in the same way that Colonel Kurtz was horrifying in *Heart of Darkness*. And I kid you not, it is a war. A brutal, brutal war. Who would have guessed that? Certainly not me. Probably not you. Definitely not Anderson Cooper but he has a daytime television show now. He is the new Ellen DeGeneres.

Birds, Boats, and Past Loves.
Or, from Beirut to Bondi.

The journey from hostage to surf journalist was easy like a Sunday morning. First, Josh and I convinced our captors that we were no good to them. I really don't know how in the world this happened, besides actually being no good to them, but it worked. They kept us in the dungeon, periodically verbally abusing us, until the sun set and then our Hezbollah dresses were turned back into head coverings and we were driven twenty minutes, or so, to a sparse home. Inside sat two older men, two armed younger men, and the creepiest creepster I have ever seen in my life. He wore a beard that looked identical to George Michael's, had possessed eyes and a slithering English accent. He implored us to sit. And then began our interrogation. "Why are you here in Lebanon? Why did you go into the Dahieh? Do you know that area is off-limits? My favorite actress is Julia Roberts. Do you think she is beautiful?" He would end each series of questions with a statement about an actress and then another question about her. "Jennie Garth, in *90210*, is very sexy. Is she popular in America?" Amazing.

The interrogation went on for endless hours. Creepster asked us questions. Every one listened intently. Sometimes we answered in Arabic, sometimes we answered in English. I agreed and told

him that Julia Roberts was beautiful but could not lie about Jennie Garth. I told him she was neither sexy nor popular. Other operatives came in and out, listening, nodding, leaving, making phone calls. Eventually they brought us cheese and bread. We all sat on the floor and feasted together, while Israeli bombs dropped around us, on what tasted like the best food I had ever eaten in my life. Then they walked us out to our motor scooters, hugged us, told us never to come back, and wished us the best of luck.

I don't know if we said the right things or if they were letting us go in order to tail us and then kill us and our other spy friends. I don't know. I just knew, at that moment, we were free and that I had a new lease on life and I knew exactly what I was going to do.

Second, I split from my wife. We married young and I believed in her. She was a talented singer/actress with a voice as big as an auditorium and I sensed great things in our future. I saw us as Norman Mailer and his jazz-singing fifth wife, Carol.

As the months became years, though, I realized something about her. I realized that she hated the cinematic life. She downplayed her own successes and completely disregarded mine. I was not an easy husband, to be sure, running around the Middle East with a seeming death wish, but I always tried to make her feel the *esprit d'aventure* and I never stabbed her with a penknife. Still, she steadfastly refused to live famous. She never saw life as an adventure, she only saw it as something to endure, a place where the deck was perpetually stacked against her. Soon after I came back from Lebanon she moved to New York to work on/endure an off-Broadway musical and then I met a blonde Russian and then the wheels fell off completely.

I admitted my infidelity when she returned from her show's run and we went to marriage counseling. I felt awful but I still hated her

and it is totally unfair to stray and hate and go to marriage counseling and hate but that was what it was. The end of any marriage is only a murky puddle.

I hadn't pitched any more outlandish ideas to magazines, like trying to buy blood diamonds from the source in the Congo, since I had come back from Lebanon. I hadn't needed to because, third, the outlandish ideas came to me from the magazines themselves and specifically from Australia's notorious surf publication *Stab*. Its editor, Derek Rielly, had read my stories in *Vice* and, as if he heard my silent pleas from a Hezbollah dungeon, asked if I would write a story for him about a convicted methamphetamine-dealing professional surfer up in Santa Cruz. He did not know or care if I surfed. He liked the idea of my writing. I agreed at once, penning "The Ice Storm," which subsequently got *Stab* sued by the Australia decency board because, in the article, I suggested that all surfers should become addicted to methamphetamine.

Derek liked the story so well that he insisted I come to Australia. I went to one more marriage counseling session and my wife told the counselor that I wrote about methamphetamine and was probably addicted myself and was most likely possessed by a devil. That was all I needed. She had no vision.

I flew one way to Australia's Gold Coast and threw my wedding ring into the waves at Snapper Rock. I watched it sink underneath a canvas of blue and white and felt free. The air was hot. Piercing hot. Humid. Cancerous, because the ozone is rotted above Australia because Australian girls love hairspray. Professional surfers danced upon the waves and I was free.

I had come to the Gold Coast, specifically, to cover the Quiksilver Pro, the first surf contest of professional surfing's World Tour season. Every year it starts on the Gold Coast. And the Gold Coast

is well named. It is gold. It is a surf paradise. There is more than one surf paradise in the world. There is Huntington Beach in California. There is Teahupo'o in Tahiti. There is the whole island of Bali. And there is the Gold Coast. The largest city in the region is, in fact, named Surfers Paradise. It is a glimmery, gleaming skyscraper village caught betwixt green lagoonish rivers to the west and green bluish seas to the east. The Pacific seas.

The skyscrapers are totally better in picture than in person. In picture, they are all today's luxury. In person, the waft of their construction date rises like Jazzercised sweat on pastel leg warmers. The waft of mid- to late 1980s. Not enough modern steel and glass. All sorts of concrete and little windowlettes. Small decks peeking out into the constant perfect weather. Or too hot weather. The weather that cancers.

The shopping streets below the little windowlettes and small decks feature purchases for the uncouth. Easy women and kids on school vacation roam and pick through discounted lingerie and shirts with outdated slogans. "I'm an angel. Not!"

As fine as Surfers Paradise is, there is no real genuine surf of which to speak because the hot sand is perfect for sitting and tanning and crafting illegitimate babies, not for the crafting of sandbars, which is what waves need to break. Wave creation is an intangible admixture of landmass direction and underwater contours and magic and sin and gods and goddesses, and Surfers Paradise sits bereft. It sits without grace. But just to the south is a small town named Coolangatta and Coolangatta is the true surfers' paradise.

Coolangatta may be the whitest town on earth, white as in Caucasian. All the food is fast and all the restaurants serve a version of the café latte, called "flat whites." All shops sell collectible shot glasses. Almost all the shops are surf shops and all for good reason because

Coolangatta features many famous waves: Duranbah, Greenmount Point, Rainbow Bay, Coolangatta Beach, Kirra, and Snapper Rock, which is the most famous.

It is a perfect place to surf. A perfect place to hold a surf contest. A perfect place to hold the first surf contest of the World Tour season. Every year begins on the Gold Coast. Every year begins in Coolangatta.

I met Derek for flat whites at the Komune Hotel. Derek is classically Australian hip. He wears plunging V-necked T-shirts, Dior Chelsea boots, skinny skinny white jeans, pendant necklaces, Dior sunglasses. His skin is always chestnut brown. He does not wear sunscreen, preferring to go to the doctor every other year and getting suspect spots carved out. He is also a genius, in small part because he wills himself to learn French by listening in the car to Brigitte Bardot sing. In small part because he loved my writing so much. He told me to fear nothing, neither the Australia Decency Board nor any man. He told me to write like Serge Gainsbourg lived.

Stab would truly become my vehicle and I drove it like a funny car. I drove it like there were no rules or regulations or police officers or stop signs. I wrote what I wanted. I wrote how I wanted. After writing about terrorists and death and hot hot deserts I basked in the sunshine of surf. I tanned. I drank. I winked. And Derek would print everything I wrote without edit, or with only the slightest edit.

I covered the Quiksilver Pro on the Gold Coast and wrote that Mick Fanning, who would later win the World Championship, was dull and surfed dull and, worse, dressed dull. I wrote that other surfers were so divinely handsome. Touched by the finger of Venus. Surfing is always homoerotic. It always has been. It is an activity where young, bronzed boys filled with health and vitality strip virtually nude and go sit in warm seas. They are often blonde. They are

often handsome. Their parents are typically wealthy enough to live on the beach and have good genes and make beautiful babies. And when the waters cool, when winter comes, surfers pull on wetsuits, which are no more than skintight pantsuits. The way surfers look is as essential to the game as anything. It is a totally aspirational element in a beautifully aspirational life.

I wrote whatever I felt, whatever I wanted, and then I followed the tour to Europe and refused to go to any of the surf contests, instead spending all my time with a half Portuguese half Angolan investment banker. I wrote about her and about me and about driving in her new BMW and about living well. I wrote about us getting all dreamy in Lisbon and Madrid and Bilbao, which is super not dreamy except for the Guggenheim. Neil Ridgway, who was a vice president at Rip Curl, one of the "big three" surf brands, got very angry with me one day in Portugal. Rip Curl was the title sponsor of the contest I was supposed to be covering and they were paying for my hotel room and he felt it was bad form that I was writing about my investment banker instead of the surf. He cornered me in an empty bar while I was doodling and really let me have it, coming through the door like a livid wind. His face was stern and he was, inexplicably, wearing a red beret. He fixed me in his anger and asked, loudly, "Are you Chas Smith?" I answered, "Yes," and he continued, planting himself in a baby-blue chair opposite mine, "I don't like what is happening here. We put you up in a hotel and you write off the event? That doesn't seem right to me." And he continued, "I don't like you saying Mick Fanning is dull when you don't even talk with him." Then he said, "I am not going to tell you what to write," before continuing, "Why don't you ask people questions instead of just standing by and observing? Have you ever talked to Mick?" I tried a half-hearted defense and replied, "Look, there are two types

of surfers. There are professional athlete kinds and the other, uhhh, not professional athlete kinds. Mick represents the professional and therefore is bland. He is like Roger Federer. Someone like Dion Agius represents the other end of the spectrum. He is more exciting because he . . ." And I didn't quite know how to finish the sentence without sounding as trite as I actually am. Dion Agius is a very short but very handsome Australian surfer with great hipster style. Neil responded, "Why do you like Dion? Because he dresses well?" And I told him, "Yes. That's it. Dion does his cinematic part in this gorgeous surf narrative we're all living. And I have no ax to grind with professional surfing, or the industry. I am just trying to be me, baby." He said, "I read what you wrote about the event in Spain and I don't know what you are doing with your financial planner and all that. I mean yesterday you were drinking espresso from a gold-rimmed cup and today you are drinking beer from a pint glass." I had, in fact, stolen a glass of beer because the bar was empty and I looked at my stolen beer and thought, "What is the difference between a gold-rimmed espresso cup and a pint glass?" But I said, "I am glad I know how you feel about my writing." And he said, "We'll just be watching what you write tomorrow," before ending with, "See I'm wearing a funny hat. Now you can write about that." Then he left with a glare, blowing out on the same livid wind that blew him in.

And I did. I wrote everything he told me and I wrote especially about his red beret. It was such an amazing style faux pas and nothing irks me more. I wrote and wrote and wrote. Writing is not a picture. It is an interpretive dance. It is a dark art and, through *Stab*, I did my damnedest to make it darker. It was my contribution to the literary world, a contribution that Derek Rielly coined "Trash Prose." "*Stab*'s favorite writer Chas Smith," Derek wrote

in the introduction to *Stab* issue 26, "has an uncanny knack for button pushing, of his subjects and of the readers in his self created genre of Trash Prose . . ." He went on to describe the joys and pains but mostly joys of being a fabulous provocateur. And Derek and I laughed together. He is shockingly self-destructive and allowed me to write *Stab* to the brink of ruin. All surf magazines are completely indentured to the surf brands. Revenue from subscriptions barely covers printing costs, meaning surf magazines derive virtually every dime from brand advertising. And the second that brands get frustrated by any content they pull their ads. They get frustrated very easily. Surfing is a completely insular world where virtually every interesting subject, like anything emotional, deep, true, funny, or feather ruffling, is forbidden to cover. I cost *Stab* hundreds of thousands in lost ads but Derek didn't care. He loved Trash Prose and he laughed and I laughed and laughed and laughed. It all felt fun. It felt like palm trees swaying in the wind and salt water on my skin. It felt exactly like I wanted it to. My reputation, as either a cocaine-abusing homosexual or a cocaine-abusing narcissist grew. It was the only way the surf-reading public could square my fascination with fashion and my fascination with myself even though neither are true. I am actually an old-fashioned Calvinist but John Calvin himself said, "There is no work, however vile or sordid, that does not glisten before God." So I did not defend myself, and my fame, like Odysseus, reached the heavens.

And then I followed the tour to Hawaii. To Oahu's North Shore. And the laugh was almost choked from my face.

The Thoughts Your Actions Entertain.
Or, My First Impression.

will always remember that first trip. Any child raised on surfing has also been raised on the North Shore, metaphorically. Stories of waves bigger than mountains. Of the men who conquer them. Of adventure. Of wild times and wild women. It is Shangri-la. It is Mecca. It is the place. The only place in all of surfing that truly matters. But there are also strained whispers of fights and slaps and men also bigger than mountains who take scrawny Caucasians by the neck and strangle them until they see stars. Of drugs being funneled through the dimly lit tropical paths and gangsters who control that trade. Of people being dragged to golf courses and filled full of buckshot. Of non-Hawaiians paddling out at any of the breaks and getting pounded for being where they don't belong. The North Shore has a reputation that far far exceeds its spatial parameters. It is mystical. Terrifying. Legendary.

The terrifying elements are, again, only ever whispered and, before going myself, I felt they were exaggerated. How can a corner of the United States of America be so lawless? So radical? Impossible. The North Shore is not Yemen. It is not Somalia. And so I boarded a Qantas flight in Sydney with my arrogance intact. It was summer in Australia but winter on the North Shore. Winter is when the waves

arrive from swells created far away in the Gulf of Alaska and it is the only time to go.

I felt very fine in Helmut Lang and skinny jeans and sockless Vans smashed at the heel. I wedged between the window and a chunky man in an aloha shirt. His chunky girlfriend sat next to him in a matching aloha shirt. I watched *Burn After Reading*, which was such a massive disappointment. Brad Pitt and George Clooney and the Coen brothers—how could it go wrong? But it went so wrong. I ate a Salisbury steak. I slept. And when I opened my eyes the chunky couple were making out. Ugh! The plane was descending into Honolulu and I wanted to feel gorgeous and alive but instead I felt the swirl of depression and madness. I looked out of the small coffin-shaped plane window at suburban Honolulu and the rising hills that separate "town" from "country" and felt depressed. I felt dark.

The North Shore is generally referred to as "country" when in Hawaii and Honolulu is "town." I had been to town a handful of times previously—once when my father took a teaching job in Papua New Guinea and I was six years old. (We stayed in Waikiki, on an extended layover, and I played in the white sand and pretended to swim out in the warm Pacific. I would windmill my arms, touching the sand with each stroke, and insist to my parents that I was swimming. They usually humored me but not those days. They would tell me that I wasn't, in fact. That I was merely crawling in the water. Rude.) Another time for *Stab*, when I was writing yet another story about methamphetamine, which Hawaiians call "ice." Ice is a plague in Hawaii. It is the only state in the Union, and maybe the only municipality outside of the Arab world, where something other than alcohol attributes to the majority of emergency room visits, car accidents, and spousal abuse. Ice is everywhere, or reported to be everywhere, and so I

went to Honolulu to find some and see what exactly was happening. I stayed at the Royal Hawaiian, also called the Pink Palace. I love pink in Hawaii because it feels both tropical and appropriately weird. I almost always wear a pink button-up, when I am not wearing a white one, and the Pink Palace is a dream. It was one of the original hotels built in Waikiki during the 1920s when the hope of paradise was only a steamer ride away. Its architecture is, oddly, Moorish and the rooms feel old but they maintain an air of dreaminess. There is a newer wing, which feels like Australia's Gold Coast, but I demand not to stay in the newer wing.

I also love Waikiki in Hawaii. I love everything about it. The way it feels. The air is always scented. It smells like coconut and lotus blossoms. The Japanese tourists glow Louis Vuitton. They love luxury labels and all Hermès, Chanel, Gucci. Tiki torches shine. Palms dance and so do Polynesian babes in grass skirts. But ice hovers, theoretically, like a Mongol horde, at the fringes. And so I went.

I poked around Waikiki for two days, asking in convenience stores and boutiques and even Hermès if anyone knew where I could score some ice. The workers would either shrug their shoulders and look at me or just look at me. And then one night during a sushi dinner I scored. My effeminate waiter, a mainlander with the neatest little mustache, brightened right up when I asked him. "Ohhhhh iccceeee?" he said. "It's everywhere. I mean, you don't see it, but you see it . . ." I asked him to get more specific. He pointed west with a manicured pinky and said, "It's west." And so I went, the next morning, to Ewa Beach, which is to the west of Waikiki.

Ewa Beach is a slum. Virtually every neighborhood outside of Waikiki is a slum but Ewa Beach is worse and as I drove west, exiting on Fort Weaver Road off of the Queen Liliuokalani Freeway, I felt that it was worse. It appeared normal, or Hawaii normal, directly

off the freeway. Standard, mainland-colonization style, Blockbuster video stores and Vons supermarkets punctuated by an odd *malasada* or local grub joint. Things started to go sour as I moved toward the water, however, which is counterintuitive since nice usually sits on the ocean. Gated communities gave way to boarded-up hellholes with bizarre accouterment strewn about. In one front yard, two battle-cocks in cages waited for their next big fight. Another garage was open, revealing a partially assembled prison-style gym.

The streets were strangely ghost-town silent and so I parked, got out of my car, and started wandering around until I heard, "Haole boy . . . you wan' beef?" behind me.

I turned around and saw three tubby Hawaiians posturing shoeless in ugly tank tops.

"No, I want ice," I replied. They gave me a long, hard look. "Whachu said, haole boy?" "I want ice." One of them reached down to pick up a handful of rocks. The other two stood, arms folded. They were fifteen years old. I continued walking but did not run into anyone else or any other trouble. I got lost, seemingly passing the same derelict house after the same derelict house until I accidentally found my car and left.

Back in Waikiki I went to a seedy Mexican restaurant and ate stale chips and salsa and also had an epiphany. I had come to the restaurant with the notion that most of the world's methamphetamine is produced in Mexico and maybe Mexicans were setting up restaurants as fronts. Things looked good for a while. My waiter was babbling Spanish and a table of very sexy Latinas fronted mine. Within half an hour, however, I had discerned that my waiter was Peruvian, the Latinas were Puerto Rican, and the owner of the restaurant was Chinese. Defeated.

Then it hit me. I was trying too hard. Ice is not cocaine. Cocaine

is sexy, sultry Al Pacino in a white leisure suit. Cocaine dealers like to show off. Their cars, clothes, and women advertise what and who they are. Methamphetamine, on the other hand, is embarrassing and tawdry. Ice dealers, if they show off, do it in stupid ways. One of Oahu's biggest local producers had recently been apprehended. The newspapers flashed reports of his bling, which included a 1985 Chevy Blazer and some Jet Skis. If Pablo Escobar had been caught with a 1985 Chevy Blazer, he would have shot himself. Cocaine is a party-rich starlet drug. Methamphetamine is a desperate drug.

I hurried outside and found an ugly, tattooed thirty-year-old standing in front of a strip club, and asked him for some ice. I'm sure my drug vocab was woefully inaccurate, but it worked and I bought a small baggie off of him.

I went back to my hotel room and stared at the baggie. The crystals inside looked harmless. They looked like rock salt. And I wrote about my experience, though I did not smoke or snort. I ended up leaving the baggie at the foot of Waikiki's famed Duke Kahanamoku statue.

Once, I told my story about Ewa Beach to a local Hawaiian, a rare Hawaiian possessing Hawaiian blood, and he was shocked that I did not get killed. Willful ignorance has always been my armor.

Waikiki and Ewa Beach are not the North Shore, though, and as my flight sank lower and lower toward Honolulu's tarmac for my first winter in paradise, I was depressed when I should have been thrilled.

There was something about the lights that dotted the island outside of the bright gold of Waikiki. Maybe it was my lust for city life, but the lights on Oahu were spread too far apart. They didn't

suggest culture or dreaminess or relaxation. They suggested the small torches held by an angry mob. They suggested rage.

I rented my car across the parking lot fronting the terminal. The only one they had was a white Mitsubishi Spyder convertible and this was the beginning of a personal trend. I now always insist on white convertibles when in Hawaii. Sometimes they are Chrysler Sebrings. Sometimes they are Toyota Solaras. But they are always white and they are always convertible. It is what my personal Hawaii film set demands just like the *Dirty Harry* film set demanded a 1968 Ford Galaxie 500.

And I drove west on the Queen Liliuokalani Freeway, turning north before Ewa Beach on the H-2. I passed palm trees and odd pines. There are so many odd pines—called Norfolk pines—on Oahu with spindly branches spread far apart and cones and scent. Pine doesn't suggest tropics but on Oahu, pine is everywhere.

The H-2 climbed up into the Wailua range that cuts across the island and more pines and skirted Mililani Town and the Schofield military barracks where the army's Twenty-Fifth Infantry Division trains. The architecture depressed. So depressed. Boxy with small windows and air-conditioning units and fences and military police. Laundry hanging on wires, washed by big-boned military wives. Depressed.

And then onto the Kamehameha Highway through acres of island weeds, waist-high kunai grass, then pineapple and past the Dole Pineapple Plantation. This is a tourist attraction here, though almost all of the merchandise—small wooden pineapples and stuffed pineapples and pineapple soft-serve—come from the Philippines.

And then past red dirt and more kunai grass and then the Kamehameha dipped and I pulled over, stood up through the open convertible top, and looked at the flicker of Hale'iwa Town and I looked,

for the first time, at the North Shore. At Shangri-la. It was too dark to see the waves but the land, this land, held so many memories even though I had never been here. Even though I had never beheld it with my own eyes. I looked and felt my heart beat.

Certainly, I was bringing my own reputation into a volatile land. A volcanic land. But the North Shore is not Damascus. So I sat back down and found a Top 40 station and curved down, down, down. Depressed but also thrilled.

And as I drove past Hale'iwa Town and past the waves I had studied since I was an Oregonian child and past raised pickup trucks with bumper stickers that read "Keep Country Country" and past ramshackle homes, I thought, "Well what the fuck is this?"

First impressions of a dreamed-about place are strange. I remember the first time I went to London. I was shocked, shocked, by how ugly the men were. Their teeth did their own thing. Their haircuts looked done by hedge trimmers. I could not imagine that London once ruled the world. I remember the first time I went to Cairo and the slums spilled out to the pyramids and the Sphinx looked like a small toy. I could not imagine that Cairo once ruled the world. I will always remember that first trip to the North Shore.

It seemed run-down. It seemed unkempt. It seemed used. It seemed rotten. It was not the gilded expanse of my imagination. It was rough and dirty. But I had a job to do so I shook off first impressions and went to sleep in a home smelling of mildew and salt water and woke up the next morning depressed. Everything was a blur. I went to contests. I surfed and got rolled off the reef. I sat on the beach with a dropped jaw and watched Pipeline explode. Pipeline. The Banzai Pipeline. It is the most famous wave in all of surfing. It is the most famous wave in the world and it comes steaming in from across the Pacific or maybe from Hades itself and it ex-

plodes on the reef not thirty feet from the shore. It is pure energy. It is a natural wonder like Mount Everest or Victoria Falls. I deflected angry looks from oversized mokes. I ate Spam *musubi*, which is Spam served like sushi on a bit of rice wrapped in seaweed. I visited with the surfers I knew and loved and deflected angry looks from the surfers I had burned too. I drank mai tais with Paul Evans, the editor of *Surf Europe*. I soaked in everything I could and listened to stories about the men bigger than mountains who pounded people. Stories about a man named Kaiborg who was as mean as a rhinoceros. Stories about a man named Fast Eddie Rothman. Surfers always whispered Eddie stories quietly and always while looking over their shoulders. He was a myth. A boogeyman. A specter. He was said to have his hands in every aspect of the North Shore scene. He was accused of involvement in the drug trade. He was accused of extorting the surf companies. He was accused of unspeakable violence. He would stop grown men's hearts just by entering a room. Nobody really knew anything, and whispers and whispered stories would take on lives of their own but isn't that always the case with men who have exceeded merely being a man and have become something more?

No one knew exactly where Eddie came from but there were whispers of New York or Philadelphia. There were whispers that he was Jewish. No one knew exactly what he did. They only knew he was a walking nightmare. They only knew if they crossed him they might end up in the worst trouble. And I didn't have much thought of meeting this particular specter. I didn't even know how to begin to meet him and so I went about my blurry business and simply listened to the whispers about Eddie and Kaiborg and the violent, just barely hidden North Shore.

It was almost too much and every day I woke up depressed but

also thrilled because every day held more potential for danger than any place I had ever been. Yes, when I sat in the Hezbollah dungeon I had wanted to escape the adrenalized life forever. I had wanted to do completely soft, easy, beautiful cinematic things but I had realized, somewhere in the transition between war and surf, that, yes, I cannot help causing problems but even more, even worse, I had realized that the dangerous elements are necessary for me to even live, that Uncle Dave's picture with mujahideen and Stinger missiles would have been meaningless without the scary mujahideen and the deadly missiles. Danger is sexy and I am cursed to forever chase it.

And then Mick Fanning, the same Mick Fanning that I wrote dressed dull and was dull, won the World Title and so I went, with Paul Evans, to the Rip Curl house for his victory party. It was a hot evening.

As I pushed through the door, leaving my cream-colored smash-heeled Vans on the stoop, it was hot. And the living area of the modern island house was filled with revelers. They were celebrating. I found a beer and dropped into conversation with a publisher of an Australian surf magazine, and then another Australian writer named Tim Baker found me. Tim Baker is embarrassing, a total surf fan and too old, and he looked embarrassing that night wearing a "Mick-tory" hat and a "Mick-tory" T-shirt. Rip Curl had produced them especially for the occasion. Tim told me that he did not like my writing, that it was too negative, and then told me he would introduce me to his friend Mick Fanning and he was sure we would get along well. I was not sure.

We moved over to where Mick was standing in a corner, looking drunk.

His blue eyes were glazed over once with tired, twice with sun, thrice with beer. Lids drooping. Puffy. He barely registered the con-

gratulatory masses. They were all there for him. Dancing and drinking in the hot Hawaiian night. A youth came by and said, "Good on ya, mate." He nodded and lifted his can of Bud Light, slightly. A gorgeous girl with pearly white teeth and a tan the color of peanut brittle pointed both her fingers to the sky. "Yew!" He nodded and lifted his can of Bud Light, slightly higher.

Tim Baker fought through the celebration and introduced us. "Mick, this is Chas Smith." Mick's glazed face scrunched. "So you're Chas Smith," he said while shaking my hand. And then his glazed face suddenly engaged. "Fuck you. You know, fuck you. You write so much shit about me. So much fucking shit. What makes you so cool? Why the fuck do you think you're so cool?" I looked down at my white Helmut Lang button-up and perfectly trim grey jeans. I did look cool. My hair was nicely mussed, but I responded, "Ahhh I don't think I'm that cool." His eyes continued filling with rage and wandered around my mouth. "Fuck you. You know, you are a fucking Jew." I responded, "Sorry?" And he said, again, "You are a fucking Jew." I told him, "No, I'm not Jewish. I am English with a little German . . ." He said, "Fuck you. You are a fucking Jew. You totally fucking write off surfing and then you make money off of surfing. You're a fucking Jew." I was intrigued by Mick's socioeconomic analysis but responded, "I don't make that much money off surfing." He said, "Fuck you. I should punch you in the fucking face. I should punch you in the fucking face right now." I was scratching my chin and trying to figure out an appropriate response. I was smiling broadly. I stood a head taller than Mick and he was leaning into me. We were only a few centimeters apart when I felt the hairless arm fold around my neck. And I smelled Spam and yesterday's beer. And I was drug away, danced away, Lindy Hopped away, for a beating that never materialized.

The story I wrote about the incident, "Tales of a Fucking Jew," was a *Stab* bestseller. It also cost them hundreds of more thousands of dollars in lost advertising revenue and giant headaches. The New South Wales Board of Jewish Deputies had become enraged. Mick Fanning had to call them, crying, and apologize, but he mostly blamed me, saying he was only using the same sort of ironic language that I regularly used. His mother blamed me. Every major newspaper in Australia ran with the story and I was alternately depicted as being the worst sort of muckraker and a brave, honest voice. It was on the radio. It was on television. It was everywhere. Derek Rielly laughed but also cringed as the magazine came dangerously close to folding.

I asked Derek to publicly fire me but he wouldn't. And so I simply went about my muckraking business. Bravely and honestly. But more than causing trouble, more than anything, the North Shore had crawled into my heart. It was all I thought about. That first tour was vicious. It was manic and I hated it with everything in me and I loved it more than I could say at the same exact time. It was beautiful. It was bizarre. The colors. Powdery yellows drifting into salmons drifting into fiery tangerines slipping into a full palette of blue. Carolina, cornflower, denim, palatinate, Persian, navy, ultramarine, midnight. The smells. Chicken and dog and teriyaki sauce and salt water and rot and surf wax. The women with chipped toenail polish and hungry eyes. The scene. Mobs of surfers high on adrenaline and cocaine. Surf industry scenesters running scared and also high on cocaine and also chasing the women. The waves. Waves known around the world. Waves that kill and make men famous. The history. The men: Brutes. Thugs. Gangsters. It was a Brian De Palma film that nobody would make because making it would guarantee banishment from the surf world, at best, being buried in the pineapple fields, at worst.

These North Shore stories are only internal top secrets. It would be like writing about the mob while being in the mob. I never wanted to go back. Yet it was all I thought about. I wanted to move there semi-permanently. I had become infected by something confoundingly at odds with itself.

And then, out of the blue, Fast Eddie Rothman called me. I was supposed to be covering the US Open of Surfing in Huntington Beach, California, but was, instead, attending the White Party, the largest gay party in the world, in Palm Springs with my woman when my phone rang. I could do whatever I wanted because, along-side my work at *Stab*, I had been made editor-at-living-large for *Surfing Magazine*. Horrible house music pumped while oiled men danced and I looked down and saw the call was from an 808 area code, Hawaii's area code, so I answered. The voice on the other end was gruff. Gravely deep. "Dis Chas Smith?" I answered that it was. "Dis is Eddie." And he didn't have to say which Eddie. I already knew. "You know dat fucken guy who call you a Jew?" I responded that I did. "Haaa. I slapped him for you." And that was all. I didn't know why Eddie slapped Mick. It certainly wasn't for my sake. I can't imagine that he was a fan of my work, but then again he called me to tell me about it. Whatever it was, why ever he did it, I was now totally stuck. I had to go back to the North Shore and sit across from this specter and look into his eyes and hear his story, even if the only thing we shared was my apocryphal Judaism. Even if it was going to get me killed. I was compelled beyond anything I could control. This was the war I wanted to cover more than any other. Yes, danger is sexy and I am cursed to forever chase it.

There Ain't No Motive for This Crime.
Or, Welcome to Paradise.

I arrived at the airport, three months after Eddie's call, ready-ish to fly back across the Pacific, toward the North Shore, on a bright winter morning. Winter, again, is the only time to go. There are no waves without north Pacific storms that only rage during the winter months and without waves the North Shore is nothing. Los Angeles International Airport buzzed. Chinese families checked shrink-wrapped luggage. Armenian men sipped bad espresso. I had a feeling in my heart that this would be the best North Shore season ever. I just knew something was going to happen and I would end up dead or famous. I had always wanted to be famous and dead is better than dull.

I was set to land in time for the Surfer Poll awards, which were taking place that night at the North Shore's only hotel, called the Turtle Bay Resort. The Surfer Poll awards are the surf industry version of the Academy Awards but they are embarrassing because most surfers, aside from Dion Agius, don't know how to dress out of the water. They have all the raw material for gorgeous. They are fit, they are tan. But they refuse to dress well. They refuse to put together any semblance of a decent outfit. They know nothing of a tailored pant or a shirt that is not an extra large bag and especially

not on the North Shore where boardshorts and slippahs are de rigueur. And so the Surfer Poll feels like an award show for preschool children. But no matter. It is our party.

I climbed into my seat, first class this time, no chunky couples in matching aloha shirts next to me. I'm wearing a version of what I wore last flight but this time my button-up was not Helmut Lang, it was Yves Saint Laurent, and my Vans were not cream but red. I put on headphones and half watched *Crazy, Stupid, Love*, which was surprisingly enjoyable, and half dreamed and half sank into typical airborne depression. I knew something was going to happen. I felt it.

And when my American Airlines flight was beginning its descent over the expanses of Pacific nothingness, as darkness filled the cabin, extraordinary events began burning on the North Shore. Extraordinary. Just in time for my arrival. Happening just in time for me.

The Wheel of Fortuna had not been spinning Billabong's way for some time. They, along with Quiksilver, are the most fabulously successful surf brands and to the casual observer that does not mean very much. The casual observer thinks T-shirts and boardshorts are cute. But surf is a multibillion-dollar industry. The brands are publicly traded. Many of the top professional surfers make over a million dollars a year. The worst professional surfers on tour still make six figures. The CEOs are worth two hundred million. The CEOs are on Forbes' richest-men-ever list. Nike has been trying to crack the surf nut for years and so has Target and so has American Express. And here is the secret. Not that many people actually surf, actually buy surfboards and wetsuits and wax and paddle out on cold mornings and shred. But everyone swims and when they go shopping for swimming trunks they buy boardshorts made by Quiksilver and

Billabong. Except. Not very many boardshorts by Billabong anymore. That damn whore Fortuna.

Billabong's high-water mark occurred in 2010 when the company's sales towered over a billion dollars, nearly reaching two. It had been on a buying spree, scooping up smaller brands like Nixon watches, Dakine surf hardware, VonZipper sunglasses, and Element skateboards. Like candy. And through the economic boom Billabong had danced.

And when the economy collapsed, their purchases kept the coffers full. Gordon Merchant, Billabong's founder, smiled his crinkled Australian smile. He was worth 570 million dollars. Selling T-shirts and boardshorts and now watches, sunglasses, surfboard leashes, and skateboards. The sun shone brightly.

Then Fortuna ground to a halt. And then she started spinning the other way. The bad way. Billabong kept up an amazingly ill-advised buying spree, scooping up brick-and-mortar surf shops around the world and many in Canada. This would never have been wise, because neither surf nor swim are popular in Canada. Canadians prefer to keep their pale flab hidden beneath anoraks. But it was especially not wise to buy physical stores when retail was being driven ever more to online sales. And while some of Billabong's brands were performing well, many more were drowning. Billabong itself had lost its sheen. Difficult to be a perpetual youth brand, to be perpetually hot hot hot. The kids no longer wanted what their parents grew up wearing. The kids were on to the new hot surf brands. On to Volcom. On to the next hot thing. On to the RVCA, which Billabong bought and turned into a mixed-martial-arts brand and rotted its status.

Overnight Billabong's sales dropped by 70 percent and private equity firms from Texas smelled blood and gathered resources for leveraged takeovers. There were allegations of horrible investment

decisions, strategic gaffes, and gross directorial incompetence. Gordon Merchant's crinkled Australian smile turned into a crinkled Australian frown. Cloudy bummer skies. No more sun.

Still, Billabong had an image to present. It was an original core surf brand and it was business as usual because, someday, Fortuna will change her mind. Billabong had always been a major sponsor of top-tier professional surf contests and it was the title sponsor of the Billabong Pipe Masters, the best event in all of surfing. So the top executives packed their bags, like they did every winter, and flew to the North Shore, like they did every winter, and set up in the three multimillion-dollar Pipeline-front homes that they keep every winter. One of the three homes was actually owned by Billabong's vice president of marketing, Graham Stapelberg. He had bought the property during high times, and lived in the house, off and on, during the year and would rent it to Billabong during the North Shore season. Billabong's top surfers and other executives would live there with him.

And, yes, bummer skies, but still. Surf is surf and the North Shore is Shangri-la. Little did they know, a terror was coming their way. A terror worse than the investor lawsuits. Worse than Texan private equity firms sniffing. Worse than bankruptcy. Eddie Rothman was coming. The myth. The boogeyman. The specter.

Theoretically Eddie Rothman is nothing to fear. Sixty-three years old and five foot seven, if generous, five foot five if honest, he could be a grandpa or a retiree. But he is not. He is roping muscle. His arms, usually bare, are perpetually flexed. His chest, puffed like a gorilla, vibrates aggression. His expression rarely changes. It is stone and his features are stone too. A pug nose broken more than once. A jaw that would be impossible to break even with a lead baton. He shaves his grey hair down to a fine stubble and the braided rattail that he once sported is gone. The neck that holds that head up is as thick as

a tree. His eyes, when not covered behind wraparound sunglasses, are dull and probing at the same time. He looks through you, very slowly. He looks into you. The reality of Eddie Rothman lives up to the whispers. He is no ordinary little man from Nebraska, like the Wizard of Oz, hiding behind a disembodied, booming voice. He is a flesh-and-blood reckoning.

And when my American Airlines plane's wheels skidded along the tarmac of Honolulu International Airport, Eddie Rothman was driving his jacked-up black Ford F-350 diesel. He had left his compound at Backyards, a famously localized surf spot, after the sun set and drove south on O'opuola Street before turning east on the Kamehameha Highway, gripping his steering wheel with scarred knuckles. He passed Ted's Bakery, known for its plate lunches, its cream pies, and its impossibly slow service. He passed the only Chevron for miles, run by a family of transgendered Samoans who flirt freely when handing over packs of cigarettes or change. They are each over six feet tall, two hundred pounds, with the daintiest touches of eye shadow and blush. He passed the rotting fruit stand selling fresh passion fruit and pineapple, Ehukai Beach Park and its just erected "Billabong Presents the Pipe Masters in Memory of Andy Irons" scaffolding, set up for the contest that would run the next day. He passed Sunset Beach Elementary School and then he abruptly turned right, without signaling, onto Ke Nui Road.

Ke Nui is the size of a small alley and runs parallel to the Kamehameha for a rough mile. Banyans and palms hover over it like a frescoed ceiling. There are no streetlights. Night can feel thick on Ke Nui. Dense. Eddie drove over the speed bumps without slowing and then slammed to a stop at its end. Directly in front of the Billabong house.

He got out of his car, went through the wooden gate and up the rock stairs and straight inside without ringing the doorbell and without the customary removal of slippahs.

And inside the house he paused briefly, glancing around, before walking up to Graham Stapelberg and fixing him in his dull gaze. Looking through him. Before reaching a scarred knuckled hand through time and space and grabbing his throat. The surfers and executives, those who had not yet left for Surfer Poll, froze. The horror. This horror. And Eddie reached his other hand back, back, back, and then, as if it was a slingshot, launched it forward. It smashed into Graham's cheek with a painful thud. Eddie kept slapping him and then dumped him in a pile and went on a tear through the house. He knocked the shit out of anyone and everyone, including a South African man with a thick neck. Like a tornado. Like a raging bull. He would have knocked the shit out of Gordon Merchant but Gordon Merchant was not there. He slapped and cursed and knocked and slapped. Like a wrecking ball. Eddie had been doing this sort of thing for years and he knew where to strike. Where to hurt. But beyond the slap it was also the possibility of where this would all end that hurt most. Eddie had a reputation. It was said a man who lived three doors down from the Billabong house had owed him money once and Eddie and Squiddy Sanchez calmly walked into his house. Squiddy pulled out a pistol, rammed it into the man's mouth, and pulled the trigger. Eddie watched, standing next to Squidd. The man lived, the bullet shot out through his jaw instead of through his brain, but still. With Eddie all bets are off. With Eddie it ends how he wants it to end.

Getting beat up is traumatic. Getting beat up in your own house is way traumatic. Getting beat up in your own house with the distinct possibility of also getting killed is super way traumatic. Getting beat up and possibly killed in your own house when you are an executive at a billion-dollar publicly traded company is beyond traumatic. And getting beat up and possibly killed in your own house when you are an executive at a billon-dollar publicly traded company

without even the option of calling the police, or help of any sort, is the North Shore.

Graham, and the rest of the house, took their beating, absorbed their beating. No one fought back. And it all ended as suddenly as it began. Eddie turned around and walked out of the house, leaving a trail of fear, paranoia, pain, and bruises in his wake.

Imagine, for one moment, that someone in the United States of America barged into Larry Ellison's or Jeff Bezos's mansion and slapped them up. And that Larry Ellison or Jeff Bezos had to take the slapping with bowed heads. That their millions were worthless because if they dared do anything then they would get a lot worse than a slapping. This does not stand to reason because a tenet of the American Dream is that a man's home is his castle and especially a rich man's home. On the North Shore a man's home is not his castle. It is Eddie's castle. Another tenet of the American Dream is that prosperity equals security. On the North Shore prosperity equals a bull's-eye. And Eddie will certainly cometh, which is part of the oddness of this floating island. The North Shore is outside of the standard working of things. The North Shore does not operate according to traditional American standards.

After Eddie was through with his slapping and choking, he drove his jacked-up black Ford F-350 diesel west on the Kamehameha toward Turtle Bay, toward the Surfer Poll. His hands were sore. And he parked, went inside, marched over to the Billabong table, and stood with his arms folded. Glaring at everyone. Glowering. Word had yet to leak of his house beating and so the Billabong surfers and executives just shifted in their seats and felt scared and felt Fortuna mocking them.

I Know You Are the One, Yeah.
Or, We Can Collide.

had been off of the American Airlines flight for twenty minutes. I had walked out of the gate, still wobbly from first-class whiskey sodas, and onto the forever long breezeway. Honolulu International loves that it is tropical. It loves that it is almost the same exact temperature around the year. And so most of it is outdoors but the breezeways are forever long and there are no people movers or conveyor belts. The airport authority decided it would be a good idea to mix pebbles in with the concrete so little dislodged stones always get stuck in wheelie suitcase wheels. This is very frustrating to mothers lugging children. Not for me, though, since I hate wheelie suitcases and carry an awesome Costume National bag instead. Still, it feels like a Rainforest Café.

So I walked and thought and noticed a strange chill permeating the air. I thought that this North Shore season would be the best ever. I felt it. I knew it. I walked out through the baggage claim, into the night. I would throw caution to the wind. I would befriend all of the North Shore thugs and really dig into their secrets. Joan Didion once wrote, "My only advantage as a reporter is that I am so physically small, so temperamentally unobtrusive, and so neurotically inarticulate that people tend to forget that my presence runs counter

to their best interests. And it always does. That is one last thing to remember: writers are always selling somebody out." Unlike dear Joan, I am tall and skinny, temperamentally manic, and just plain neurotic. Everyone in my world, the surf world, knows who I am. But they think I am so wild, so flamboyantly over the top, that, even though I have criticized half of them in print, they speak freely. And even though my memory is a rusted sieve, I remember. And I will remember everything that happens this North Shore season. I will write. I will cover this war. And I stumbled across the street to rent my white convertible. Outside it was even colder than on the breeze-way. Cable-knit sweater weather.

The only white convertible they had this night was a Chrysler Se-bring, not my favorite Mitsubishi Spyder. A downer but it had to do. I entered the freeway, drove through the chill, and Rihanna kept me company. My top was down and my shirt was fluttering but, really, why was it so cold? I passed the Norfolk pines and the barracks and the Dole Plantation. I saw the lights of Hale'iwa and dropped down the hill and drove and drove and drove. Past Waimea. Past Pipeline. Past the Chevron with the trannies and Ted's Bakery and the con-valescent home that had been burned and now is only walls without windows or roof, then I turned left into the Turtle Bay. I parked.

And I walked toward the main entrance smoking a Camel Red that was half finished because I lit it three minutes ago. Hate and love mingled in my heart, the same infection confoundingly at odds with itself that I feel on the mainland. Hate and love had really started to gush since I passed Hale'iwa or even since I got off the plane. Hate and love were clouding my whiskey clarity of how to cover this war. I hate the North Shore and I want to dish its dirty secrets and make it look like the dirty, violent hovel it is. But I love the North Shore and I really love it. I love that it is lawless. I love that

it is gritty. I love that it has secrets. I love its undeniable beauty and
its waves. Hate and love at the same time. Confounding but maybe
not. Why, for instance, do some men enjoy being abused by beau-
tiful women? The abuse and the beauty heighten each other. They
each make the heart beat faster. Harder. And the North Shore is a
beautiful abusive lover. I am abused and I am in love and she makes
my heart beat fast and hard.

I saw Brandon Guilmette, a photographer and Hurley's global
team manager, leaving the resort, opening his rental economy car
door, and he asked me, "You going in to Surfer Poll, Chas?" Then
told me, "I wouldn't unless you want to get punched. There's a rough
energy happening tonight. Something off. I am getting out before
whatever is going to happen actually happens . . ."

And I continued walking while my heart beat harder. Faster. Had
I manifested a riot? And it was so cold that I lit another Camel Red. I
saw Bede Durbidge standing just inside of the entrance talking on a
cell phone and bouncing his adorable new baby. Bede is a rangy, tall,
blonde Australian with a smile as big as the moon. He is friendly
and well liked and I once wrote that he is so bland that when he pad-
dles out for competitive surfs everyone leaves the beach and goes
for champagne brunches instead. Or at least I do. He looked at me
and grimaced. His baby was beautiful and I felt bad for what I wrote
and for smoking near her and for smoking in general and my soul
was dark. Fox, Bede's main sponsor, pulled all their ads from *Stab*
because of the story.

I moved through the lobby and into the Surfer Poll ballroom. It
was hot, not like outside. Sticky, humid, packed wall to wall with
surfers, surf industry, hangers-on, fast women, and great women.
The women who surf on the Women's World Tour are amazing.
They are beautiful and charge just as hard as the men and surf

more beautifully than the men, at times. As usual, nobody was well dressed, except a handful of the women pros. I arrived in time to see Joe G.'s *Year Zero* win the coveted Film of the Year award. I was proud and happy. He is my friend and we cowrote it together. It was a fantastical film about surfing in the apocalypse. He walked up the stairs to the podium and looked like a deer, gazing out vacantly into the audience. "Uhhhhhhhhh. Thank you," he muttered. The klieg lights burned the stage. They washed it out. "This is a big award and I want to say that I am humbled to win it and I am humbled . . . by Hawaii." I wondered why he was saying that. Joe and I had had long discussions about the aches and joys but mostly aches of the North Shore and neither of us had ever mentioned feeling humbled by it. Only unbalanced. Only off-put and psychotically thrilled.

The show finished an hour later than it should have. The ballroom emptied into the lobby and into the Surfer Bar across the lobby. Surfers, surf industry, hangers-on, fans, and tourists mingled and drank. I saw Joe G. still looking uncomfortable drinking a mai tai and approached laughing. "You are humbled by Hawaii?" He laughed back uncomfortably. "I had no idea what to say. Eddie and the boys were in the audience and standing right next to my table. I swore that I was going to get hit if I didn't say something like that. It was like they were patrolling, just waiting for someone to slip up and then pound them." We made small talk for a while longer and then I went back outside to escape the heat and the bad fashion. Wondering why everyone was so off-put, or more off-put than normal. I saw Eddie talking on his battered cell phone and then he hung up. He was wearing a skintight long-sleeved shirt that said "100% Hawaiian" across the chest. I had heard the whispers. I knew he was not 100 percent Hawaiian. That, in fact, he was 0 percent Hawaiian. That he was maybe Jewish and from somewhere on

the mainland. What I didn't know was that he was fresh off a seismic Billabong house beating, though I would soon learn about it. Everyone would soon learn about it. "Ho," he grunted in my direction. Even though we had never officially met I had caused enough trouble in the surf world to get my picture in the magazines and also the *Australian* newspaper. He knew how I looked. "How you doing, Eddie?" I answered. And then he asked, again, "What was that guy who called you a fucken Jew . . . what was his name?" I told him, "Mick Fanning." "I cracked him for you last year," he told me, again. I smiled. My hook. And thanked him, again. I will never tell Eddie that I am not Jewish. It will be our bond. It will be my key to him. And, like that, like two cats, we parted for the night but not forever. My work was just beginning. And, for better or worse, I felt, really felt again, that this season on the North Shore would be the most abusively beautiful yet. Or maybe it was just mai tai clarity.

Addicted to a Certain Kind of Sadness.
Or, I Don't Even Need Your Love.

The sun rises, the next morning, at its normal hour through a pastel watercolor sky. Oranges and salmon pinks and the palest blues. It is barely up, just over the horizon, but pierces my glass-shard mai tai hangover and I stumble out of bed. It is too early but I always wake up too early on the North Shore. And last night after seeing Joe G. and Eddie Rothman and drinking, drinking, drinking, I got a room at the Turtle Bay. And what an awesome piece of shit it is. It was built in the early 1970s to be a casino, the first casino on Oahu, but a gaming initiative on a mid-1970s ballot failed. And the dream of crazy slot machine madness died. Kuilima, its original name, was turned over to Hyatt and renamed Turtle Bay because no one could pronounce Kuilima. Then it was turned over to Hilton. Then, after almost foreclosing, it was turned over to Credit Suisse. And nothing was ever done to it. No rebuilding. No remodeling. No love. The locals don't want it to expand and local government locks it in perpetual "environmental impact" limbo so it looks exactly like when it was built: like early 1970s economic meltdown chic.

I move into the bathroom that is indescribably ugly and into my suitcase looking for sunglasses and a T-shirt and pants. I never wear

shorts. Even in tropical humidity. It is a holdover from my time in the Arab world, where only small boys wear shorts. And also it is difficult to make shorts look masculine. I already have too many fancy-lad elements in my wardrobe. My grey skinny jeans are tossed in a corner. And I can't find a T-shirt but I see the same wrinkled pink button-up I wore yesterday. I pull it on. I feel like *Miami Vice*.

I slide my balcony door open, letting in the salt water and melancholy, and watch a seventy-five-year-old Hawaiian gardener cut the resort's grass not with a lawn mower but with a Weedwacker. His head is bent in concentration. His green-on-green khaki T-shirt/pant combination is stained and greasy and he wears headphones to drown out his gasoline whine. The back of his green khaki T-shirt reads "I Facebooked Your Mom Last Night" but I can't imagine that he really did. She doesn't have a Facebook account. It is too early for this. It is too early for anything. He whacks and gouges the grass-carpeted earth, exposing Oahu's famous red dirt. Volcanic dirt. And I look at the ocean. It is alive. There is swell everywhere. The Pipe Masters will be running for sure today unless it is too big.

From my balcony it appears entirely messy. Miles of white water. Mountains of white water as far as the eye can see. The ocean is a boiling mess. The lines don't seem to be rideable waves but appearances are deceiving here. The observer would also think that the North Shore is an idyllic tropical paradise.

I look back at the gardener. He busily continues to destroy what he can. A small act of terrorism. Red dirt flies into the air. I wonder where he got his shirt.

I close the sliding door to block out the whine. I make a cup of Kona coffee while popping Tylenol while preparing to head to the Pipeline event site, or Eddie's house if I can figure out where he lives. My coffee tastes good. Hawaii is the only state in the union that pro-

duces coffee. It is the only state in the union that is completely sur-
rounded by water. It is the only state in the union that does not have
a straight line in its boundary. It is one of only two states in the union
that doesn't participate in daylight savings time. Hawaii is different.
It's weird. Historically weird and presently weird and Oahu's North
Shore is its weirdest corner. But still, anyone even remotely related to
the surf industry finds his or her way here every year. Every single
year. Surfers, photographers, surf brand executives and lower-downs,
team managers, agents, junior agents, editors, associate editors, and
advertising salesmen all brave the forever long flight, the utter lack
of appropriate hotel, the pall of aggressive violence, and they all do
it every winter, from November to late December, when the storm-
born waves arrive. For one-twelfth of every year this is home. And
why? They will say it is because of the waves. Because they are varied
and perfect. Because they are the most photographed, photographic
waves in the whole world. They will say because of the history. Their
fathers and their fathers' fathers have been coming to the North
Shore in order to ride, ride, ride the wild surf. They will say because
it is the proving ground, the place where boys become men. They
will say to see and be seen. They will say that every winter something
boils up in their heart that compels them to Oahu and they don't
really know why. This last answer touches nearest to the truth. The
North Shore, more than anything else, is an addiction. Not necessar-
ily a modern drug, it is closer to Derrida's definition of *pharmakon* in
his fine work "Plato's Pharmacy." *Pharmakos* was the ritualistic sac-
rifice of a human scapegoat in ancient Greece. The poor, unwilling
scapegoat was the *pharmakoi*, and the sorcerer, who gave him some
sort of magic drug before his slaughter and maybe made him will-
ing, was the pharmakon. *Pharmakon*, linguistically, is where we get
our English word "drugs." Derrida argued that *pharmakon* actually

also meant both "cure" and "poison" at the very same time before moving on to destroying the distinction between philosophy and mythology. And this is what the North Shore is to the surfers and to the surf industry. It is a ritualistic slaughter that they are compelled to reenact every single year because the magic drug burns in their soul. They don't know why but they become willing. They go and jump into the pumping surf where reality, existence, and mythology are one in the same and they smile before eventually getting choked the fuck out.

The violence—it hangs in the air like a fine mist. It is ever present. Breathable. I felt it last night as soon as I wandered into the Turtle Bay. As soon as I saw Eddie. As soon as I saw Kala Alexander and Dustin Barca ordering drinks at the Surfer Bar and glaring at me. Kala and Dustin are both originally from the island of Kauai but through the shared virtues of endless fighting and fearless surfing have become notables here on the North Shore. They are handsome but endless fighting has marred their elegant features. Dustin walks with a perpetual slouch. He always looks like he wants to crack someone in the face. Anyone. He has a large gap between his two front teeth. Kala, equally punchy, walks upright, almost too upright. He is kinetic. Always twitchy. His knuckles are tattooed with the words "WOLF" and "PAK." And Kala and Dustin glared at me so angrily. They did not like my pink shirt. Or my 1940s director mustache, which I am auditioning this year. It is a good look and I think it will stay. Kala and Dustin only like black. Black with the only flourishes advertising something about the islands, like 808, or an assault rifle with the words "Defend Hawaii" above it.

Pink shirts and director mustaches aside, not everyone will feel the perpetual violence of the North Shore. The hapless tourist family that packs into a rented Buick Regal and points north for

a day trip from town, for instance, will likely never experience it. Their minds will be filled with stock images of coconut scent and relaxation, of paradise, not of their gutted IRAs or Fast Eddie Rothman. They will drive, from Honolulu, up into the hills, stop by the Dole Plantation for some soft-serve Filipino pineapple ice cream. Ukulele covers of Britney Spears's "Baby One More Time" waft on the radio while they drop down into the North Shore milieu with eyes wide and cameras ready. Their hotel concierge has told them, "The North Shore is where da surfing is. Da big waves." And if their concierge is malicious, allowing them to think they can participate in da big waves, then maybe they have brought floral-print Boogie Boards from one of Hawaii's ubiquitous ABC stores and are ready to get their own surf on. If he is not malicious those Boogie Boards stay in their Waikiki hotel room.

They will drive north on the Kamehameha and look past the ramshackle homes and the beauty and they will see the mountains of white water off to their left. It will look like the end of the world.

They will stop at Waimea because they have heard the Beach Boys sing its praises. They remember the falsetto croon, "Alll ooover La Jolla, and Waimea Bay, er'rybody's gone surfin'"—(beat) (beat) (beat)—"Surfin' USA." La Jolla, in Southern California, rarely breaks over four feet. Waimea is either completely flat, if the swell isn't right, or a towering fifty, sixty, seventy feet. And when it is towering, the whole island knows it. There is something very specifically magical about Waimea. They will gape. And park. And wander down to the sand, gaping.

The bay itself is picturesque. A study in perfection. Worthy of their adoration. At its easternmost point a finger of land juts into the crystalline water. A lush finger filled with some of the nicer homes on the North Shore. There is a famed Catholic church, Saints Peter

and Paul, across the Kamehameha, with an iconic steeple overlooking all. The bay, the nicer homes, and also the shitty methamphetamine double-wide that sits directly in its shadow. The church was built in the mid-1970s, like the Turtle Bay, like everything here, and is usually empty. I can't recall seeing a soul, in fact, on Sunday or any other day. The North Shore has a different religion that does not involve praying the Rosary.

Spreading from eastern finger to the bluff at its westernmost point is a crescent moon of sand so white, so pure, that it defines tropical vacation. And when it is big, when the waves get to be sixty feet and darken the sky, blocking the horizon with their otherworldly size, the family will stand on that sand in ugly sandals paired with uglier aloha shirts with digital cameras dangling and watch while screaming, "Did you *see* that?" Really screaming with all their lungs, "Did you see *that*?" as they watch the waves and the surfers who are crazy enough to paddle out and ride them. One of their members will inevitably venture too close to the swirling rage, on those days, and get pulled into the water by turbulent shore break and spun around and tossed back up on the beach minus camera or shirt or sandal, if they are lucky. Waves move more quickly than the corn-fed.

Waimea is host to one of the most fabled events in all of surfing. The Quiksilver in Memory of Eddie Aikau. The Eddie only runs when Waimea exceeds twenty feet of open ocean swell, which translates to forty-foot waves in the bay. It has only run eight times since its inauguration in 1984 (which happened to be at Sunset Beach three miles up the Kamehameha; it moved the next year to Waimea), which is not to say that Waimea has only exceeded forty feet from December to February eight times but simply that perfect conditions, giant and smooth, are not a given.

Unlike any other surf competition, the twenty-eight participants

and twenty-four alternates in the Eddie are chosen among their peers by their peers, the best big-wave surfers in the world. Once selected, they wait through the winter and if ocean forecasters see a window where the waves will be big enough and good enough the participants have twelve hours in which to get to the North Shore. The competition takes place in one day and the surfer who rides the four biggest waves wins.

Its namesake, Eddie Aikau, was a North Shore legend. He was born on Maui but moved, with his family, to Oahu when he was thirteen. At sixteen he dropped out of school, went to work for the Dole Pineapple Plantation, used his paycheck to buy his first surfboard, and began surfing Waimea. Twenty years earlier the thought of riding Waimea was not even a glimmer in the eye. It was seen as too big. Deadly. Impossible. But a few brave souls paddled out in the 1950s and a few more followed them in the 1960s. And then Eddie followed them. Beyond just surviving, he surfed Waimea uniquely and beautifully. He was never afraid. When he was not surfing he saved lives, working as a lifeguard between Hale'iwa and Sunset Beach.

In 1978 the Polynesian Voyaging Society attempted a thirty-day 2,500-mile journey following the ancient path of Polynesian migration between the Hawaiian Islands and Tahiti. The path of migration that brought human sacrifice and the art of choking out. Eddie Aikau was a crew member. The society had made an original-style double-hulled canoe and set sail in March and almost instantly sprung a leak. Eddie, in an attempt to get help, jumped into the water to paddle a surfboard to the island of Lanai. The crew was eventually rescued by the coast guard but Eddie Aikau was never seen again. Lost at sea.

His legend burns brightly in the contest and on ubiquitous bumper

stickers and T-shirts that read "Eddie Would Go," referring back to his lack of fear. It is a battle cry for other surfers trying to emulate his brazen panache.

I was standing on the rocks above Waimea when the Eddie contest ran last in 2009. It was a massive day and watching the competitors paddle out to face monsters was, damn all, it was humbling. The sounds, the smells, the pounding hearts . . . all of it. Spectators stand and trade information about who they think is going, which surfer just dropped down the monster, and if they think his monster was bigger or more critical than the previous surfer's. Everyone shouts and screams and throws hands in the air. Everyone from the most hardened cynic to the freshest wide-eyed daisy. There are bigger and deadlier waves in the world and even on the North Shore than Waimea but there is something about the natural stadium of the bay and there is something about the history, both Hawaiian and surf, and I will say, without fear of contradiction, that the Eddie is the best sporting event to witness live in the entire world. Better than the Super Bowl. Better than the World Cup Finals. Better than the bullfights in Spain. Better than anything.

During the big days, and especially if the Eddie is running, the Kamehameha rounding the bay will come to a standstill as people stop their cars, drop their jaws, and watch what James Joyce called "the scrotumtightening sea."

And the tourist family will very much enjoy the spectacle for the afternoon and nothing particularly violent or menacing will happen to them, aside from an ocean beating, because they are unaffiliated. They are not involved in the surf world. They are aliens from Muncie, which might as well be outer space, and they are looked right through by the likes of Kala, Dustin, or Fast Eddie Rothman. Maybe their car will be broken into by vandals. Maybe the father's

wallet will be stolen from the beach but that is all. No violence. No knocks or cracks or slaps. They will simply wander around the sand and look at the waves and look at the tranquil river that flows from the middle of the bay up the Waimea Valley. The valley, very fertile and tropical with two fern-shrouded cliffs cascading down to the river, is protected by the state because of its diverse flora and fauna. A few North Shore residents grow marijuana up its somnolent green folds too, adding to its diversity.

Everything About This Is Real. Or, a History.

This same valley was home to a vibrant native community when Captain Charles Clerke and his HMS *Resolution* anchored in the bay on February 28, 1779. Waimea must have had no swell that historic day because there is no way that the HMS *Resolution* could have anchored in God's bay if sixty-foot bombs were exploding. It must have been calm enough, at least meteorologically, for Captain Clerke and his men to row their landing vessels to shore and become the first Europeans to set foot on Oahu. Their place of landing being, of course, the North Shore.

According to contemporary accounts, they were met there by the royal subjects of Oahu's Ali'i Aimoku Kahahana, the sovereign king, and they must have had nerve-jolting, itchy-trigger-finger fear flowing through their sinews, for not two weeks prior, the famed Captain James Cook had been stabbed to death by natives on the neighboring island of Hawaii, or the Big Island, in front of them all.

There is much historical debate as to the exact circumstances surrounding Captain Cook's death. A year earlier his flagship *Resolution* and smaller *Discovery* had anchored off of a bay in Kauai in order to reprovision. This was Cook's third Pacific voyage with the aim of finding the fabled Northwest Passage in North America and his first view of the Hawaiian Islands.

The sailors had arrived, historians say, during the time of Maka-hiki, a period of either weeks or months, scholars are unsure, set aside for the collection of taxes. There were ceremonies and fun making and sex making so war was suspended.

Cook and his men stayed and had fun and sex for three days before heading to North America and not discovering the North-west Passage. One year later they returned to the Hawaiian Islands also during Makahiki.

They first dropped anchor off Maui and met Maui's king, Kahe-kili, and things went smoothly. This was before the unification of the islands under King Kamehameha—namesake of the North Shore's main thoroughfare—and therefore Oahu, Kauai, Maui, and the Big Island each had their own sovereigns.

Cook next sailed to the Big Island and met King Kalani'ôpu'u, who had been warring against Maui's king but the fighting had been put on hold for Makahiki. Party. Sex. Sex party.

Cook traded with the Big Islanders but did not make landfall, in-stead circumnavigating around the windward side of the island, but his ships were so rotted and in need of repair that he reanchored, before moving on, in Kealakekua Bay. It is said that thousands of natives on surfboards paddled out to welcome them back.

The history of surfing itself is as shrouded in fog as any ancient art and it certainly was an art as practiced in Hawaii. It involved pray-ing, carving boards from giant koa trees, and showing off for topless babes on the beach. Tongans, Samoans, and Tahitians all take credit for being the first "wave sliders." It was the Tahitians who were first observed, by a European, riding waves in 1767. Captain Cook and his men witnessed surfing in 1769, also in Tahiti, on their first jour-ney, and in Hawaii on this their third.

Captain William Bligh—the *Mutiny on the Bounty* Captain Bligh,

the Captain Bligh who got kicked off of his own boat near Australia—was sent ahead to check the depth of the bay and find fresh water. He became the first European to set foot on Hawaiian soil.

Cook invited some of the Hawaiian elders to dine with him on the *Resolution* and they brought him a pig and a red cloak. They also kept repeating a particular word according to Lieutenant James King, who kept detailed journals of the proceedings: "We were received by three or four men who kept repeating a sentence wherein the word E Rono was always mention'd, this is the name by which the Captn has for some time been distinguish'd by the Natives."

"E Rono." Some historians have concluded that the natives felt that Captain Cook was Lono, the god of fertility, agriculture, rainfall, and music. Hunter S. Thompson, two hundred years later, also felt that he was the god Lono when he arrived in Honolulu soaring on acid. Eddie Rothman's youngest son is named Lono, as I came to find out.

Other historians dispute that "E Rono" was referencing the god Lono and instead believe the natives were saying "E Rono" or "listen," which they called out to attract attention to what the captain was saying.

Whatever the case, Cook's historian writes that Cook was brought ashore to an important rock temple and made to kiss an image of the war god, Kû. Feral parties ensued and the men settled in while the ships were repaired. They learned dirty songs from the young Hawaiian women and feasted and boxed and raised hell.

And then Makahiki ended. The natives began stealing goods and materials from the ships. When one was seen making off with a pair of blacksmith's tongs, some of the sailors rowed to shore and tried to take his canoe hostage and hold it until the tongs were returned. The natives threw rocks. Captain Cook and some men came down the

beach to intervene and calm the tensions. He asked where the tongs were and the natives willfully misguided them, as a joke, and then proceeded to laugh. Cook ordered his men to shoot at the scoffers.

The next day a boat went missing from the *Discovery* and bad tempers flared. The thefts may have been playful but they were most likely malicious. The natives wanted what these white men had and they were going to get it. The novelty of Cook and his men had worn off. This time the cannons were ordered to be fired at the canoes in the bay and Cook himself went ashore to try and kidnap the king until the boat was returned. The natives put on their war clothes and tempers flared even more. Cook fired his musket into the crowd but he was vastly outnumbered and couldn't swim. There was no escape.

A contemporary telling claims that he was whacked with a club from behind—"false-cracked"—and then stabbed repeatedly. The *Resolution* fired cannons at the beach and dispersed the crowds.

Captain Clerke was elevated to the number one spot and tensions remained high for the next few days with the natives on shore taunting the sailors and the sailors shooting cannons toward them. Clerke repeatedly asked for Cook's remains, which had been cut into pieces and the bones stripped of flesh, as was the custom in the treatment of a high chief. The natives believed that the keeper of the bones inherited the spiritual powers of the dead called *mana*. *Mana*, defined simply as "power" in English, has a much deeper meaning of spiritual currency. Mana could be obtained in three main ways. One was to be born into royalty or marry into it. Two was to defeat a powerful warrior like Captain Cook. Three was a process called *aikane*, which literally means "to eat man." It does not mean cannibalism, though. It means giving a more powerful man a blowjob. Totally amazing.

Finally, two chiefs came to the ship to discuss peace but that same day some sailors, who had been sent to shore to replenish the fresh water, were pelted with rocks. The sailors lost their composure and burned a village and decapitated two heads, which they kept on poles before dumping them in the ocean to prove they were not cannibals.

The following evening a truce was declared. Captain Cook's ribs were returned and sunk in the bay. Clerk and his crew left, sailing to Waimea Bay, on Oahu's North Shore, all crazy-haired and paranoid and adrenaline-filled. Breathing in the mist of violence. Perpetual violence. Violence that very much predated the white man on his age of discovery. Violence that predated the North Shore's whacking, stabbing, choking, slapping locals. All geological births are violent. Earthquakes, landslides, floods, fires. But Oahu was formed in the most violent of ways. It was born from the center of the earth. Formed by a volcano shooting magma from the seafloor, growing into an island the shape of a melted snowflake. Sizzling magma. Hot, hot angry heat.

The earliest inhabitants carried the violent mantle. Polynesians from Bora Bora, Marquesas, and Tahiti settled there first, bringing with them a system of governance called *kapu*, which carried a death penalty for transgressing many and varied laws. They brought, also, a form of human sacrifice that pacified the gods and took place at white-cloth-covered temples, or *heiau*s. The temples shimmered on the horizon. They shimmered for Captain Cook and also for Captain Clerke and also for all other early seafaring explorers. The largest *heiau* on Oahu overlooked Waimea Bay, in fact. And here poor farmers or vanquished enemies or law transgressors were dragged up and brutally killed by either having bones crushed, innards removed, or being strangled. Choked out.

Violence without end.

And, even though some were being sacrificed, or maybe *be-cause* some were being sacrificed, the people multiplied. Small chiefdoms became larger chiefdoms and warred with each other, across the Hawaiian island chain, and warred with the first European interlopers and warred while becoming unified under King Kamehameha the Great and warred, metaphorically, while getting annexed by the United States and were warred on by kamikaze Japanese during World War II and war, today, against poverty, staggering methamphetamine addiction, marginalization on the fringes of a faltering U.S. economy, and surf invaders from da mainland greedily sucking down all their waves. Hellfire, death, anger, volcanoes, blood, war, sunken battleships, bashed skulls, crushed rib bones, strangled necks, Eddie Rothman. Kala Alexander and Dustin Barca shooting daggers at my amazing kit. An eruption. A forever eruption.

Violence, amen.

And the tourist family knows nothing of it because it feels, on the surface, like a postcard and they have no vested interest in digging deeper. They may be vaguely aware that Hawaii used to have a king and that the Japanese bombed Pearl Harbor but that is the extent of their care. The tropical sun shines on them. They watch giant surf pound the shore, when they come north for the day, and smile. Instead of breathing the fine mist of violence they just breathe the liquid scent of salt water and sun and happiness and momentary freedom from lives lived in the cold.

But, the violence is alive and well. It is not a relic. It is not a quaint part of Hawaii's past. No, it flows as untamed and free, today, as it ever did. And every surfer, every photographer, every surf brand executive and lower-down, team manager, agent, junior agent, editor,

associate editor, and advertising salesman has stories that are told like battle stories. Stories that frighten. They are whispered over drinks in crowded bars with eyes always shifting. On the constant lookout for someone who might take offense at the story and dish out a false-crack. They are told carefully, almost always in low tones.

The Joy Formidable. Or, Here We Are, In the Dark.

My damned head. My hurting head. That damned gardener outside Facebooking my mom and destroying the grass. I decide to leave the Turtle Bay and head out into the mayhem. The Pipeline event will not run for a few hours but that is OK. There are cigarettes to buy and trannies who want to flirt. It is time to get into the North Shore mix, proper, and embrace everything that it entails. Things can seem peaceful sitting in a hotel room but hotel rooms and ESPN and poolside happy hour are not the North Shore. I must get out into the weird. It is time to get cinematically weird.

I leave through the lobby, passing two parrots and a man trying to sell tourist Segway tours. I walk through the parking lot and find my convertible and smile even though it is a Sebring. It starts. I leave.

There is not much traffic yet because it is too early but in a few hours the single-lane Kamehameha will be clogged for two miles each side of Pipeline. I stop at the Chevron and buy Parliament Lights because they don't sell Camel Reds because this is an island, after all, with island problems like no trucks able to drive direct from the North Carolina tobacco fields. I am flirted with. And I move back into the North Shore flow, back toward Pipeline, and park in a ditch between the Kamehameha and Ke Nui. And even

though it is too early, the Ke Nui is filled with surfers and surf in-
dustry people catching an early morning surf or at least checking
the conditions down at water's edge. And even though it is too cold,
many of them are wearing boardshorts only. Many of their faces
are also white. Not haole white but terrified white. Pipeline must be
huge. It must be growling.

I walk and nod at friends and deflect glares of surfers I have
burned. I deflect the glare of Dusty Payne, a Maui surfer with a hor-
rible attitude and Mormon father. Dusty, like most island kids, has
been coming to the North Shore ever since he first started showing
promise at home on Maui, and so he is comfortable in Pipeline no
matter the size. Pipeline is it. Pipeline is the only thing and it mat-
ters not which country, which state, or which island a surfer is from,
he comes to Pipeline as soon as he is able. This is partly because of
the way Pipeline breaks, perfectly and very close to shore, making
it scenically dynamic. Partly because it has claimed more lives than
any other wave and has the mystique of a beautiful killer. Partly
because it is the most holy admixture of science and magic. Every-
thing surfing means is wrapped up in Pipeline.

Dusty has red hair that has been bleached to red-white by the sun
but his redheaded attitude has not been bleached. It is fiery. I stood
next to his father once on the Gold Coast, after I wrote a profile
on Dusty. He looked at me when I said I wrote for *Stab* magazine,
glared, and said, "Some writers only ever want to push their own
thing. They have an agenda and they don't care about the person
they're interviewing." And I answered, "Yeah? Who are you talking
about?" And he was talking about me but was too embarrassed
to say anything so just responded, "Some writers. I don't know." I
stared at him and tried to make him feel awkward before popping a
beer. It was ten in the morning and he grunted at me, disgusted by

my behavior, and shuffled off. I forever want surfers to embrace the cinema of their lives too but they often refuse, falling back on cliché. Cliché is easy. Cliché is something parents and grandparents like but who wants to live that way? Certainly not me.

I look away from Dusty and see Damea Dorsey, a photographer on retainer at *TransWorld Surf* magazine, fiddling with a camera in the middle of Ke Nui near the Billabong house, and he motions for me to come to him by throwing an ironic *shaka*. The shaka, or hang-loose sign, is the classic Hawaiian greeting. Hawaii's national wave. Thumb and little finger extend. Index, middle, and ring finger bent into a fist. Those fresh from the mainland throw very tight shakas. That is to say, the smallest finger and thumb are made very straight and the rest of the fist is balled up very tight. Hawaiians, and those who have been here many times, throw very loose shakas. They extend their open hand with smallest finger slightly above the ring finger and the thumb slightly open. How a man throws a shaka speaks volumes. I used to throw ironic shakas, like Damea, all the time but it accidentally got into my blood and now I throw real shakas, loose Hawaiian shakas, everywhere. To Starbucks baristas in New York City and Parisian taxi drivers. I walk over to Damea.

"Brah," he says. "Brah," I respond. We are covered in a Ke Nui tropical-foliage tunnel. It feels dark and then he drops a juicy bomb. The juiciest bomb. "Did you hear about the Billabong house?" "Nooooo," I respond. His eyes open wide. He is excited to share a nugget of gold with me. He is glad to flow the coconut wireless straight into my heart. The coconut wireless is the North Shore's rumor mill. Information and titillation and gossip and juice. And all information travels right through it. The more connected a surfer or surf industry type is, the more information he will have. Information is a commodity here. It conveys status because it shows

the depths of one's relationships, or access or relative importance, and so, even though whisperers must look over shoulders, and even though a crack is inevitable if it is discovered that someone is "talking story," the coconut wireless fires all winter long.

Damea looks over his shoulder. "Well, I don't know, but I think Eddie went in there last night, maybe, and kicked Graham's ass. He also busted up everyone else in the house and some other heavies were there too, I heard." Damea looks over his shoulder again. "And Makua got into a fight earlier with T. J. Barron and the two fights were somehow connected." He looks over his other shoulder. Makua is Eddie's eldest son. Makuakai Rothman. And this is all such good news. Such surf world–shaking news. This was my premonition on the plane and this is the way I need the North Shore to feel. Lawless and completely unhinged. This is what I need for adventure and it goes so against my silent pleas from a Hezbollah dungeon but it is what I need to live. I cannot stop.

I had heard of Damea being slapped by North Shore heavies. Damea is a photographer but is also model handsome himself. He has very fine features and good full-sleeve tattoos, and marries and dates models. Right now he is wearing a camouflage baseball hat that says "Aloha" in big white letters.

And I had heard that during his second trip he wasn't a photographer but rather a team manager for Rip Curl. He showed up on the North Shore filled with excitement. The Rip Curl house, down by the wave named Off the Wall, would be his home for the next month-plus and it is a good home. He put his bags away and went into the living room to relax only to notice that the living room was strangely empty. And then he looked outside. Angry mokes hung on the fence looking over, looking into the yard. Tattooed arms draped. Fleshy arms. And Dustin Barca, the aforementioned Dustin Barca,

was coming in through the front door followed by another angry moke. The same one who walks with a perpetual slouch and always looks like he wants to punch someone in the face. Damea was stuck. There was no running.

Without saying a word, the angry moke grabbed Damea's arms and Dustin set up to work him over. Cracking his knuckes. Ready. Dustin had been sponsored by Rip Curl but had been let go by the brand two weeks prior to Damea being hired. And now Damea was going to pay for a sin that he didn't commit. It is said that certain Hawaiians are sponsored for life and Dustin is one of them.

Damea fought back as well as he could, throwing the angry moke to the ground before Dustin could land a clean, unfiltered shot on his model-handsome face. But he was still hit often and well. It hurt. And the fight raged until at some point it stopped with Dustin and his entourage leaving, without warning, just like they came. Damea's soul was scarred. And he has come back to the North Shore seven more seasons since being thrashed. It was his baptism.

Damea does not tell me this story. He won't because he is a good North Shore soldier and does not talk outside of the barracks, but I believe it to be true. But who could punch that gorgeous face? We say our good-byes by throwing more shakas and spread to other corners of the madness.

I head straight for the Billabong house. Now I have a real mission. Now I have a story and that story involves my hook. My Eddie. I had known something was going to happen, just known it. Yes, I felt it on the plane. I felt it driving. I felt it at the Turtle Bay. I felt it when I saw Eddie in his "100% Hawaiian" shirt. I feel it now. Eddie exploding inside the Billabong house is just too much. It is the reality, existence, mythology of the North Shore, in the flesh, handing out

meaty slaps to executives in their own homes. So brazen even in this apocalyptic land. Roll the fucking camera.

I walk across the Ke Nui and through the wooden gate and up the rock stairs and into the Billabong house without ringing the doorbell. Like Eddie. Except I take my red Vans off and leave them in the slippah pile.

Inside it is very, very quiet. It is very, very early so maybe that is why but it's also eerily quiet and smells of fear. Stale fear. No one is on the couch watching TV. No one is in the kitchen cooking breakfast or making coffee. No one is giggling. It is the scene of an emotional crime and a physical crime and I look at the walls to see if there are any bloodstains. I don't see any or I might see one but it might be teriyaki sauce.

Outside on the deck I do see a silhouette of a solitary man gazing out to sea so I move through the sliding door. It is Sterling Spencer. Sterling has been surfing for Billabong for many years and he is special. He is handsome and his sister is an actress. But being handsome is not special. Again, surfers have the genetics. They have the muscle tone and the tan and I insist on describing their beauty because, again, physical beauty is to surfers what a brown-fur felt hat is to Indiana Jones.

Funny, on the other hand, is special. Surfers are dumb. They are funny to laugh at but rarely to laugh with. Sterling, on the other hand, is very funny to laugh with. Earlier in the year he made a video of French professional surfer Jeremy Flores refusing to give a child an autograph. Apparently the child did not have a pen and Jeremy had told him to go and get one. But the child threw himself onto the sand, pitching a gigantic fit. Sterling provided voiceover for the video, including a deliciously clipped French accent for Jeremy saying things like "Shoo shoo. Go away. Go on. Read some

books" and posted it on his website. It became a small viral sensation. Jeremy Flores was not pleased. And so when he saw Sterling at the Surfer Poll awards just last night he went up behind him and choked him out. Very funny.

But this is not the story Sterling tells, right now. He tells, instead, of coming home late last night from the Surfer Poll and curling up on the couch. The house already felt off, he says, and he had heard snippets of the earlier beatdown. Everyone was on edge. But he was tired and the night had been personally eventful. He had been choked out. So he went to sleep. After some hours he was jolted awake in sheer terror. A face was peering down at him, so close to his. He could feel the breath. He could sense bad intentions. And the face spoke, menacingly, "Who is dis?" And he felt terror, barely coughing out, "It's Sterling." The menace disappeared. "Ahhhh, Sterling. It's Makua. Hey, nobody heard nothing about what happen here tonight, OK? Nobody saw nothing." And the way Sterling imitates Makua's voice is very funny. He does the high North Shore strange pidgin girl voice perfectly. Sterling muttered, "Yeah, yeah. Nobody heard anything. Everything is fine." And Makua said, "Right on," and slipped back through the door into the night. So crazy. North Shore ghouls creeping around after dark.

The public perception of surf culture is all gauzy *Beach Blanket Bingo* party party Jeff Spicoli "What's up dude bro brah let's shred some waves and smoke some weed together," which is no more accurate than any hackneyed generalization. Surfers are dumb, yes, but they are socially complex and extremely selfish. Surfing is, essentially, a lone activity. The greater number of people in the water means less waves to go around and so surfers don't very much like other people and especially other surfers. And on the North Shore

this quality of surf culture is completely magnified and given an extra ten helpings of violence.

I ask Sterling if he had ever been slapped by Makua. He laughs and says that he hasn't but heard that Makua had slapped T. J. Barron yesterday. And then tells me of his first trip to the North Shore. He was sixteen years old and Billabong had rented him and another young team rider a house that had been previously occupied by two North Shore locals. The locals hadn't been paying their rent and so their landlord kicked them out and rented the house to Billabong instead.

The two locals felt an injustice had been done and so, one night, decided to have their revenge. They gathered up a small mob, including Kala Alexander, the same Kala Alexander previously mentioned. The same one who walks too upright, is kinetic, twitchy, and has tattooed his knuckles with the words "WOLF" and "PAK." And this mob surrounded the house. Sterling says he was upstairs in his room and heard shouting outside so looked out the window and saw the mob, including Kala Alexander with his shirt off. Shaking anger. Shaking rage.

The mob was yelling about how they were going to come in and get the boys and teach them a lesson, etc., etc. And Kala was shaking violence. Vibrating rage. Sterling could tell he wanted to shout something too. He could tell that he was mustering something up, some damning epitaph. Kala rattled and then threw his head back to the night sky and let out a bloodcurdling scream. "Koooooooooooooooooooks!" Kook is the lowest slur denoting a person who cannot surf.

Sterling hurriedly locked the door, ran into the kitchenette, grabbed a steak knife, and locked himself in his closet. He huddled with the steak knife. And the door outside rattled as the mob

smashed into it. This went on for a seeming eternity but finally stopped. The door was oddly sturdy and the mob was very drunk. Sterling was spared that night but the next day one of the two locals went spearfishing and caught a tuna and gutted it in Sterling's Billabong house living room and smeared it all over the floors and threw the rest of it in the washing machine.

When Sterling came back from a surf he saw the floor move. It had become a sea of ants gorging themselves on the sacrificial fish. He did his best to clean up and then washed and dried his clothes. After he put on a clean T-shirt he almost vomited because the stench of washed and dried tuna was so thick.

He told some friends about the incident, especially the part where Kala yelled "Kooooooooooooooks!" and the rest of that winter, whenever anyone walked or peddled or drove by the house, they, too, would yell "Kooooooooooooooks!"

Sterling laughs when he is finished with the telling and says, "Oh man, you are going to print this, aren't you . . ."

All the soldiers in the North Shore war laugh after telling their stories and none of the soldiers want their stories published. The war never ends. It restarts every winter and all of the soldiers must come back. And they will get slapped if their stories are published.

But right now I want to find Graham Stapelberg and get to the bottom of his slapping. I don't care if he never gets to come back to the North Shore. I don't care if he gets slapped ten more times. I don't even care if he gets slapped by Kaiborg, whose arms are as big as Toyota Land Cruisers, because Graham once said he would give me the real truth on the most famous Billabong surfer ever, Andy Irons, who died in his prime of a drug overdose, and then he totally shined me. He said, "Yeah, bru. I'll tell you what you need to know." And then he refused every single one of my calls and even

fled the country so he wouldn't have to talk. That burned me bad. And so I would gladly tell his story. I would gladly heap beatings upon his beatings. But Sterling says no one has seen Graham since last night. No one even knows if he is still here, which leaves me with one option. Fast Eddie Rothman himself.

I pat Sterling's handsome shoulder and hop off the deck, into the yard, and exit through the side gate that opens on a sandy path that leads down to Off the Wall.

And Off the Wall is absolutely exploding. The waves this morning are bigger than I have ever seen them here. It is horrific. Meteorologically terrifying. They rise up like sea monsters, white and frothy and hungry for human flesh. The sand shakes under my feet when they break. A literal earthquake. I see Pipeline, which is equally horrific. Macabre even. And I think, again, about the violence here, looking at the ocean and looking back at the Billabong house and looking at the ocean and feeling the sand shake. It is easy, in most of our Western lives, to lock out nature. We build homes. We retrofit their foundations. Our pajamas are fire retardant. But on the North Shore it is impossible to lock nature out. It is always there, absolutely exploding, and all it takes is a glance to know these waves will, without malice, kill a man.

The violence, while certainly terrifying, and off-putting and depressing and paralyzing, is also invigorating. Very few places in the United States of America retain any sort of berserk cowboy-and-Indian energy. Our country has become thoroughly litigious. People sue each other for everything and call the police for everything else. Men openly weep on talk shows. Men no longer know how to take or throw a punch.

The North Shore is different. Men know how to throw punches. And surfers or soldiers learn how to take them. Hawaiians have

words for "punch" like Eskimos have words for "snow." There is the crack, the false-crack, the knock, the knock on the head, the slap, the slap on the head, the jap slap, etc., etc. Each is different. Each carries with it a particular brand of rectitude. Each is employed at different occasions, depending on what the offender deserves. Graham Stapelberg was slapped by Eddie, for instance. Very demeaning. The slap is the most demeaning form of justice.

Others are false-cracked and the false-crack is particularly interesting. In mainland parlance "false-crack" would be similar to "sucker punch" or a man getting hit when he is not looking. The sucker punch is seen as a cheap shot and the sucker puncher is greeted with derisive hoots. In Hawaii, however, the false-crack is seen as completely legitimate. An offending male can be standing in the kitchen of a home he is visiting and his feet might be very sandy. The next thing he may know is that he is on the floor with a throbbing head. He has been falsed for bringing sand into the house and every witness will understand that it was deserved. A local explained to me that "falsing" someone is simply a quicker way to victory.

But the most commonly employed form of justice is not a punch at all. It is, rather, the "choke out." As in the "Ho, brah, fucken no make high *makamaka* o' I goin' to choke you out."

The choke out is exactly as it sounds. Getting choked until almost losing, or actually losing, consciousness. And this can happen with a hand wrapped around the neck or a bicep squeezing the neck or a forearm pushing a neck into the ground. Squeezing it. I have been choked out. Sterling has been choked out. Everyone, if they are truly here, has been choked out. Democratic North Shore justice.

The only real law on the North Shore is physical force. There are no lawyers or lawsuits or concerned and nosy neighbors or helpful citizens or good Samaritans. There are rarely policemen. It is the

Wild West. It is the exact opposite of *Beach Blanket Bingo* party party. It is a frontier. And it is as scary as hell. The specter of danger, of violence, always looms and each man is left to his own devices, more or less. He must solve whatever his dire situation may be by himself. On the North Shore no one will ever come to an offending haole's assistance, partly because haoles are hated for stealing this land from the local Hawaiians. The indigenous here were treated with the same sort of disrespect dished out upon the indigenous on the mainland. There is a history of stolen land, stolen children, raped identity. The associated pain and anger is reflected back on the white skins. The haoles. And though there are not many with Hawaiian blood anymore, the nonwhites from Mexico, the Philippines, Tahiti, wherever carry the mantle and dish out retribution.

And no one will ever come to an offending haole's assistance partly because coming to an offending haole's assistance means being put on a blacklist. As soon as the Hawaiian menace rises, friends and colleagues will blend into the walls. There is no "I got your back, bro." There is only individual pain. A difficult prospect for generations bred on getting helped. A difficult prospect for generations bred on the benefits of tattling. Tattling doesn't work on the North Shore, and so it fades away, along with the concept that salvation from danger or trouble is a phone call away. As scary as hell but also exhilarating. The North Shore is a last bastion of rugged individualism. Of forced rugged individualism that resonates, somewhere, in the American psyche. The North Shore causes the dragooned masculinization of surfers, which is so good since surfers are not naturally supermasculine. They are very much more like ballerinas. It is good for the future of man and it makes surfers very desirable especially in our much too soft, let us say sissy, era. It is why Damea Dorsey and Sterling Spencer smile and laugh about being brutalized

even though they are also scared and even though they hope I will not out their stories. The stories are meant to be told in private, in whispers, between the veterans. There are enough good reasons to get slapped on the North Shore without giggling about Dustin Barca and Kala Alexander. No need to add fuel to the fire. Teddy Roosevelt would smile here too. And he would get choked out, at some point, if he ever decided to trade in his hunting rifle for a surfboard.

No One Laughs at God. Or, It Ain't My Backyard.

The bustle has begun. The too earliness has moved into just plain early and surfers who are going to surf in the Pipeline event are rubbing bleary eyes on their house's decks, trying to focus on the apocalypse in front of them. Trying to imagine paddling out into that. Super surf fans are just beginning to drag folding chairs down the beach paths. Photographers are setting up tripods in the prime locations. The sun is sneering and it might be mocking me but it might also be mocking haoles on the North Shore in general.

I am standing on the sand directly in front of Off the Wall. The sand radiates a strange sort of cool back toward me. Even though my red Vans are firmly on I know that it is cool. And the ocean thunders. I turn to my left and walk down the beach, two houses, and then move up another set of stairs, these ones leading to the Target house. Target as in classy Walmart. Target as in Expect More, Pay Less. Strange that Target has a house on the North Shore but they are here because they sponsor two surfers: Kolohe Andino, an exceptional seventeen-year-old young man from San Clemente, California, and Carissa Moore, an exceptional seventeen-year-old young woman from Honolulu, Hawaii. They are here because "action sports" is seen as a growth market. Shaun White, the

famous redheaded snowboarder, for example, has a clothing line at Target that does well. The kids want edge and their moms want clean, positive role models. The kids, and their moms, will certainly buy Kolohe Andino too. His hair is angelically blonde. His features are defined: strong jaw, straight teeth, fine nose, perfectly tanned skin. He is handsome and becoming more handsome as he reaches the summit of puberty. He is also the future, or a future, of surfing. If Target can sell redheaded snowboarder Shaun White they will certainly be able sell angelically blonde surfer Kolohe Andino.

The house itself is small and clean and Middle America. It is not necessarily in a prime location, slightly too far down the beach from Pipeline, but it is still in the thick of the action. And I am up the stairs and on the deck, pondering my next move. Pondering how to really get Eddie Rothman to take me into his own personal madness and then sell him out in Joan Didion fashion. I wonder what she really meant by "selling out." Like, all we humans are is a composite of our stories and in telling someone else's we sell them down the river? Like, making money, honey? Working in journalism for a while I have to assume that she means, no matter what people think, they hate to be written about. They love to have their pictures taken but they hate hate hate to be written about. Their words, on the page, are more truthful than a picture and exposing that truth is the selling out. Whatever. I've got to tell Eddie's. I've got to tell Kaiborg's. I've got to tell the story of this whole goddamn North Shore even if it gets me cracked, or worse, because this is one great fucking story. Eddie. How? How did Joseph Conrad's Charlie Marlow get to Colonel Kurtz? Charlie Marlow told a good fucking story. He was tenacious and Teflon-coated and wrote super Trash Prose–ish. I'm tenacious, Teflon, and trashy. I'm a "fucking Jew." Ahhh yes, Eddie and I have a Jewish connection, I think, and I should find a way to leverage it . . .

The Target deck is coming alive. J.D., a brand manager in charge of the action-sports push, is leaning over the white railing, blowing on a ceramic mug of hot, hot coffee, looking at the surf. The coffee smells very fine. He looks at me, nods, and then goes back to his surf study. I sit down on a compressed-wood chair painted white that is clean and comfortable. It must be from Target. There is a new grill in the yard, which must also be from Target. I kick my red Vans up on the white railing inside and continue to ponder. I did not remove my Vans because the Target house is not scary and doesn't have meandering Hawaiian enforcers. I can hear snippets of Dino Andino's voice drifting in and out of the sliding glass door. Dino Andino, an ex-professional surfer and Kolohe's father, is talking coaching strategy with Mike Parsons, a famous big-wave surfer and Kolohe's coach. I can hear the stress in Dino's voice. I can hear the thunder rolling off the ocean. The Pipeline Masters will be running very soon and the swell is still rising. It may be the biggest—wave-size-wise—opening day of the Pipeline Masters in event history. Kolohe is used to surfing small and perfect wedges in Southern California. He is not used to surfing heaving madness. He is not used to surfing giant sea monsters.

His name is Hawaiian. It means "mischievous" but he is as far from Hawaiian as can be and he is a prodigy but the North Shore doesn't care about pedigree or hype. The sound of these waves must be like a vice grip around poor Kolohe's heart.

And Eddie? How will I crack that nut? Just then, just at that moment, my phone rings. It is him. My own Fortuna has begun her turn to either make me famous or crush me dead. I know it is him because I saved his number when he called me and told me about cracking Mick. I saved it to show off and also to know when to throw my phone in the ocean and run for the mainland,

never to return to Hawaii again. I feel a cold chill. I answer. The voice on the other end is low and grumbly and rough. "Ho. Is this Chas Smith?" And I say, "Yeah." The voice responds, "Dis is Eddie." Then there is an awkward pause. It sounds like he is in a cave. In a speakerphone cave. I break the silence and ask if he is at Pipe, watching the waves slam. He says, "No. Why da fuck would I be watching Pipe?" And then tells me to come to his house. "You know where I live, yeah?" I don't but tell him I do. He gives more information anyhow, "It's da house wit da big truck in front and a brown gate. Aloha."

How did he know I was looking for him? Does he know I want to sell him out? I am manifesting the end of my life. It is time for me to sail up the Congo, like Charlie Marlow, to the place that is only whispered about. To the place where innuendo and fact are inseparable, covered in a brume of fear. Only now it ain't Charlie Marlow, but Chas Marlow. A fabulously cinematic Chas Marlow like Marty Sheen's version in *Apocalypse Now,* but in pink instead of army green. And Colonel Kurtz ain't dead on a riverboat in Africa. He is very much alive in da house wit da big truck in front.

I stand up, stretch, look over at J.D., and say, "Yeah, I have to go see Uncle Eddie." Hawaiians love to call people "uncle" and "auntie." I would get so cracked for calling Eddie "Uncle" Eddie right now if there were any Hawaiians around. J.D.'s eyes go wide and he asks me why. I tell him I don't know and go into the house. I really don't know.

Inside I see Tony Perez, who is the publisher of *Surfing Magazine.* He is also drinking a cup of coffee out of a ceramic mug and he is also watching the surf except out of the window. It is not odd to run into many and varied people in surf houses like Target. Most of them have an openish-door policy for the soldiers in the North

Shore war. I approach and he mumbles under his breath as a set grows. "Look at that . . . the kids are probably shitting . . ." "Tony," I interrupt him, "I've got to go and see Eddie . . . do you know where he lives?" Tony turns to face me with a look of surprise and uh-oh and hahaha and please-don't-get-us-all-in-trouble on his face. He is a midforties, short, stocky Mexican, always and forever in a surf-branded baseball hat. The job of a publisher in the surf industry is to glad-hand the brands, to get them advertising. Controversy, for him, is a real mixed bag. It sells mags and he can use increased circulation to sell more ads or sell them at a higher rate but the wrong kind of controversy? Eddie Rothman getting angry controversy? It scares the brands away. Remember, they are fickle and all-powerful. Also, If Eddie Rothman is angry at *Surfing Magazine* then *Surfing Magazine* will no longer be invited to the North Shore during the winter and it will be open season on every *Surfing* writer, photographer, editor. And publisher. He tells me, "You know where Backyards is?" The waves are always used as geographic reference points among surfers. I tell him I do. "Yeah, so it is that left that takes you to Backyards, that last left before you get to Sunset." And then he tells me, "Fuck, dude, I've got to tell you. Something happened last night. Eddie went in to G.'s house and knocked him around and some people got hurt and I don't know . . . it's real heavy right now. My wife called me crying last night . . ." Tony's wife works for Billabong. "Just be real careful but . . . ask him about it." And his eyes sparkle. Tony can't help it. He has a troublemaking streak. It is why he made me editor-at-living-large.

I leave Tony, laughing about Uncle Eddie and getting cracked and getting us all banned from the North Shore forever and Uncle Eddie busting into Tony's San Clemente, California, office. Once, *Surfer Magazine* published a photograph of Eddie smashing some poor

soul on the beach at Velzyland. Eddie did not like that, so he gathered some of his friends, flew to Los Angeles, drove to San Clemente, walked into the office, kicked in the editor-in-chief's door and said, "I just want you to know, Hawaii is not that far from California." And then he turned around and left. Just a little reminder that the Pacific Ocean, the largest expanse in the world, is not enough distance to put between oneself and a scorned Eddie Rothman. Yes, Hawaii is the United States of America. The scene never wraps.

I leave the Target cocoon out the front door and walk out to the Ke Nui, which is now fully awake and buzzing with surfers, surf fans, tourists, schoolchildren ditching class, and surf industry infantrymen. They are all ready for opening day. They are all ready for a historic opening day. And I try to prepare myself to get thrashed.

There is something about Eddie that is scary beyond sheer physical menace. Sure he can dish out a mean crack. He is musclebound. Sure it would hurt like hell but material pain, however severe, eventually fades. There is just something more about him. The specter. It seems as if he can actually thrash the soul. I find my Sebring where I left it and spin back onto the Kamehameha, getting into the traffic creep, and head toward Backyards, before Sunset.

Don't You Want to Share the Guilt?
Or, Waves Are Oil: an Interlude.

Off the Wall, Pipeline, Backyards, Velzyland, Sunset. The geography of the North Shore is defined by the water, by the waves, and the waves are themselves violent. They are poison. They are cure.

Wave creation is, again, simple geology and it is voodoo. Underwater topography, currents, offshore islands and their locations, weather patterns as they relate to landmass, reefs and the rates at which they grow, sand and how it moves on and off the reefs or forms bars, the direction the beach faces, curves along the coast, is the geology. The fact that a shore faces just so, or the reefs have chosen to grow here and not there. And the sand is a certain density and the weather is a certain way and the wind whistles from there and not here. And the fact that the earth spins in space and its moon pulls on its oceans and makes them go up and down is the voodoo. Seeing a wave lift itself off of the ocean and into the sky. Seeing it roll in, majestically, and break, destructively. Feeling it. Hearing it. Breathing it. That is also voodoo that no science can ever explain.

A proper wave, a magnificent wave, makes the heart pound and Oahu's North Shore is the most superlative. It is called the North Shore, unless it is being called Country or Mecca or the Seven Mile

Miracle, but, in truth, it faces at a sharp northwestern angle, and this angle could not be any better for collecting all of the ocean's fury. Swell is formed by howling storms thousands of miles out at sea and the larger the area they have to form the bigger the waves will be when they reach landfall. Raging storms, wild storms in the North Pacific, formed off of Japan and also in the Gulf of Alaska, have thousands of miles to swirl, to dance, and then the swell moves out, away from the center of the storm, and marches across the open ocean much like the ripples that move out from a rock thrown into a still pond. The more open ocean it has to march across, and the deeper that ocean is, the bigger that swell becomes. The Hawaiian Islands are the most isolated islands in the world, farthest away from any major landmass. They are in the middle of the Pacific, the deepest ocean in the world. And they get all that energy, all that power, undiluted.

These swell lines organize themselves as they march. They form lines, clean lines, and the amount of space between these lines depends on how hard the storm raged and for how long. And the swell marches. For it to turn into waves that will break and can be ridden, it must move from deeper to shallower water. When this occurs it grows in size and when the water becomes very suddenly shallow near shore it breaks, meaning the crest of the waves, or lip, moves faster than the base and it pitches forward and the detonation rolls. Also, if the ocean floor has certain features—canyons, reefs, etc.— they will cause the wave to refract and focus its energy on one specific point rather than diffuse toward many. And the reefs that dot the entire North Shore are perfect little nuggets.

A reef can be rock, sand, coral, or even man-made. They cause a wave to act differently than it might otherwise have. Waves hitting an open stretch of sand beach can break here or there or every-

where. They will change depending on the shifting sand and break randomly. Waves hitting a particular outcropping or reef head will act consistently. They will break in, roughly, the same place, depending on swell direction.

The North Shore's direction, the exact slope from deep to shallow, and the reefs that dot the entire shore are its magic. Seven supernatural miles with everything in the right place to make perfect waves and massive waves. Waves that are as tall as a seven-story building. What is more, the fact that it faces both north and west means the trade winds that constantly howl around Oahu, blowing from the sea to the land, blow, instead, from the land to the sea. When wind blows off the ocean near shore it can destroy waves. It can turn them into a giant cauldron of nonsense. Surfers call this phenomenon "victory at sea" since it feels World War II–like to bob in messy garbage. It feels like the film *Action in the North Atlantic* where navy cruisers go up and down and up and down. But when the wind blows from land to sea, blows offshore, it grooms the waves, smoothing them out, and makes them even better.

There are many great waves in the world. Waves that conjure happy images in the mind of the surfer. Names that echo sexy adventure to those who have never surfed in their lives. The Superbank in Australia. Supertubes in Portugal. J-Bay in South Africa. G-Land in Indonesia. Lower Trestles in Southern California. Maverick's in Northern. Rincon, Teahupo'o, Bells, Uluwatu, Dreamland, Macaronis, Cloudbreak, Blacks, the Box, Jaws, Gas Chambers, Padang Padang, Scorpion Bay, San Dimas, Barra de la Cruz, Malibu, Baja Malibu, Lance's Right, Sand Spit, Mundaka, Steamer Lane, Canggu, Pinetrees, Swamis, Biarritz, Vanthrax, etc. The world is a large and glorious place for surfers. But there is only one North Shore. It is the alpha and omega. And beyond its geographical glory, remember, the

North Shore is pharmakon. It is the magic drug burning in the soul of every surfer on earth.

The town of Hale'iwa is the westernmost point of North Shore surf geography. Hale'iwa is semicute but otherwise not notable. The name means "house of the frigate bird" in Hawaiian and the population is just over two thousand middle-, lower-middle-class adults and their sticky-jam-faced children. It was named by a sugar and railroad baron from Cape Cod, Massachusetts, who started a hotel on the land in 1898.

A single main street runs through small, wooden, plantation-worker-style homes and double-wide trailers and wooden storefronts. The storefronts reflect the middle-, lower-middle-class tastes. There is a hardware store, McDonald's, many surf shops, and a Cholo's Home-style Mexican restaurant, which, rumors say, doesn't have an oven in the kitchen. Only microwaves.

Venice, California, icon Jay Adams used to wait tables at Cholo's, or rather bus them. Jay was a very famous skater/surfer made mainstream famous by the movie *Dogtown and Z-Boys,* and later *Lords of Dogtown,* documenting his young teen life when surfing began to borrow the urban "fuck you" from skateboarding. Jay was a giant "fuck you." He was played, in *Lords of Dogtown*, by the cute Emile Hirsch, and was a cute kid himself. Long California-blonde hair. Vacant but sexy eyes. Tan skin without blemish. Today he looks like crystal methamphetamine addiction. Shaved hair. Wild eyes. Broken nose. Tattoos everywhere. On his chest, opposite his heart, one reads, "100% skateboarder." On his neck, like the cut of a guillotine, one reads, "Menace to Society." Jay has been in and out of jail his whole life, charged with felony assault, and various drug-related shenanigans. He is a perfect fit on the North Shore because he was so preternaturally talented and became so pocked with violence and

death. Maybe he always had the violence and death inside of his beautiful, talented heart. Beauty, talent, violence, death. Reality, existence, mythology. Cure. Poison. North. Shore.

Continuing through town one passes Matsumoto's Grocery Store, which always has lines winding underneath its corrugated metal roof. Matsumoto's, it is said, has the best shave ice on the island and so the tourists from town come and stand in the sun or rain and wait for a taste. Shave ice is quintessentially, typically Hawaiian, as is Spam, the de facto national food. The Hawaiian diet is, in fact, a thing of wonder. A mash of cultures from Spanish to Portuguese to Filipino to Chinese to heartland American. "Plate lunch" is what Hawaiians call it and plate lunch features two scoops of white rice, one scoop of mayonnaise macaroni salad, and teriyaki beef, chicken *katsu*, or a hamburger patty covered in brown gravy. Shave ice traces its history to Japan circa 800–1000 AD. Spam traces its history to Austin, Minnesota, circa 1937.

Leaving Matsumoto's and continuing northeast still, one passes Hale'iwa Joe's restaurant at Hale'iwa's easternmost point. Surfers congregate in one of four places on the North Shore: Lei Lei's, Foodland, the surf houses, and Hale'iwa Joe's. Like Lei Lei's, Hale'iwa Joe's shares a bland, mid-1980s design aesthetic, the same indoor-outdoor without real separation flow, the same staff as the year before as the year before. It has better mai tais than Lei Lei's and worse baby back ribs.

I remember sharing many mai tais with Brodie Carr at Hale'iwa Joe's—Brodie who was, at the time, the CEO of the Association of Surfing Professionals, the NBA, NFL, MLB of surfing—and both of us almost getting punched out by Dustin Barca.

Brodie is a tall, well-built, blonde, classically handsome Australian with a warm smile, firm handshake, and an easy laugh. He is the

best and one of my favorite men on earth. We first met after I made fun of his fashion too. He has a penchant for baby-blue T-shirts and ill-fitting jeans. Unlike Mick Fanning, though, Brodie did not throw nonsensical racial invectives my way. He challenged me to an arm wrestle instead. So we met at night at a bar in Peniche, Portugal, and wrestled arms. I am skinny and smoke cigarettes so Brodie easily beat me but it was a fine loss and we have been fast friends since. An odd friendship, he the CEO and me the star of Trash Prose.

And so we met for drinks and drank mai tais but then Dustin Barca came in through the door while we were standing near it. Dustin used to be on the professional tour but fell off due to less-than-inspiring competitive prowess and having a reputation that scared the other surfers. He approached Brodie with brooding eyes and Brodie, knowing no other way, gave him his warm smile and firm handshake. Dustin stared hard and slow before saying, "Eh, Brodie, tanks for all da support you showed me on tour, brah." Brodie didn't know how to respond and Dustin kept repeating the same thing over and over. "Yeah. Tanks a lot, brah. You were reeeee-aaaaal nice . . ." He was being sarcastic in a slow evil way. I don't know what Brodie could have done for Dustin, besides surfing in his place and winning or bribing the judges to slide him through heats or physically stopping him from punching out competitors, but no matter. We were in Hawaii. We were on Dustin's turf and Brodie was to blame for his travails.

Brodie tried to stammer something nice. "Ahhhh, Dustin mate, it was a pleasure. And, ya know, things just work out the way they do sometimes. No bad blood . . ." It was awkward. I was awkward. I was standing next to Brodie with a silly grin and Dustin kept glancing at me in between telling Brodie how much he appreciated the support on tour. Brodie was on the verge of getting cracked and I was on the

verge of getting false-cracked because I pulled out my phone and was texting next to Brodie to relieve some of the awkwardness but it only made things more than awkward. It made them weird.

We eventually backed away very slowly and sat at the bar. Dustin moved to the other side of the bar and kept staring. Brodie couldn't believe it. He had been coming to the North Shore for such a long time but, no matter how many years one has under his belt, it is always weird. He looked at me, wide-eyed, and said, "He wants to have a blue, doesn't he?" A "blue" is Australian for a "fight." Hawaiians use "beef."

Brodie wondered if there was a back door but there isn't, and so we left through the front door, right by Dustin, and into the night. A friend later told me, "Wow. You know a place is a real rough bummer when a grown man has to look for a backdoor exit from a public place." But the waves. Always back to the waves. The poison, the cure. The waves are worth everything. They are worth beatings and public humiliation and a troubled soul. They are worth dragooned masculinization or a hard, embarrassing look in the mirror the next morning. The full knowledge that toughness is easier said than done.

At the exit/entrance of town is a green wooden sign that features a bikini-clad Hawaiian girl riding the word "Hale'iwa" like a wave. It is the most photographed part of the town. And as soon as one exits Hale'iwa he is with the true waves. The first, of note, is Hale'iwa, sharing the name of the town but more famous than it, for surfers. When a surfer says, "I'm going out to Hale'iwa," it is assumed that he is going to surf, not going to Cholo's.

Hale'iwa is a fast-breaking right. The lip pitches over and moves down the line, steamrolling and barreling all the way into the Toilet Bowl, an easy section of reef near shore where the wave power has

been sapped. Surf jargon, like all jargon, is odd. And layman's terms are odder. But here they are, anyhow. The wave has three main parts: lip or crest, which is the top portion; face, which is the middle; and trough, which is the bottom. Waves are either rights or lefts, meaning when the lip pitches over it crashes moving progressively to the right (a right) or to the left (a left). Usually, regular-footed surfers prefer rights and goofy-footed surfers prefer lefts. A regular foot rides with his left foot forward, on the board, therefore looking at the face of a right-breaking wave and the beach on a left-breaking wave. A goofy rides with his right foot forward and looks at the face of a left and the beach on a right. Riding while facing the wave is called riding on the "front-hand" or "frontside." Riding while facing the beach is called riding on the "back-hand" or "backside."

There are many things to do on a wave, mostly on the face, lip, and above the lip. Surfers carve this way and that. They rocket airs. They do floaters, riding on the back of the lip before the wave breaks. But the highest art, the crème de la crème, is getting barreled. Tubed, shacked, swallowed, slotted, kegged: barreled.

A surfer gets barreled when he paddles, catches the wave, pops to his feet, slides down the face, stalls, and gets covered completely by the lip of the wave. He rides the hollow section. And then he is spit out into the sunlight with acclaim and pride and a general feeling of well-being—unless the wave closes out, meaning he is not spit out and the lip crashes all at once instead of its slow-curving arc, breaking left and right at the same time, trapping the surfer and then punishing him. Getting barreled is as difficult as it is dreamily beautiful. No first-timer has ever been barreled and probably no person surfing less than two years. It takes time to master the balance inherent in surfing but, more important, to master wave knowledge, to actually know what the wave is going

to do, and both balance and knowledge are necessary in order to get barreled.

Hawaii is the most famous for barrels. And Hale'iwa has a good barreling section when the swell is decently sized. Decent size in Hawaii is four feet and up, which sounds very small, but Hawaiians do things differently. False-cracks are praised, Spam is a delicacy treated like sushi, and the back of the wave is measured instead of the face.

The genesis of Hawaiian wave measurement is shrouded in surf lore but the most commonly held belief is that North Shore residents wanted to befuddle their South Shore counterparts. Townies from Honolulu would come and clog the lineups at the best waves, and so those who lived in the country would measure the back of the wave when delivering surf reports. They measured from crest to some amorphous spot behind the wave. All others, everywhere else in the world, use crest-to-trough measurement, measuring the face of the wave. When the back is measured it roughly halves the wave-face height and makes it appear not worth the almost hour-long drive from south to north. And so four foot, Hawaiian, is eight feet of face. Ten foot, Hawaiian, is twenty. Etc.

All surfers use back-of-the-wave measurement when on the islands but not the National Weather Service in Hawaii, which has reverted back to crest-to-trough measurement for fear of being sued by a hapless tourist who paddles out in six-foot surf only to get pounded by twelve angry feet instead.

The numbers, though, are clinical. Ten foot, Hawaiian, does no justice to how ten foot, Hawaiian, feels. And it feels like all hell has broken loose. When standing on a North Shoreline while the surf is pumping is to be in the middle of a bombing sortie. The sand shakes with each wave that detonates on the reef. It shakes and reverber-

ates up the sand through bare feet and out toward tanned hands and right into the beating heart. *BOOM!* It rattles fillings and the inner ear and the sound from those waves shell-shocks the spirit. All the megaton power of the Pacific Ocean let loose in one place at one time. *BOOM!* The waves spit with a hiss. A spitting barrel means that vapor trapped deep inside a barrel shoots out the opening with the force of a cannon. This only happens at waves that break heavily and quickly. *WHOOSH! BOOM!* Getting spit out of a barrel is orgasmic.

Hale'iwa can be very good when, again, the swell is decently sized. It can boom and whoosh. There is a smaller wave on the inside, or closer to shore, that the surf schools use so that tourists can come and say, "I surfed the North Shore!" But they haven't really. And if they get caught in one of the North Shore's many rip currents and taken out to big Hale'iwa then they will have a much better story but also may have to tell that story to the angels in heaven. Rip currents are everywhere on the North Shore. Sometimes they are helpful, and the surfer intimate with them will use their energy to get out to the waves quickly and easily. Sometimes they are deadly, taking the unsuspecting three miles out to sea before a proper thought can be had.

Continuing northeast on the Kamehameha, past the Point, are Papa'iloa Beach and then Himalayas. Himalayas is what is referred to as an outer reef, that is to say the wave breaks a half mile out to sea over a large reef outcropping far from shore. There are a number of outer reefs on the North Shore. Some, like Avalanche, Himalayas, and Outer Log Cabins, are known by all. Many more are known by locals only. The names of the waves themselves are apocryphal. Sometimes they look like what they are called, like an avalanche. Sometimes an architectural marker is present, like a log cabin on the shore. But mostly they were named by some strange local many

years ago for some personal reason. Outer-reef waves carry a particular dreamy mystique and also their own brand of extreme man-versus-nature danger. They are huge—forty-, fifty-, sixty-foot-high walls of energized salt water. The swell has to be gigantic for them to break at all, and water swirls and man is alone in the bosom of the ocean's wrath. The surfer must paddle for miles out to sea. And sit out at sea alone even if he is surrounded by his close friends.

Big-wave surfing is its own animal. Most surfers never paddle out at waves bigger than two times overhead. They content themselves with smaller, enjoyable waves. Big-wave surfers are different. They are missing the fear gene and maybe love the idea of drowning. Big-wave surfing is not where the money in surfing is because it is not comprehendible to most or replicable and so big-wave surfers ride mountains for passion, not for economic advancement.

Himalayas to break must be at least thirty feet, Hawaiian, with a half-mile paddle out and a half-mile swim back in once the surf-board is broken by the power of the surf, which happens more often than not. Hammerhead and tiger sharks like to swim at Himalayas sometimes, as they do at many outer reefs.

Continuing northeast, past Laniakea, are Hultin's, Jocko's, Chun's Reef, Pidleys, Right Overs, Left Overs, Baby Sunset, Alligator Rock, Marijuanas, and then, around a slight bend, Waimea. *The* Waimea.

And all the waves before Waimea are good or great. Each has its own peculiarities that make it special and each has its own group of locals, which feel whatever wave they surf regularly is stellar and worthy of adoration. But *the* Waimea is, again, special. There are three distinct breaks that can be considered "Waimea" and this can be problematic to the casual observer. A wave is named differently depending on where it breaks. It will be the same swell, the same bay, the same everything, but if a wave breaks on, say, a different

reef head or rock then it will have its own name. The different reef head or rock is what causes a section of wave to do this or that. Causes a section to barrel here, race off down the line there, stand up, sit down, rah rah rah! And so the reef heads become idols. They are the key not to the swell but to making the swell rideable and, beyond rideable, metaphysically transformative.

One small stretch of shore can have twenty or thirty named waves, distinct underwater topography that makes the magic happen. The stretch just passed, for example, from Hale'iwa to Waimea, is roughly two miles and there are sixteen distinct waves in those two miles. Many of the waves will look like one swell line to the casual observer but the surfer knows every single one by name. In Waimea's case there is Waimea, on the outside; Pinballs, midway through near the rocks; and the Shorebreak up on the sand. Sometimes the Shorebreak is called the Shorepound.

Waimea Bay is also the proper beginning of the most exciting stretch of the North Shore. It is here, from Waimea to Sunset, that the North Shore really becomes Dante's *Divine Comedy* in all of its Renaissance tawdriness because the waves are that much better and the violence, of both water and man, is that much more severe. Leaving northeast, one passes, first, the aforementioned Catholic church Saints Peter and Paul, some homes and palm and tropical scrub, wooden fences peeling and partially rotten, the North Shore's one stoplight that doesn't always work and sometimes swings limp, and then quickly comes upon Shark's Cove. It is not a surf spot. Tourists enjoy sitting on its white sandy beach and swimming and eating fried chicken or fried tamales or fried spring rolls or fried potato wedges from across the Kamehameha at Foodland.

Foodland is a long and low beige grocery store with a teal metal roof, which is partially pitched. It is a simple grocery store, typically

American with long aisles, a freezer section with Eggo waffles and *mochi* tapioca ice-cream balls, liquor with more expensive brands at eye level, cheap firewater at the bottom, gum and candy and tabloid magazines near the cash registers, and other trappings of a chubby lifestyle, but it is an iconic establishment. It is the only true grocery store on the North Shore (outside of Hale'iwa Supermarket, which nobody frequents because it has no hip see-and-be-seen cachet), and it is closest to every wave that matters and it has a Starbucks so every surfer or surf industry type can be found in Foodland at least once a day during the winter and usually more.

As a child, I remember reading about Foodland in the magazines. It would always feature in the stories of the pros and their daily comings and goings on the North Shore. It seemed surreal that one could go grocery shopping and see, say, surf stars Tom Curren or Kelly Slater also grocery shop. Mundanely surreal.

And Foodland, in real life, lives up to the fantasy. Every surfer can be seen with a six-pack of Heineken or a gallon of milk. As a child it would have been fantastic to ask them for their autographs or just observe their habits. As an adult I rack my memory and try to remember which pro I have offended in the past or which wants to punch me for picking on his clothing. It is a minefield of potentially damaging encounters and, like the rest of the North Shore, has its own rules. The entrance and exit to Foodland, off the Kamehameha, are split and separated by an island of grass and a mango tree. One enters on the Waimea side and exits farther northeast on the Sunset side. Transgressing this is a guaranteed beating. I once saw a surfer haphazardly drive his rental Chevrolet Aveo through the exit, coming in to Foodland. A local, standing nearby, ran over to his car and kicked the door so hard that it smashed a size-thirteen dent right below the passenger window. The surfer did not stop at Food-

land that day. He drove a circle through the parking lot and exited where he mistakenly entered with his head down. I once heard a story about a British tourist driving his rental out through the entrance. He was stopped, pulled out of his car, and beaten badly by a local. His "Britishness" was not taken into consideration regarding how it may have affected his driving confusion.

Behind Foodland hovers a large green hill. It feels ominous, looking down, scowling down. Its red dirt and tropical ground cover look like they hide secrets. But up Pupukea Heights, as it is called, it is pleasant. Surfers who wish to keep lower profiles rent homes up the winding road. It feels positively country. Roosters crow in the morning and hens cluck all day. Wild pigs can be seen foraging in people's yards.

Continuing northeast from Foodland is the center of the center. If the North Shore is Mecca, then this area is the Grand Mosque. Here, the most important surf houses hug the beach. Here, the Kamehameha and the Ke Nui are packed at all hours with everyone who matters. Here glory, true and everlasting glory, is a barrel away and paranoid fear is a crack away. Here is Pipeline. The Banzai Pipeline. The most famous wave in the world.

Pipeline is publically and directly approached from the Ehukai Beach Park, across the Kamehameha from Sunset Beach Elementary School, where young children daydream of fame and fortune while reading abridged versions of *Huckleberry Finn* and snickering when Huck and Jim sail the river nude.

Ehukai Beach Park, like the Kamehameha, like the one limp stoplight near Foodland, is neglected. It is where Billabong sets up its scaffolding for the Pipe Masters but when the scaffolding is torn down only dead and dying grass remain. Grass with hidden brown pokey nubs of pain that stick into the foot and hurt. The cement

picnic bench sits in the middle, cracking. *The* picnic bench. All the others have been stolen by marauding North Shore residents even though they are cement and weigh a ton and the ones that haven't have been destroyed by vandals. Smashed during nights of methamphetamine creativity. Only rectangular grey slabs remain amidst the dead and dying grass. But none of it matters. No one sits in the park, for the action is on the sand and in the water.

The sand is expansive throughout the summer into the fall. The beach is broad like a desert and smooth. And in those months the Pacific is a giant lake. Tourists giggle as they splash and float on air mattresses. As soon as winter fury creeps in, the sand disappears, getting swept out to sea by the oversized surf, and the beach shrinks down to a small, thin strand and the waves bomb. Those first few winter swells are always strange as the sand retreats back out to sea and covers Pipeline's reefs. They are dangerous because the wave acts unpredictably, like a petulant child with the strength of a bull. But just as the sand disappears from the beach it also disappears from the reefs, and Pipeline, proper Banzai Pipeline, comes alive.

Pipeline's reefs are the most mythical of all the reefs in the world. I snorkeled them one summer when stuck on the North Shore for three weeks. The North Shore is the biggest drag ever in the summer. It is a hollow shell, a castrated giant. And getting cracked is still imminently possible but it will be a lazy crack and not worth telling about afterward. There is plenty of time, however, to partake in frivolities like snorkeling and laughing at Japanese women who fear the sun. And the reefs.

Pipeline has three distinct reefs separated by strips of sand and smaller reef-and-rock chunks. Bite-sized. The farthest outside, called Third Reef, is a rockish shelf. It is flat and hard. It is also in deeper water so needs a giant swell in order to break. Larger fish

swim around it, nibbling smaller fish. Reef sharks dart around too and scare people. No one calls it Third Reef Pipeline. It is just Third Reef. As in, "Third Reef pumpeen' today, brah." Third Reef waves are bigger than Pipeline waves but don't pitch like Pipeline waves. The lip will, instead, usually crumble down the face of the wave, which is called "burgering."

Not every large swell will break over Third Reef. Sometimes the waves stretch to the sky but then shrink again before breaking on Second Reef. It is difficult to distinguish Second Reef waves from proper Pipeline waves. Usually the Second Reefers break a bit farther out and dump harder on the inside section. All the water, all the force, explodes instantly and suddenly, shaking the ground. Second Reef is also rock and coral but less shelflike and more jagged. It is also shallower than Third Reef. The swells that don't break on Third Reef but do on Second Reef are unpredictable, usually meaning a giant, riding swell is on the way.

I have been caught in the rising swells out at Pipeline, or more specifically at Off the Wall, which is directly to the left of Pipeline's reefs, if standing on the beach and looking out to sea. They're indistinguishable to the untrained eye. I once paddled out near the end of a sunny day when the trade winds groomed the water and aloha floated in the air. It was a relatively uncrowded day, rare for North Shore winter. And feeling aloha in the water is also rare for North Shore winter. I sat in the lineup, on my board, rock-shelf reef two feet below my dangling legs. Third Reef is maybe seven feet underwater, Second Reef maybe five. Pipeline and Off the Wall are two or three feet. The tide was also dropping slightly, meaning that the water was becoming shallower by the passing minute. It was a great day for surf. A perfect day for me. Three feet, Hawaiian, six feet of face. What surfers call "head high." And I was thoroughly enjoying myself, trading waves with friends

and enemies alike. Acquiring that saltwater tan that money can't buy. And, again, I had grown up surfing in Oregon, by myself, without an internal surf industry compass and also with my own, very personal supersick surf style. I am tall. And I am skinny. The best surfers are short and muscular. But I like the way I look, in my mind's eye. I have never seen footage of myself surfing but I feel I look like a graceful gazelle. A gorgeous giraffe. And I drop in and carve gracefully but don't do the crazy snaps, or airs, or really anything progressive. I am a supermodel on the catwalk. Subtle movement. Swaying hips.

I hadn't read the swell report before paddling out and was not privy to the fact that it was rising. I caught a wave, and rode it toward the inside, near the shore, thoroughly enjoying myself. Watching the reef scoot under my board. Feeling like Gisele Bündchen, who incidentally dated Kelly Slater before marrying Tom Brady. And then I kicked out and began paddling back to the lineup. All I saw was swell. Big, rising swell. My heart went into my throat. Bile and a panicked breath mixed. A wave broke far out and rolled toward me like a steam engine. I duck-dove and got pinned to the reef. My board, and me on top of it, pinned. Held down by a fat wrestler. Unable to move. Duck-diving is when a surfer pushes the nose of his board down into the water, when paddling out, and kicks the tail down too in order to get under waves. The whitewash finally let me up and I scrambled as fast as I could, paddling to sea. I could see the surfers, farther out then me, scrambling too, which meant that more waves were coming. Being inside, or closer to the beach, of surfers who themselves are scrambling is maybe the worst feeling ever. I finally made it out of the back and sat and caught my breath. The three feet had, instantly without warning, turned into five feet and was, instantly without warning, turning into eight feet. Sixteen feet of angry force breaking over two feet of reef. I was

in a damned position. My options were to sit out at sea for two days until the swell subsided or take off on a bomb and pray. I sat for forty-five minutes and then took off on an eight-foot bomb, sixteen feet of face, and prayed. I remember seeing it rise up and I was in position. It didn't, at that moment, look like a dumper. It didn't look like the lip was going to pitch far out and toss me off my board before I had a chance to master it. And who knew? Maybe I would master it. Maybe I would drop down the face and get barreled all arched back and steezy and throw a shaka to the braddahs at the houses and be toasted on the beach. I paddled. And paddled. And as the wave rose I stared down the inverted mountain, a straight sixteen-foot drop, and popped to my feet. I rode, like a king, for seconds. Heart pounding. And then the lip of the wave, which had indeed dumped heavily, smashed into the back of my head. And I smashed the reef and bloodied my back as I smashed it, and broke the fins off my board, and kicked the reef and bloodied my foot and popped to the surface and took another wave on the head before washing up on the sand. I lay for a minute, exhilarated and bloody. The rising swell, transforming itself into even bigger waves, instantaneously explodes and bloody feet, ringing ears, kidnapping, or death are natural consequences. I spent the next two weeks limping.

Third Reef and Second Reef and Off the Wall and Waimea and Sunset and every other wave in the world are amazing but all must prostrate themselves and worship at the Pipeline. The reef at Pipeline, roughly fifty yards from the shoreline, is a blend of rock, coral, and bulbous lava flows that jut out of the sand floor like miniature continents. Some of the lava flows form underwater caves and it is not uncommon for a surfer to wipe out and get forced into one of these caves. He must keep his head in order to find the surface and

many have lost their lives, drowning before finding a proper exit.

Pipeline's reef is deadly and scary but it is also perfect. It could not be any more perfect and when swell hits it, the waves stand up and break like nowhere else on earth. The force and consistency and pitching lip and barrel that the pitching lip creates are one of a kind. Pipeline's barrel is its legend. It gapes and spits and a surfer lucky enough to catch a true Pipe barrel becomes the worst sort of addicted ritualistic sacrifice ever. He will offer his soul to catch another. Jamie O'Brien is an addict. A very bad addict. An accomplished addict. Sucking down the pharmakon.

Jamie is a twenty-eight-year-old haole, white, ruddy even, with gangly arms and a silly gait, but he grew up directly in front of Pipeline. His house smells like cat urine and sea rot and lack of cleaning even though it is beachfront and theoretically expensive. The land alone would be worth a few million dollars. But Jamie lives with his dad. His mom caught island fever many years ago and fled to Colorado, and neither he nor his dad ever thinks about cleaning.

Inside it is stuffed to the rafters with relics. Trophies of Jamie's victories at Pipeline and his invitations to the Eddie Aikau. Posters of the surf films he has made. Coconuts carved into pirate heads. An old green parrot that swears in Hawaiian slang. "What da fuck, eh? What da fuck, eh?" The parrot is particularly incorrigible.

And he has surfed every good swell of every winter for the past fifteen years. He wakes up in his home and exits through the back door and stands on his back deck and watches Pipeline roar. He could, if he so desired, throw a rock from his deck to the wave. On the good days he paddles out and knows it like the back of his ruddy hand and so gets deeply barreled. He is very stylish but he has suffered for his addiction. He has broken his leg out at Pipe on two different occasions. The first time he took off on a late one,

meaning he popped to his feet as the lip was already pitching, and got pile driven into the reef and it splintered his tibia. He paddled to shore feeling something was very wrong and dragged himself up the beach and over to the lifeguard stand where his father was working. His father, Mick O'Brien, came from Australia many years ago and got a job as a lifeguard on the North Shore so his son could surf and become famous. "Dad," he said. "I broke my leg." Mick did not believe him at first and Jamie spent the day in his room until his leg swelled to a purple balloon and then Mick took him to the hospital. The second time he also took off on a late one and, again, got pile driven and when he surfaced he thought, "Fuck. Not again." The second time his father was not working and so he had to drive himself.

Two broken legs and he continues to paddle out whenever it is good. Whenever it is big. There is nothing he would rather do. Addiction.

Like all waves, Third Reef, Second Reef, Pipeline setup requires certain swell directions to break perfectly. When a swell line approaches that has more west in it, say, than north it will break slightly different than if the swell has more east in it. It will run along the reef in a slightly different way and barrel slightly differently. These adjustments and variables are known, intimately, by the worst Pipeline addicts. They can sit out at sea and know by looking out at the swell lines a mile away which will do what. Their knowledge of the break is encyclopedic. They are part scientist and part mystic and they line themselves up with the reef underwater, knowing that they must sit on this reef head, or near that rock with its particular markings. They also line themselves up with homes or trees or other landmarks on the shore. They also just have the feeling. Years of experience teaches them where to sit and a novice will never be able

to succeed simply by aping one of them. Novices at Pipeline must learn like everyone else. They must take waves on the head and must be willing to sacrifice their limbs. And if they are willing they will slowly learn how to read the tea leaves but no one ever masters, truly masters, Pipeline. There is simply too much happening. It is a force of nature too great.

Many waves, as previously discussed, peel either right or left. Some waves peel both ways. That is to say that the wave breaks in the middle and peels down the line both left and right. These sorts of waves are called teepees, because they look like a teepee, and highly prized because surfers can get barreled going either right or left. Pipeline is a teepee but only the surfer's left is called Pipeline. The surfer's right is called Backdoor and it is as famous, almost.

Pipeline breaks and barrels left and then shrinks into a channel roughly fifty yards from its birthplace. Channels are deeper areas where the seafloor dips or the reef disappears and the sudden depth saps a wave of its energy. Pipeline's channel is where surfers paddle out from the beach without having waves smash their heads. And when a surfer has ridden a Pipeline wave he can also paddle back out of the channel relatively easily. Backdoor is different. It breaks and barrels right, a barrel as gaping as Pipeline's, but it does not end in a channel. It ends by closing out on the reef, the same reef on which Off the Wall breaks. The surfer taking a Backdoor wave will, therefore, put himself into imminent danger not only on his wave but also on the following waves. He will be without channel and therefore without grace. He will get smashed. But Backdoor is very photogenic and some surfers prefer to catch only Backdoor waves.

And so, sitting on the beach, the spectator will see Pipeline and Backdoor and Off the Wall, and also Ain'ts, which is a small boil between Backdoor and Off the Wall that also breaks right. It is called

Ain'ts because it ain't Backdoor and it ain't Off the Wall. The spectator will see them all at the same time in his line of vision, the entire panorama, all four waves, battling in six hundred yards. And on big days it will look like a complicated swirl of fury. It is simple to pick out Pipeline and Backdoor and Off the Wall and even Ain'ts from pictures. It all seems to make sense. But sitting on the beach, on big days, it only looks destructive. Pipeline will be breaking at twenty feet over there. Backdoor will be breaking at twenty feet right here. And Ain'ts and Off the Wall will be closing out at twenty feet down there. Each explodes. Each rattles fillings in the teeth. Each looks deadly. Together they look like war. And watching surfers on the sand, waxing their boards, idly chatting with each other, preparing to jump in the channel and get sucked down the beach before getting sucked out to sea, looks like kamikaze suicide, which is why it is called the *Banzai* Pipeline.

It's impossible to tear eyes away from big Pipeline days. Most of the North Shore residents will hover around and tourists from town will be there too and locals and tourists alike will gasp and point. The locals will grimace while laughing when the surfers in the water wipe out. The tourists only grimace and look fearful.

Backing away from Pipeline, the war to end all wars, past the grimacing tourists and the laughing locals, through the Ehukai Beach Park and its one cement picnic table, crossing the Ke Nui and out on to the Kamehameha and continuing northeast, one passes shabbier neighborhoods, the Chevron, Ted's Bakery, O'opuola Street, Backyards, Velzyland, Rocky Point, Rocky Rights, Rocky Lefts, Arma Hut, Kammieland, and then Sunset Beach.

Sunset breaks off a small headland at the northeastern tip of the beach and relatively far out to sea. The Kamehameha runs directly in front of the sand and the sand makes a small crescent like it is

a bay and the sand is paradisiacal. The sky is blue. The ocean is blue. The sand is white. The palm trees are green. The lifeguard stand, on stilts, is red. Paradisiacal unless storm clouds swirl and unless the swell is large and then Sunset is also a horrible phantasm. It was one of the first surf spots that those seeking larger and larger waves conquered in the 1950s. It was where the first Eddie ran before moving to Waimea. It has history as a famed big-wave spot and the waves do get very big but they are also less predictable than other spots. More difficult to read but easier to catch since they don't break top to bottom, meaning the lip doesn't throw out like a guillotine. The lip, instead, collapses down. It pinches and crumbles and rolls like drumfire.

Sunset is raw, maybe more raw than any wave on the North Shore. It breaks far out to sea and so surfers must paddle a quarter of a mile, or so, in order to ride. It is considered a big wave too, because it breaks well at forty feet, but it is rough. A messy, raw slog.

Sunset has its lovers. It has a crew that ride here and nowhere else. And they have pride in their ability to sit in the middle of a stormy sea, surrounded by waves forty feet high and shifting all over and riptides that would take them to Kauai or into the belly of a tiger shark. They have pride and patience.

The Kamehameha tilts slightly inland, away from Sunset, as it passes Turtle Bay and begins its southwestern trajectory around Oahu back toward Honolulu some thirty-eight miles away. And that, geographically, is the North Shore. The Seven Mile Miracle. Mecca. These are her waves, from Hale'iwa to Sunset, and they are unique and they are individual and they are finite. Certainly they each break many times every winter season. And certainly they each break well many times each season. But there are only so many waves on those good days and the lineups are all choked.

And the energy. And the danger. And the power. And the choking. All things considered, these waves are no different than oil or diamonds or uranium or any natural resource pulled from the earth. They are unique, individual, finite, and worth dying or killing for.

Fade into Darkness. Or, Eddie.

I creep north on the Kamehameha until I pass Ehukai Beach Park, and then the traffic subsides. The traffic for Pipeline. Word of its size has spread far and wide. Word that the event will run today. Epic Pipeline. A contest. A double-laned road with potholes. Traffic.

I pass Rocky Rights and see a dripping-wet haole stumbling up the road with blood streaming from his nose and a hangdog look on his face. He either smashed the reef or was smashed, Hawaiian style.

I pass the Chevron and then Ted's Bakery and then see O'opuola Street, which is the last left before Sunset. I turn left.

O'opuola Street is typically decrepit for the North Shore. Barely wide enough for one car to drive, much less two, there is nothing particularly daunting or menacing about it. It runs toward the beach, toward Backyards, for two hundred yards, flanked by modest Hawaiian homes, slightly ramshackle with pitched roofs, wide covered porches, and yards hedged with bougainvillea, palm, and banana trees.

And today there is nothing particularly menacing about it, though it has just gotten darker and started to sprinkle and, since my white convertible top is down, I start to get wet. I don't feel like being wet. I don't feel like tramping wet into Eddie's house.

I drive to the end. Directly in front of me is a small grassy park and directly behind the park is Backyards, the surf spot. It is a swirling mess of energy. O'opuola ends at Backyards but another unnamed smaller alley runs off to the right and dead-ends with no outlet. This is where Eddie lives.

I park at Backyards and walk, looking for the big-truck/brown-fence description. Walking in places like this on the North Shore, when haole, is not very cool. Two chunky kids sitting at Backyards, shirtless and shoeless and even slippahless, stare. If anyone says anything at least I can respond that I am going to see Eddie. It might spare me abuse.

But why does Eddie want to see me at his house? What if I'm walking into some sort of trap? What if I had written something bad about him or Hawaii or Makua at some point? I wish I could remember everything I had ever written. I really wish I could. Would he really make a production out of it, though? Like, invite me over to his house so he can crack me? Wouldn't it make more sense to crack me in public so all could witness my humiliation? Tony Perez and J.D. from Target are the only people who know that I am going to Eddie's. And it would serve Tony Perez to keep it real quiet if something did happen and J.D. doesn't know me well enough to care. But, still, why does Eddie want me at his house? I walk down his smaller road. There are speed bumps in the middle, though I can't imagine who would dare speed here. The houses, maybe five, front the beach and in front of them all are parked an assortment of boats, cars, and all-terrain vehicles. The other side of the smaller road is island scrub. Palms. And I walk by a jacked-up black Ford diesel F-350 parked in front of a shoulder-high rock wall that turns into a large brown gate. This must be Eddie's house. There are actually two houses beyond the rock wall and fence. It is a compound.

One house, two stories, pale green with a large covered porch, pitched roof, runs perpendicular to the smaller road. The other, set behind it, is in a similar style except tan instead of pale green and parallel instead of perpendicular. There is a clump of palms pressed up against the rock wall.

The gate is closed and I debate my initial approach. Entering a home, a compound, on the North Shore is fraught with enough etiquette variables to send lesser men into insane asylums. To enter or not to enter is the first variable. It shows strength of character to march into someone's home, here, and assume that you are not only invited but welcome. And strength is greatly valued. But it can also show a lack of respect and respect is also greatly valued.

My friend Marcus Sanders, editor of *Surfline*, the most trafficked surf website, is a great example of the dilemma "to enter or not to enter." *Surfline* features cameras that point at every good beach in the United States and many in Mexico, Brazil, Australia, and Europe. Lazy surfers who don't feel like driving to the beach to check with their own eyes can, for a fee, log on to the Internet and discern the quality of the waves on any particular day at any particular spot. *Surfline* saves the brutal, cold, unnecessary surf-check dawn patrol. It also has original editorial content, which Marcus takes care of. He is a cute man. Short and a little pudgy with brown curly hair and a nasal voice. Very bookish but cute. He is a father of small children and lives in San Francisco. When I used to cover the ASP World Tour, those dreamy days in Australia, Europe, and California, I would always feel very old-school journalist when having whiskey at the end of the day with Marcus Sanders. I would feel very Bob Woodward, as played by Robert Redford, to Marcus's Carl Bernstein, as played by Dustin Hoffman.

One winter he had to photograph all the surfers in their team

houses. He went to the Billabong house, the Quiksilver house, the Rip Curl house, the Analog house. Things were moving smoothly and finally it was time for him to go to the Volcom house.

Volcom is a surf brand from Newport Beach, California, but has a fierce reputation on the North Shore. The fiercest. Kai Otton, an Australian professional who hates *Stab* because they published topless photos of his ex-girlfriend, and hates me by extension, was surfing out at Pipeline once and was dropped in on by someone causing him to smash his face, badly, on the reef. I asked him if he had gotten in a fight, when I saw him, and he glared at me and then said he had gotten burned by someone at Pipe. I asked if he punched the offender and he glared at me again and said, "No. He had a Volcom sticker on the nose." Kai does not ride for Volcom. He rides for Insight, which is hipster Australian, not fierce. Volcom is fierce. Physically intimidating.

Marcus called Kaiborg to set up the shoot time. Kaiborg. Kai "Kaiborg" Garcia, as mean as a rhinoceros, with arms as big as Toyota Land Cruisers, is perhaps the only person on the North Shore that is feared equal to, or maybe even greater, than Eddie. His legend looms almost as large as his body. He is originally from Kauai, in his late thirties, six four, three hundred pounds, and a rock of a man. A giant granite statue. He has a black belt in jujitsu and used to fight in mixed martial arts matches in Brazil. Today he takes care of various things for Volcom and so Marcus called him and Kaiborg told him to come over.

Marcus gathered his camera and his notepad, professionally, and walked to the Volcom house. He saw surfer Shane Beschen outside and they chatted for a moment before they both pushed open the gate and walked up the outside stairs to the deck through the sliding glass door into the living room. Kaiborg was in the kitchen and

he greeted Shane and then his eyes went black. He fixed Marcus in his black eyes, got off his stool, and charged him like a bull. Marcus didn't know what was happening and stumbled back and stammered, "Borg . . . it's Marcus Sanders from *Surfline* and we spoke about—" Kaiborg cut him off. "Never fucking come into someone's house without getting fucking invited in." Kaiborg's voice is authoritative and final. Marcus kept stammering an apology while stumbling back out the sliding glass door, down the outside stairs, and through the gate. He stood in the alley next to the Volcom house, panting. A slap from Kaiborg could knock a man's head from his shoulders and especially a cute bookish head with curly brown hair and a nasal voice. Marcus waited for two hours in the alley until Kaiborg finally came out. Marcus apologized again and Kaiborg repeated his admonition before inviting him in. They proceeded to take care of the photo shoot and all was well except for Marcus's scarred soul.

Here are the etiquette variables that rule the North Shore and God only knows where they came from. Some from the ancient Hawaiians, probably. Some from Japan, some from Brazil, some from Italian mafias, some maybe from Satan himself. Let us say, for instance, that Marcus stood outside like a fearful clown. Kaiborg could just have easily bull-charged him for being a big sissy and standing awkwardly in everyone's line of sight like a big sissy. Let us say that Marcus didn't show up at all and left the Volcom house out of the photo shoot. He would have certainly been called out for slighting the brand and, next winter when he came to the North Shore, he would have had to answer for his slight. He would have had to pay excessively for attempting to evade his Hawaii Tax.

Even the simplest human act of entering or not entering someone's house can seem like a no-win situation, a situation destined

for a beating either way, but I have a personal guiding principle on the North Shore and that is, if I am going to go down, at least I will go down on my own ship. I act like I want to act and if I get slapped at least it is for just being me, baby. The North Shore can take my pride but it will never take my freedom.

And so I push the brown gate open and move into the Eddie Rothman compound. There are surfboards everywhere, scattered and leaning against the sides of the two homes. There are two Jet Skis on a trailer. There is a broken-down weight bench stacked with metal plates and there are three pit bulls running at me.

I assume the dogs are a scare tactic. A filter to see who will run away scared and who will stand firm and who will flinch and who will not. Dogs are fine judges of character and these are well-muscled dogs with the widest heads I have ever seen. Two of them are dirty brown and one is blue. His head is wider than the others. Wider than the heads of three German shepherds put together. And their ears are shaped into tiny triangles. They arrive at my legs with green eyes and eager faces and small scars. I smack the blue one on the cheek with force. I love a good, wide dog head. I love the way it feels to smack it, all hollow and thick. I used to own a Saint Bernard.

Eddie is standing on the deck of the tan house looking down on this corner of his kingdom, and says, "Don't worry, brah. Dey don't bite." I respond, "I never worry," and then look up.

He is silhouetted against the sky, shirtless and reddish-brown and beyond well muscled. He is a pillar. A five-seven or five-six tower of power in baggy black boardshorts, running shoes, wrap-around sunglasses, and a white "Da Hui" baseball hat. And his muscles. Those roping muscles. His arms are hard and stiff and do not dangle. There is too much muscle for them to dangle so they jut

out of his torso at frozen, obtuse angles. His arms are marked with evidence of a lifetime spent shirtless in the sun. There are darker brown and white spots among the reddish-brown. And also black tattoos that have faded to darker grey. His shoulders are shoulder pads and swell around a neck impossibly thick. His neck is a tree trunk. And his pectorals are filled like very hot sausage ready to burst and his abdomen is so solid that it seems he has muscle stacked upon muscle stacked upon muscle. It seems like his intestines have packed their bags and moved away and he is only muscle. A torso filled with muscle.

He looks down at me slowly, then into me slowly, as I come up the stairs. I look at his hands. I wonder how it would feel to get slapped by those hands. He tells me to come in. "Hey. Come in, Chas." And his voice is so guttural that it shocks the system. Every part of Eddie Rothman shocks the system. It is as if he was composed piece by piece, from physique to voice to stories, to shock the system.

I would have removed my shoes, here, but I had already removed them at the base of the stairs, just to make sure I was not in transgression even though the base of the stairs is virtually in the dirt. I think about my pink button-up and wonder what he thinks about it. I can't see his eyes because of the sunglasses but he must be thinking something. And I follow Eddie through his front door into his home.

It is nice. It is clean and nice with a completely open living room and windows that look north toward Backyards. The Pacific, alive and full, takes up the entire vista from floor to ceiling. A fan spins listlessly at the peak of the high living room ceiling. A large flat-screen television flickers silently and two chairs are pulled up in front of it. Eddie doesn't go down into the living room, though, instead turning left and going into his kitchen, which is also clean and nice.

His computer is open on the breakfast bar and he sits down on a stool, takes his sunglasses off, and starts to search for pictures. His eyes bore holes into his computer screen. Dull holes. I sit next to him, even though he did not invite me to sit, surprised how really clean the kitchen is. No dirty dishes and not even any clutter. Not typical for most surfer houses. It is quiet until he says, "Why da fuck did *Surfer* not run dis fucken picture here, huh?" On his computer screen is a picture of Makua, his son, getting barreled at Pipeline. "Fucken Russo said dis was one of da best pictures of da winter and fucken *Surfer* didn't run it? Why's dat, eh?" I study the picture and it is good. The composition is good, the lighting is great, green and gold and luscious, and Makua is getting very barreled. He is deep. I tell Eddie that I don't know. It's a good picture. He goes back to his computer keyboard and slowly searches for another. His computer screen has been magnified to 200 percent and everything looks slightly blurry and slightly off. He hunches over the keyboard and his finger, stiff, drags slowly across the trackpad. Searching. He finds it and this time it is a darker picture of a kid surfing an outer-reef bomb. A large wave. I ask if it is Makua and Eddie says, "No, dat's fucken Koa and *Surfer* didn't run dis one either. Dat is a fucken bomb there . . ." I ask who Koa is and Eddie slowly turns his head and looks at me. "Koa is my boy." I am surprised. I thought Eddie only had one son and I tell him that. He is not angry but also surprised and says, "No no no. I've got three boys. Makua, Koa, he's da middle boy, and Lono is da youngest. Three boys." I respond, "Oh. That's cool." And Eddie returns to the computer and is looking for another picture in a folder he can't find. "I fucken hate computers. I never sort nothing right and I can never find nothing." He reads the names of the folders out loud as he searches—"Makua Pipe. Makua

fights. Koa"—and then finds what he was looking for. "Look at
dis shot. What is da fucken photo editor at *Surfer*'s name? I can't
believe dey didn't run dis shot. Dey told me dis one was going to
make da cover and den, you know, dey didn't do nothing with it.
Dey didn't do shit . . ." I tell him that I can't remember *Surfer*'s
photo editor's name and then tell him that I work for *SurfING*
and *Stab*, not *SurfER*. *Surfing* and *Surfer*, or *ING* and *ER*, are both
owned by the same company, Source Interlink, both have offices
in the same building, and both are published by Tony Perez, but I
will not take responsibility for the damned fools at *Surfer*. I never
speak with them.

Eddie looks through me with slightly cocked eyebrows but an
otherwise expressionless face. "Ahh? *Surfing*? Yeah?" And I tell him,
"Yeah," and then ask, "What do you think about *Surfing*?" And he
says, "Yeah, yeah. I like *Surfing*. Makua was on dat cover last year.
Surfing is OK. *Surfing* is good." Amazing. Totally amazing. I am
not in trouble, or not yet. I haven't been invited to the Rothman
compound to get a pounding. Or not yet. My wheels turn. Slow
morning wheels, but wheels nonetheless. Eddie invited me over be-
cause he cracked Mick for me and so I owe him. I was in his pocket.
And he thought I worked for *Surfer* so he was going to take his pay-
ment in getting coverage for his sons in the magazine. But now, for
this second, I have the upper hand because Eddie is accidentally
happy with *Surfing*. I take advantage. I press my luck. I get brave
and say, "Rumor has it that you slapped Graham last night." Eddie
pauses a longer pause. The longest pause. Staring. Looking. His own
wheels turning. Muscles flexing. Before responding, "Slapped him?
I fucken slapped him eleven times, brah." And he sits there chuck-
ling. A low chuckle. A truly scary chuckle. Then he goes back to
his computer to find a video that was taken yesterday afternoon of

Makua and T.J. fighting at Backyards. It is what set off last night's Billabong house beatdown. Eddie is giving me context. He is giving me gold and he is also putting me back in his pocket. I ask him what happened and he says, "Makua and T.J. were surfing at Pipe and den T.J. burned Makua and Makua wanted to fight him so dey went up to da Billabong house and fought but den someone kick Makua and so dey come to Backyards to finish." Getting "burned" means T.J. took a wave that Makua was in position for. He finds the spacebar and presses it and the video plays.

It is surreal to see the whispered rumors playing live. The video is shaky and the filmer is never in the frame but Makua is there and T.J. is there and Eddie is there and T.J.'s uncles and parents are there. All of them standing in a semicircle on the grass.

T. J. Barron is a Hawaiian who is sponsored by Billabong and was the cute little starry-eyed kid in the film *The Endless Summer II*. He had grown up now. Strong jaw. Good dark features. His hands tattooed in Polynesian style. A series of black-and-white triangles all interconnected. He had lived his whole life on the North Shore of Oahu. His family had lived their whole lives here too.

T.J. and Makua had been friends for years but one summer, when Oahu's North Shore turns into a giant lake, they went to Bali together and something happened to drive them apart. Nobody is quite sure what but they began to fight and their fights were bloody. They fought on Bali, back on Oahu, at the Billabong house, and then they fought at Backyards. On Eddie's computer screen Makua hops around, adrenalized, ready, and T.J. bounces slightly but doesn't look as ready. Eddie tees them up like they are in a ring, like it is a professional bout, and then they fight and Makua beats him badly. He smashes him. "Look at dat fucken elbow. Makua had him right there . . ." Eddie provides commentary as his son bloodies T.J.

"I don't know what da fuck T.J. was thinking. I don't know why he didn't just stay down right there. Stupid. Fucken stupid. Makua was done there, after dat choke. He was finished fighting"—and he points to the screen again—"but T.J. kept coming. Fucken crazy. T.J. is fucken crazy." The video plays for five minutes and it is a fair fight with Eddie pulling his son off of T.J. twice when Makua has him in an untenable position. But T.J. fights back and also fights dirty. "See how T.J. is trying to grab his balls? See right there how he's trying to gouge his fucken eye? I told Makua not to break nothing on T.J. because I know what's gonna happen. And I told him, 'Don't cut your hands up.' See all those little scars?" And Eddie holds his knuckles an inch away from my face. They are tanned to the same reddish-brown as his skin. They are gnarled like an old branch. They have seen more action, tasted more flesh, than I will ever know. And someday they may taste my very own flesh but my nose is already very crooked so I don't much care. It got crooked when I was five and was smashed in the face by a young boy holding a log. It got more crooked when I slammed my face with my surfboard's rail in Oregon. It got most crooked when I was jumped by a gang for mouthing off. "See all those little scars?" And I do see them. White little lines cut into the reddish-brown branch. "Those are all fucken teeth. Every fucken one of 'em. I've had teeth stick in my hand and I was like, 'Whoa!'" He pauses for a thoughtful moment. His face doesn't give any clues. The pause speaks loudly enough. "But I had no choice, you know?" And then we both return our attention to the computer screen. To the present battle. "I told Makua not to break nothing in T.J. but den after all da shit T.J. was saying, he was saying he was going to come and get Makua, so I told Makua, after dis, after da fight, dat if T.J. comes after him again to break both of his fucken arms and both of his fucken legs."

And the video finishes playing. Without provocation, without my probing questions, Eddie then tells me that he went over to the Billabong house because people there were yelling, after the first fight, that they were going to get Makua and that he was a kook. So Eddie went over and did what he knows how to do. Unapologetically. He slapped Graham and slapped whoever else deserved it in the house or whoever else he thought deserved it. He looks through me and says, "Fucken Graham knew he had it coming. He told me, after it was done, dat he knew I had been waiting a long time to do dat and I told him fuck yeah I been waiting." I asked him why. "Because Graham told me dat Billabong would sponsor da Shootout. He told me dat he would give me two-hundred thousand dollars and so we made plans for dat and the next winter I came up to him and asked him for da money and he fucken acted like he never heard nothing about it. Like it was da first time and he told me dat he never promised me nothing. Bullshit." The Backdoor Shootout is Da Hui, Eddie's, event at Pipeline. It has a flexible window but usually happens sometime in January or February after the Pipe Masters. "It ain't like some fucken shit AS fucken P contest either," he says about the contest. "The boys just show up and if dey on the beach then dey surf. There is no fucken bullshit." He tells me that Graham didn't get the worst of the beating either. "Graham didn't get the fucken worst of it, brah. Nah, nah. That big fucken South African from Billabong did. What's his name?" And he is looking at me. Through me. And I have no idea. "He has dat big fucken neck. What's his name?" I still have no idea and he says, "Well shit. You know." I don't. I ask Eddie if anyone in the house fought back. "Nobody did fucken nothing. Dey were all saying dat dey were going to do dis or do dat, and there were enough of dem, but nobody did nothing. Dey just took it." Eddie shrugs his shoulders slightly. Like he is

both surprised by their lack of getting it together and fighting back and also that he understands why they would never fight back. He has a reputation. He knows his reputation.

His reputation is exactly why he wanted me here. To look at him. To feel him. And now, with all this gold, with the story of his going to Billabong and the video of Makua, he really really has me in his pocket. I owe him. This is a very personal version of Hawaii Tax.

Hawaii Tax is what the magazines and brands call sponsoring Hawaiian surfers or running Hawaiian surfer photos in the magazines or doing copious editorial features on Hawaii. Every surf magazine releases one entire issue, every year, that is based solely around Hawaii, and more specifically the North Shore. The brands each sponsor at least one notable Hawaiian. And this is not to say that Hawaii, and more specifically the North Shore, and notable Hawaiians don't deserve coverage and sponsorship. Hawaii has the best, most famous waves in the world. And Hawaiians surf them better than anyone. But still. Sometimes a season doesn't justify an entire issue. And, to be quite honest, most Hawaiians surf poorly everywhere else in the world besides Hawaii. They have perfect waves at home and they get used to riding them. They can't be bothered with small and junky California or Florida or New Jersey but it is essential to surf California and Florida and New Jersey because they are population centers and the surf consumer loves to see progressive surfing on his own waves. Even so, the magazines will be goddamn sure they still have their yearly Hawaii issues. If they don't they will never be allowed back to the North Shore again.

And most Hawaiians feel this one issue is not enough. They feel perpetually marginalized but maybe they are. After a recent *Surfing* Hawaii issue, I was emailed this letter by an angry mainlander. He wrote,

> I got my April issue, and lo and behold, there's more bullshit
> about Hawaii, about how I should behave there, about "people
> trying to make Hawaii something it shouldn't be," etc. etc. . . .

He went on and on, burning hundreds of words, looking into the ethnicities of the world and their corresponding IQs on a bell curve before eventually stating that Hawaiians are retarded. And that they are retarded because they are inbred. Rude and racist, bordering directly on Nazi Germany eugenics. Many mainland surfers are rude and racist about Hawaii, about the North Shore, when they are sitting comfortably behind computers in Newport Beach, California. It is, really, no wonder why haoles get their faces smashed so often when they do show up in person.

The brands struggle too. They will not drop their poorly performing Hawaiians out of fear of either physical reprisal or not being allowed back to the North Shore. And if they do they will quickly replace them with other better Hawaiians. But sometimes the replacement is not enough, or a Hawaiian who everyone knows is sponsored for life is dropped and then please refer back to Damea Dorsey and his trouble. Hawaii Tax is joked about in California but never joked about in Hawaii. It is paid with all the head-bowing, knee-dipping gesticulation of recently conquered subjects bringing treasure to a vicious conquering king.

Surfing ran Makua on the cover and will certainly run him again. I am current, for now, on that tax. But now Eddie has shared golden secrets and we shall see when payment for that comes due. Being OK, here, is granted on a minute-by-minute basis.

Eddie is looking through me but not maliciously. Not yet. So I continue to press my luck and ask him for his life's story to really get to the Joan Didion heart of what I want to do. "My life's fucken

story?" he responds. "My memory ain't no fucken good." So I start simple and ask him if he was born an orphan in Philadelphia, Pennsylvania, because that is what I heard and he looks through me with his eyes frowning. "I wasn't born no fucken orphan. My parents were my parents . . ." and his story begins to flow.

Edward Rothman was born in Philadelphia to an abusive father and a more abusive mother. He was born Jewish, though nonpracticing. "I don't know nothing about Jew stuff but once dis lady who lives on da North Shore made me some Jew food and it was good," he says. He also says that his mother physically abused him as a boy without elaborating how or why. Eventually she left and his father moved to Southern California. He says, "Everybody talks about how I lived in Huntington Beach when I was a kid. I never lived in no fucken Huntington Beach. People always just make fucken shit up . . ." He, in fact, lived in Long Beach, which neighbors Huntington Beach to the north. And Eddie grew and his father beat him. "My father would fucken beat da shit out of me because I was little and dat made him mad so he'd just beat me." Eventually Eddie had enough. He didn't want to take anymore. And so, when he was sixteen years old, he stole enough money out of a Texan's Cadillac with long horns affixed to the hood for a one-way ticket to Honolulu, Hawaii. He surfed in California and had seen the pictures in surf magazines. He had seen the pictures of perfect giant surf and palm trees and white sand and easy smiles.

He landed in Honolulu knowing no one. He only knew that he was closer to home then he had ever been. He stayed in Honolulu for a few years, flying back to Southern California, picking up marijuana, and bringing it back to Hawaii. He went to school in Long Beach for a minute, when he was in California. "Yeah. I went to school a couple times but da school told me dat if I didn't show up

den dey would pass me so . . ." Socially promoted out of the class-
room because, even as a young young man Eddie Rothman was
fear-inducing. And eventually he went to the North Shore.

The North Shore hooked him like it hooks so so many. He had
everything he needed. Surf. Sun. Surf. A market for his pot. And
as a sixteen-year-old he would get by selling it and jacking cars. By
partaking in the derelict market.

One bright day he was in the bushes at the Sunset parking lot,
doing his thing, jacking the cars of oblivious and oiled-up tourists
on the sand, when he ran into a pack of Hawaiians, North Shore
locals, who were also doing their thing, jacking cars.

Jacking cars is a sport here just like jacking blacksmith's tongs
was sport in Captain Cook's day. Rental cars from Honolulu come
with stickers affixed to their glove boxes reading, "Don't leave valu-
ables in plain sight. Lock them in the trunk. Mahalo." And, again,
I have always had the distinct feeling that if a Hawaiian smashes
the window of my car to steal three dollars in change from the cup-
holder he would just as soon pop the trunk, once the window has
been smashed, and dig around there too. So I rent convertibles and
leave their tops down and leave valuables in my home. But Hawai-
ians like to jack homes as well. Every season on the North Shore
houses are plundered. Camera equipment, computers, clothes, wal-
lets, passports, money, whole quivers of surfboards. A quiver is any-
where from five to ten surfboards, shaped differently and different
sizes to surf the varied conditions. And whole quivers disappear.
Anything is fair game. So I go white convertible and don't lock my
room and consider anything I bring to the North Shore written off.
Aloha, things.

And back in the bushes at the Sunset parking lot the locals looked
at Eddie. He looked at them. These were tough kids who had been

born here. These locals and Eddie started to work together. I ask
how they accepted him, a Jew from the mainland, and he looks
through me and pauses. Thinks. And then says, "I don't talk good.
I have a bad speech like dem so it was easy and uhhh everything
went from there. I sounded like dem and so dey just accepted dat I
was like dem." Eddie is right. He don't speak good. I later make the
mistake of saying these tough Hawaiian locals adopted him and
he bristles. "Dey didn't adopt shit. I proved myself every fucken
day. I proved myself with these." And, again, he holds up a fist. A
scarred fist. A tooth-nicked tree branch. Not speaking well only
goes so far.

Eddie tied in with this crew. He was tenacious. He was deadly.
And so he would be flown around the islands to teach lessons. He
would crack heads for various offenses like not paying debts within
an appropriate time frame. He also flew around the world and was
there around the discovery of the famed Grajagan. It is hard to be-
lieve, in the twentieth century, that there were still undiscovered
breaks but there were. And there still are. New waves, never-before-
surfed waves, are stumbled across even today. Surfing is the grand-
est adventure.

Grajagan, Indonesia, only ever called G-Land, was a lost-boy surf
Eden. Australian and American surfers had discovered Bali in the
late 1960s and loved it. They loved it all. They loved the endless
curving bays that opened up and showered them with point breaks
(waves that break off a slice of land jutting into the sea), reef breaks,
beach breaks, barrels. They loved its happy blend of mystical Hin-
duism and prostitution. They loved its heroin fresh from the Golden
Triangle. They loved the so cheap rice, fish, and coffee. And while
the 1960s summer-of-love idealism collapsed into selfishness and
corruption and Charles Manson in the West, Bali remained free for

them. They could eat mushrooms and get freaky. But then selfishness and corruption found Bali too and so the most intrepid Australian and American surfers set sail across the Bali Sea for the island of Java, for Grajagan.

They set up a tree house complex and lived free and easy and surfed one of the best reef breaks any of them had ever seen. And they dreamed big dreams. The more entrepreneurial of them felt, "Let's stay here forever. Let's make enough money selling cocaine and heroin that we can do just that." And they did. They acquired boats and moved drugs from island to island and flew drugs to Australia and America. Surfing and drugs have always been a sometimes happy, sometimes deadly, always feisty dysfunctional couple.

Mike Boyum, a Floridian and one of the first discoverers, started charging money for visiting surfers to come and surf perfection. By the mid-1980s he was grossing more than $250,000 but it was not enough and so he began trafficking cocaine. He was arrested in 1985 on the island of Vanuatu and served two years and then went on the run. Rumor was that he had stolen money from North Shore gangsters and they were out to get him.

He was found dead while he had been living in the Philippines and surfing another perfect wave he had discovered called Cloud Nine. The official cause of death was starvation. He had, years earlier, decided that fasting was the path to spirituality and was in the forty-fifth day of a fast when he died. There are still those, though, who claim that he could fast longer than that. They claim that the North Shore gangsters finally found him and snuffed out his life.

The Indonesian government had, in the meantime, closed down the G-Land camp, and the lost boys spread out across the world. Some started surf companies. Some smuggled drugs and disap-

peared between Indonesia, Thailand, and Vietnam. Some, besides Mike, ended up in jail. But at the height of the glory, they were all at G-Land. Getting freaky. Surfing.

Eddie Rothman spent some time there too, surfing the perfect. A grainy video shows him walking on the beach all tanned and thick wearing orange surf trunks, but he was mostly on the North Shore and some of those same G-Land surfers came to the North Shore too in those swinging 1970s. "Dis is da place everybody wants to be," Eddie says. "Dis is da place dey dream about. Big banyans, palms . . ." He gestures out of his window, and Backyards can be seen breaking furiously. A palm tree sways in the wind. Two roosters heckle each other vocally.

Surfing had been mostly crushed by Calvinist missionaries who came to Hawaii throughout the 1800s. It was seen as part of a rotten, native religion. George Freeth, the son of an Irish sea captain and half-Polynesian mother, who lived in Honolulu, was one of the first to revive the art. He surfed along Oahu's southern shore, even giving novelist Jack London a surf lesson in 1907. London called him "a sea god . . . calm and superb." Freeth sailed to California in 1909 to bring surfing to the mainland and was the first to ever do so. He gave demonstrations in Redondo Beach, San Diego, Ventura, Huntington Beach, and Palos Verdes and helped bring the Hawaiian swim team over to the mainland for the first time too. One of those swimmers was Duke Kahanamoku, who later won an Olympic gold medal in swimming and made surfing famous throughout the world.

Back on Oahu surfing was only ever done on the South Shore because the Hawaiian surfers assumed the North Shore waves were simply too big. The very first surfers to trek north from Honolulu were brave like spacemen. It was the 1950s and the North Shore was

even more empty and ramshackle than it is today. It was Quonset huts and pineapple and wild boars and nothing more. But the waves were still here, too big to surf. The biggest waves surfed previously had been big Southern California winter. Maybe twenty foot, non-Hawaiian.

Greg Noll, called Da Bull, knew they weren't too big. He knew they were just right. He was born, big himself, in San Diego, grew up surfing in Manhattan Beach, and moved to Oahu in 1954 as soon as he graduated from high school. A horse of a man. Broad shouldered and tough. He surfed Makaha, on the west side, and Makaha was the big-wave spot of the day, breaking between fifteen and twenty feet, Hawaiian. But knowledge of the North Shore waves existed. Much much bigger waves. But Greg Noll just knew they weren't too big. He knew they were legend making. And so, in the winter of 1957, he paddled out on a thirty-foot day at Waimea while people on the beach gaped. Not tourist people either because the North Shore in '57 was pre-tourist. And the day was thirty foot, Hawaiian. He caught a wave and proved its possibility. He also caught a wave at Third Reef Pipe and spoke about how there was so much speed, so much power, that it felt like he was getting shot into space.

Brave souls followed Greg Noll's lead. It was a small community at first, those surfers gutsy enough to ride the North Shore, those surfers gutsy enough to sleep on the dirt and eat only fruit and sleep with rats, but it grew steadily. The surf magazines, just starting to print toward the end of the 1950s, featured the North Shore regularly. It was as exotic as the moon for a surf culture that was just beginning to find its legs in Southern California. Southern California was Malibu and *Beach Blanket Bingo* and Jan and Dean. It was sun and bikinis and health and even though it looked clean and perky there was a raging appetite for more. For bigger.

Surf grew unchecked through the 1960s. The Endless Summer. The postwar ideal. It spread from Southern California to South Africa to Australia. It captivated the youth and there has always been something very addicting about surfing. Surfing and drugs. And the expanding core would look at pictures of the North Shore and know that it was the place to prove themselves. The place to be. And so they flew across the Pacific, got lei'd, and found rides north. Through the pineapple fields. Into the dirt and rats.

And when they arrived they would see the Hawaiians in the lineups. Riding the giants like they were born for it because they were born for it. They were born breathing that air, having it running through their historic blood. And even though it was a San Diegan by way of Manhattan Beach that first paddled out, the Hawaiians took up the mantle. They rode Waimea, Pipeline, and Sunset with flair and style. They were so damned stylish. They would ride the waves like loose-limbed dancers. They would get barreled and spit out and had long brown hair and dark brown skin and looked like the times. Like marijuana smoke.

A few contests started toward the end of the 1960s and the money wasn't great. It wasn't, in fact, about the money. It was bragging rights. It was who could surf those waves the best. Who could surf them with the greatest fluidity.

And then in the early 1970s an explosion of brash Australians came roaring in like Huns. Unwashed convicts. They went out and tore through the North Shore and rode it all, each tall-tale wave, on every type of day. All the big days and the messy days and the victory-at-sea days and the most severe days. They didn't ride like the Hawaiians. There was no fluidity and even though they smoked much they did not surf like marijuana smoke. Their style was, instead, harsh. They would carve. They would make vertical slashes on

the waves. They would hack and lacerate. They surfed brutally. They didn't flow with the waves but rather tried to destroy them. It was a radical approach, a very different approach, and one that resonated in the magazines. These Australians were hungry, starving. Poor kids from a different continent hell-bent on proving themselves. There was no such thing as a "professional surfer" then but they had the notion that if they could become famous, if they could win the contests and own all coverage in the magazines, then maybe they could make a living out of the thing they loved more than any other.

And so after that first 1974 season on the North Shore they went home, to Australia, and planned to come back the next year and enter those contests, and more than enter, win. The contests were reserved mainly for the Hawaiians. Only a few wildcard slots were available for each, and so they wrote letters to the contest directors. They pleaded their cases and said that the surf world would be enhanced by their inclusion.

When they came back in 1975 they were invited into the contests. Among them was Wayne "Rabbit" Bartholomew but he was called "Bugs," because one nickname is never enough for Australians. Rabbit was brash and stylish and amazing. He would dress like Mick Jagger and strut around because he wanted to be more than famous. He wanted to be a rock star. Shaun Tomson and his cousin Michael Tomson, who were from South Africa, also came. Shaun was quieter but surfed very well. He was the benchmark of style and very naturally handsome. Michael was a good time and is still a good time. I was out with him recently and between the heavy South African bru bru accent and the booze I could not make out a word he was saying. But he was having fun and so was I. Mark Richards, from Australia, was the most professional. He won more contests but kept a low-profile. Ian Cairns was big and from Aus-

tralia. His pride came from riding giant Waimea and Sunset like he would ride a three-foot wave back home. And in 1975 not only were they invited into the contests, they won everything. They won the contests at Waimea, Pipeline, and Sunset. They were walking among the gods.

Afterward they went home to Australia and South Africa feeling high. They felt every ounce of their victories, of their rewriting the way surfing is done on the North Shore, of their chest-thumping bravado. They gave ridiculously enthusiastic interviews. Rabbit was given the nickname "Muhammad Bugs" after the great Muhammad Ali and posed in *Surfer* wearing a boxing robe with index fingers raised high. He was number one. He also wrote an article in *Surfer* titled "Bustin' Down the Door" and in it he claimed that they, this group, had came to Hawaii and conquered. That not only were they the best, they were the future. Ian Cairns gave an interview where he said, "We seem to be able to push ourselves harder than the Hawaiians do. Our surfing, as a group, has improved outrageously; whereas theirs, as a group, has stagnated." Ian Cairns also wrote an article, under the name of a fellow Australian surfer, that claimed "Aloha Is Dead." That was the title of the article. And these magazines found their way back to the North Shore between 1975 and 1976. And the Hawaiians were furious. And Eddie Rothman was furious.

The next winter of 1976 these same Australians came back for the third time. Rabbit Bartholomew landed, as usual, in Honolulu and got a ride north, as usual. He checked Sunset and saw it was a good day and so paddled out. As soon as he reached to the lineup it cleared. Everyone paddled in. He could not believe his good luck. Not only would he be able to surf perfect Sunset fresh off of the plane, he would be able to surf it alone. He would be able to put on a

clinic. Then he looked to the beach. He saw men, big men, Hawaiian men, pulling longboards from under a house. He saw a line of men standing on the shore and he wondered what was happening.

A few Hawaiians paddled out to him, one from the left, the other from the right. And they paddled up and he watched them come and then they asked if he was Rabbit Bartholomew. He knew something was going to happen and this was it. There was no running in the middle of the ocean. No hiding. He answered that he was and they cracked him like he had never been cracked before. He thought he was going to die. He blacked out and they slapped him awake and they made him swim to shore. When he got there, the line of men was waiting for him. They were all wearing black shorts. And he got slapped in the head. He had been officially introduced to the Black Shorts. To Da Hui O He'e Nalu, which in English means "the club of wave sliders."

Eddie Rothman, one of the founders of Da Hui, had been furious about the disrespect. He was not a professional surfer himself. He surfed for passion and for love. His external identity was one of intimidation but first and foremost Eddie was a surfer. He lived his whole life to surf, which is why he came to the North Shore in the first place and not to Coeur d'Alene, Idaho. But the Australian brazenness was too much and as a man of action he acted. He, along with others, founded a group that would protect what they loved. That would throw the bravado back into the faces of these Australians. That would make them shut their goddamn mouths. He calls Da Hui, simply, "da club." "Brah, we founded da club because all da influx of people. And we wanted . . ." He pauses. Thinks. "Da local people were just getting pushed out of da North Shore left and right, you know? And it seemed like da new guys . . ." He pauses again. Looking for the right sentiment. "There was just no respect." Re-

spect. The greatly valued respect. Respect gets spoken of much on the North Shore. Every visiting surfer is in perpetual limbo making sure they are giving proper respect but also getting it, if they hope to excel. Respect is shown by speaking to the right people or not speaking to them. By making eye contact or not making eye contact. By taking off shoes before entering homes. By not entering homes. Respect is the currency of the North Shore and it is a fluctuating currency that depends on the person and the situation and the way the person is feeling.

Most Hawaiians feel regularly disrespected. Historically disrespected. Their land, they feel, was stolen from them by the United States of America. Their royals embarrassed. Their culture trashed. Their language banned. And this new crop of young Australians claiming that aloha was dead? That the Hawaiians couldn't surf progressively? It was too much. And so Eddie and Da Hui forced respect on them. Enough had been enough.

Eddie continues, "Everybody in da world wants to come here. It's like, I seen Gerry Lopez get burned how many times? Get hurt by some fucken foreign kook?" Eddie means "mainlander" when he uses "foreign." "And he's walking around with a colostomy bag because of it and I'm like, 'What da fuck? Dis is fucked.' You know, one of da best Pipeline riders of all time, Gerry Lopez, and here is some fuck taking off on him. What da fuck is dat about?" Apparently Gerry Lopez had been burned and hurt and forced to wear a colostomy bag. I had never heard this episode. Eddie pauses again, genuinely perplexed. Caught up in the moments of thirty years ago that set his course to this day. Gerry Lopez is, indeed, one of the best Pipeline riders of all time. His nickname is even Mr. Pipeline. He was born and raised in Honolulu but moved to the North Shore in his early teens and mastered Pipeline. His fluid style, gorgeous style,

is still emulated today. Seeing Gerry, Mr. Pipeline, get burned and
hurt was an injustice tacked onto all the other injustices. To injus-
tices stemming back to Captain Cook's "discovery."

And so, enough being enough. And so, the club. "When we
started da club we would, like, start at V-Land and surf each spot
when it was good and make sure sometimes dat nobody caught a
wave except for da local people. Just so da foreigners would know
dat other people were here." V-Land, Velzyland, is just to the north
of Backyards.

Da Hui would paddle out and they would punish those who dis-
played any sort of disrespect. They would crack and slap and punish
and the legend of the Black Shorts spread. It scared traveling surfers
and made Hawaiians proud. Respect. I ask Eddie what he thinks
of the *Bustin' Down the Door* business and he catches fire. "Bustin
down da door? Dey didn't bust down no fucken door. Dey didn't
bust down shit. There was no fucken door to bust down." And then
he launches into a screed about how Shaun Tomson acts effemi-
nately. I think, again, about my pink button-up and I wonder, again,
what Eddie thinks of it.

Soon Da Hui began paddling out during the contests and the
contest directors would hire them as "security." A fine line between
"security" and a "payoff." The feds became involved and tried to
prosecute Eddie and Squiddy, the founders, as criminal conspira-
tors and promoters of dangerous drugs but nothing came of it. They
were acquitted by a jury of their Hawaiian peers. What was the fed-
eral government going to do on the North Shore, anyhow? It is a
Wild West island that floats too far away from Washington, DC. It
is too hard a nut to crack.

The lineups through the 1970s and 1980s were owned by Da Hui.
Sometimes traveling surfers would forget their lessons, their re-

spect, and Da Hui would flare up and remind everyone what was what and who was who. There would be brawls and heavy physical punishment. They would take money from the brands so that their surfers could come and surf. They would take money from the brands so that they could run their contests. A fine line.

Legal problems and other, younger groups of Hawaiian surfers like the Wolf Pak (tattooed on Kala Alexander's knuckles) have changed the exact nature of Da Hui today. But their legend exists in the pantheon and Eddie Rothman exists beyond legend. I ask him if he feels that the North Shore has lost the localized justice that Da Hui brought even though I know it hasn't. Even though I know that every mainland, Australian, South African, European surfer moves in perpetual fear of crossing him or a handful of others. And he shakes his head slowly, sadly. "You go to Brazil now and dey have beaches where, right here is da line." And he slices a reddish-brown finger scarred with teeth through the air. "Maybe da beach is fifty yards long. Dat's the place. And da next fifty yards belongs to da other guys and dey don't pass dat fucken line or dey fight. And there's no foreigners. There's none. Dey don't have to deal with dat. Their localism is right there with themselves. There are no cops telling no one, 'You can't do dis, or you can't do dat,' whining fucken . . . so you know . . ." and he becomes wistful. "You know what? It's a fucken joke. Like Waimea. I tell my kids, 'Don't even go out and surf. There's a million fucken kooks in da water and my kids are trying to get in da barrel and guys, kooks, on da shoulder sitting on twelve-foot boards just dropping in on dem and fucken eating it and shit. What do you do? It's fucken stupid. One of my lifeguard friends told me he had dis South American guy dat he rescued with a Jet Ski out at Waimea and about an hour later da guy wants to paddle back out. My friend tells da guy, 'No. You're not going back out.' And da

guy is like, 'Why?' And my friend says, 'What do you think I am? Your personal fucken rescue guy? You get in trouble and I come rescue you on da Jet Ski? Fuck you. You're not going out.' And my friend stood on his board. Stood right on his board. I want my kids to surf and have a good time but sometimes it doesn't happen. Look at it." He is talking about the crowds. The endless crowds.

But still. I have been coming here for many years and I don't know anyone, anyone, who would dare drop in on a Rothman, or any Hawaiian for that matter. And if they do it accidentally—if they do it unconsciously—there will be a swift reminder. There will be a crack. Their face will be bloodied. Every day surfers get pointed to the shore. Every day they paddle in and waiting for them is a Hawaiian who will dish out the consequence of taking waves from another Hawaiian.

I tell Eddie that people are beyond scared of him. That surfers walk around literally shaking. And he looks through me slowly. And speaks slowly. "I don't know where anyone gets that impression. I don't want to be fucken scary. I don't want fucken kids to be scared of me. I want to be a jester. I want to make jokes."

I don't know if he wants to be a jester. But his reputation, his work, has gotten him on the fed's radar and he doesn't like to be on the fed's radar. He is smart enough to know to keep a low profile and he has done enough to necessitate a low profile. "Racketeering laws. Dat's how dey brought down all da mafia. And Obama just passed all these terrorist laws," he says.

When Eddie was not policing the North Shore, *is* not policing the North Shore, when he was and is not slapping the disrespectful foreign hordes, he was collecting money for a man in Mexico, not elaborating on where this money came from or what it was for. This is not his business anymore but it was. "There was dis guy in Cabo

and we would fly around and collect his money. In those days as long as you didn't ask where da money came from, it wasn't illegal to collect it. So we would fly around and collect and get to keep half of what we collected. Everybody says I was selling drugs but who was I going to sell it to? My friends? Yeah right. There were people on da North Shore selling drugs, though, and I would fucken take their money sometimes." And he laughs his low rolling laugh.

So he flew around and added to the collection of teeth in his knuckles and collected money. "I'd pay taxes on dat money I collected too," he says. Real taxes, not underworld ones. And then in 1987 "collection" turned into "extortion." And the police came crawling.

He remembers the day. He was home. Not this home where we sit now but a home a few blocks up the beach, and he saw the cop cars roll up in front of the wrong house. But he knew it was coming. He knew he was a marked man. And when they discovered their mistake and came to his house he was waiting. They grabbed him and took him to Honolulu.

Makua also remembers that day. He says it's his first memory when I speak with him later, gazing over Pipeline breaking huge. His voice is that surprisingly high iconic Hawaiian inflection. "My first real memory of the North Shore is when the cops came and raided our house to take my dad away. They were fucken sticking shotguns in my fucken head and all that shit. My mom was naked and they were throwing her all around. Broke my fucken front door right off. Yeah. I'll never forget the gun near my head or wherever it was but it was fucken pretty traumatic, brah. That's my first experience, my first memory on the North Shore." Makua was three years old.

Eddie got taken to Honolulu and thrown in jail with bail set at

$5 million, which was much higher than it might have been. And he was charged with everything. With criminal conspiracy and extortion and two degrees of promoting dangerous drugs. A heavy run and if convicted he was staring at twenty-five years. They wanted him gone. They wanted him away.

He might admit to the extortion charge. "Maybe," he says, "maaaaaaaybe," drawing out the vowel, "if dey would have just got me on da extortion or racketeering I would have been convicted. Dey would have got me for ten years and I would have served three and a half but da corrupt fuckers wanted more den dat. Dey were going for everything. Dey had busted some limo driver who had drugs and he said dey were mine so dey built da case around dat fucken bullshit. Da racketeering shit, I mean, I have friends in jail for racketeering. Dey shot a bunch of people on da golf course, yeah? But dat was self-defense but dey still got busted for racketeering."

Eddie was in jail for seven months while the trial first started and the whole thing took around three years to finish with an acquittal on all charges. Eddie claims that there was blowback against the office of narcotics. "Da whole office of narcotics doesn't exist in Hawaii anymore because of my case. Dey don't claim it because dey don't want to look like fucken losers but it's true." I wasn't able to confirm actual changes in the office of narcotics but the deputy prosecuting attorney and chief of the narcotics division, Gary Modafferi, was arrested ten years later and charged with distribution of crystal methamphetamine—ice—to a government informant. Eddie Rothman is also smart. He is savvy. He knows what he is doing and is able to play the game because he has a fantastic gut instinct.

When it was done he moved back to the North Shore and built his house at Backyards. Where we sit now. Though he did almost get put back in jail for flipping the cops off when he was on the stand.

Today he claims that he wants to be a jester and that he is involved in real estate and that he doesn't rule the North Shore. He is smart enough not to want attention even in this day and age of reality celebrity. It is why he is real and why he causes so much fear on the North Shore. He does not grandstand or posture. He acts.

He called me, after I spent the morning in his house, and told me that Jaws, a famously chunky wave that breaks off of Maui's north shore, is really a soft, easy wave. That it only looks big because all the photos of it are from a cliff and if they showed it from the water it would look soft. In reality Jaws is a beast. It is a mutant. But Eddie wanted it denigrated because it is on Maui and not his North Shore. I told Eddie I would write a story about it, trying to claw out of his pocket, and later called one of the most famous photo editors in the world, Pete Taras, and asked him if Jaws was soft. He laughed and said, "Hell no." I said, "Eddie called and told me it was a soft wave and only looks heavy because all the pictures of it are from up on the cliff." Pete instantly stopped laughing and responded, "Hey, if Eddie says it is a soft wave, then it is a soft wave." If Eddie said the world was flat then every surfer would agree.

His phone rings. It is old and battered and he flips it open and squints at the screen trying to make out who is calling. I had called him earlier, after he had called me, while I was driving to his house, and his voice message said, "I don't have a phone right now because I broke it and it felt good. And, uh, so I don't have one right now. So if you want me to call you back you gotta leave your phone number. Because I don't have a phone and I'm gonna get a new one but it's not gonna have anybody's number in it cuz I smashed it to pieces. Hah. So, give your number if you want me to call you back. Aloha." Studying his phone it seems this might be a regular occurrence.

And while I am studying and while he is squinting, a midtwen-

ties woman carrying groceries enters the front door and the living room. Eddie looks up at her from his phone and says, "Ahh, yeah. I have three sons and one daughter . . ." The woman coos, slightly, while setting the groceries down on the kitchen counter and then comes over to Eddie and sits on his lap and says, "Hi, Daddy." It seems so strange but whatever. This is the North Shore and there are different rules and I question very little of what I see. I say, "Man, I didn't know you had three sons and you have a daughter too?" She giggles and Eddie says, "No. She is my girlfriend." And I fidget in my seat. Eddie looks at his girlfriend and says, "I think Chas was just leaving." And so I get up and let myself out his door, past the pit bulls, smacking the blue one with the wide head once more, and gather my shoes at the bottom of the outside stairs. But before I leave entirely Eddie leans over the railing and says, "Where are you going now, brah?" and I tell him, "The Target house." And I am very curious so ask, "What do you think about Target on the North Shore?" Eddie who has seen it all. Eddie who has been involved in every aspect of this shore since he stole enough money from a long-horned Texan to come here. And now from the days of Quonset huts and pineapple fields and dirt and spiders to multibillion-dollar department stores renting houses on the sand for million-dollar team riders. He thinks for a moment. "Target? Yeah. Dat's all right. Do you know those guys?" I tell him that I do and he says, "Ask dem if dey want to sponsor the Shootout." The way he says "ask dem" means tell them they are sponsoring the Backdoor Shootout. Amazing. I leave through the brown gate. Back onto the small alley. Back. Breathing. Sucking in the fine mist of salty, humid air and of the North Shore myth/reality. I feel exhilarated, even though I should feel bad because this is exactly what I did not want for my new life. A relationship with Eddie is a relationship with trouble is a

relationship with danger and tenebrism. Eddie, the man, is a key to the North Shore but what does this key open? A true understanding of it? An honest feeling as to what it all means? I don't know. I am now Chas Marlow being consumed by ambiguity. The horror, the horror, brah.

Yes, Eddie came. He surfed. He fought. He went completely native and now his specter grips seven of the most miraculous miles on earth. He may well be walking evil and stories are whispered everywhere of his evil. He is a boogeyman. His name causes trembling. Everywhere. But there is so much more and no one can judge Eddie Rothman as he or she would an ordinary man. Maybe his soul is mad but he loves the North Shore, deeply loves it. He loves the people who live here, the "local people" as he always calls them. He loves the flora. He loves the way it smells and feels. He loves the surf, each and every wave. He, from Philadelphia and Jewish. He who doesn't speak good. And however dirty his hands are, he genuinely gives back. Each winter season the brands hire almost every able-bodied and willing North Shore local to run security. Jobs that help cover the expenses of the year for the locals. He demands that the contests have at least five times the amount of local wildcards that the other contests have. A top-tier contest in France, say, may have three or four French surfers. The contests in Hawaii, all considered, will have no fewer than twenty Hawaiians and often many more. This does not include the Hawaiians already on the tour. These are simply the wildcards. And their contest money definitely covers the expenses of the year. Surfers don't have to win to get paid. Simply being in the contests equals a few thousand dollars. But the Hawaiians usually do win, at least a few rounds, and their earnings grow from round to round and their families are fed.

The water is safer because of Eddie. The specter of getting a Black

Short pounding looms so large that those who don't belong usually smell it and don't paddle out. And when waves are breaking that big and that deadly it is actually a service to their lives. Pipeline, as described, breaks in a few feet of water. A giant lip, hundreds of thousands of pounds of pressure smashing into water the depth of a kiddie pool. And even though Pipeline is the deadliest wave in the world, fatalities are not nearly as common as they could be, should be, because of the fear—and not necessarily the fear of the wave but the fear of Eddie. The fear of what Eddie represents.

The gap between rich and poor is rapidly, and rudely, expanding around the globe. The wealthiest are, for the most part, unchecked in their acquisition of resources. And the poor are slipping into an impossibly desperate position. But on the North Shore those rules, and that particular hierarchy, fly out the window into a plumeria- and sometimes rot-scented night. The locals, usually poor, have the waves, and the executives, always rich, get slapped in their homes— even as the rights given to corporations have never been greater. Corporations, as the Supreme Court recently ruled, are people. Corporations can give unfettered "independent expenditures" to politicians, virtually guaranteeing passage of favorable laws and a skewering of our very national fabric. Corporations are becoming more powerful at the expense of the individual. But, no, not on the North Shore. Corporate and political power is meaningless where a small number of very tough individuals hold all the cards through use of intimidation and violence. But I will take intimidation and violence from a man I can see rather than from some business idea any day of the week. Yes, on the North Shore Target will likely end up sponsoring an event it has no self-interest in sponsoring because Eddie tells them that is what they will do. Amazing. Fast Eddie Rothman is a modern Robin Hood. An old-fashioned Colonel

Kurtz with stories of his beatings and trouble and pain dancing all over this island instead of mere decapitated heads on posts around his house.

I drive back toward Pipeline with ringing ears and a heart on fire. Ringing because Eddie's words, and the very fact that he is so "other" yet so "human," mingle with a Beyoncé dance remix that is pouring out of my white convertible's speakers into the colder-than-it-should-be air. European dance pop. But that is my North Shore style. Pink button-ups, grey skinny jeans, European dance pop mixed with Top 40. White convertible, the top perpetually down. Whatever. If I am going to get cracked I am going to get cracked being me. Not effeminate, mind you, but flamboyant. And I will feel good about that.

The rain is still falling, lightly, and my heart is on fire because it loves being where it is not supposed to be, like Hezbollah turf, like Eddie Rothman's kitchen. It is exhilarating, it is adventure, and I cannot stop. I am addicted. I am fucking addicted.

The real trouble here is that Eddie is very possessive of his story. He told me that the producer Brian Grazer sat in his living room and wanted to do his life's story. Eddie claimed that he laughed him off. And, to me, Eddie's guttural laugh would be twice as scary as anything Harvey Weinstein could throw.

And Eddie will feel I sold him out, Joan Didion–ish, and he will be right in some ways but here is the truth. I can tell Eddie Rothman's story better than Brian fucking Grazer. I can tell Eddie Rothman's story better than anyone. I understand it in all of its cinematic, panoramic sweep because his story is so deliciously Trash Prose. Tawdry, violent, expletive-laced, superwildly awesome. It is a story that needs telling because the United States of America needs the likes of Eddie Rothman like it hasn't since

slave-owner-fighting wild man John Brown. This country needs another folk hero and it may as well be the man bringing Billabong, Target, Nike, and Red Bull to their knees. The Robin Hood of the North Shore. Or maybe he is simply one bad man and this whole place is evil, indeed, hell. I ain't seeing clearly. Maybe that is Eddie's point. Or maybe he doesn't have a point, which would be the scariest/best of all. Maybe he is just trying to be him, baby. Alo-fucking-ha.

Girls, We Run This Motherfucker.
Or, a Wander and an Explanation.

drive past Ted's into the Chevron. I need a pack of Parliament Lights to clear the fuzz even though Parliament Lights don't work nearly as well as Camel Reds. I park and walk through the door, pushing past a strung-out moke with dirty white socks shoved through slippahs and wearing a fluorescent green T-shirt, into the bright gaze of transvestite love. I see twenty-year-old Oliver Kurtz, no relation to the good Colonel, in line buying a bar of Hershey's white chocolate cookies 'n' cream. Ollie is a classically out-of-place feature on the North Shore. He is a stylish surfer from Florida with ridiculous blonde hair that points only up and out. He wears dingy grey pants cuffed mid calf and a loose tank top and pink girl's slippahs three sizes too small even though he is tall and broad. He reads *Vogue* and *Cosmopolitan*. His brother is a DJ. But, still, his sponsors demand that he come here every winter. This is the place to see and be seen and get coverage in the magazines and those surfers who are too timid or weak to put their time in will quickly get dropped. Ollie is not rich. He makes, he claims, five figures a year and a small travel stipend. And he won't get rich because he doesn't compete regularly but who knows? Surfing is still oddly democratic or at least meritocratic. Ollie has a progres-

sive air repertoire, which goes further today than any other kind
of surfing.

The North Shore is most famous for heaving barrels but it also has
a handful of sexy air waves. That is to say waves that provide the
right sort of dynamic for aerial surfing. The most popular, on the
North Shore, is Rocky Point along with its brother and sister Rocky
Lefts and Rocky Rights. They each have nice ramping sections and
good wind so the progressive youth, that is the kids who love to do
airs on a surfboard above all else, can speed down the line and then
fly and grab their board with their front hand near the front of the
board on the toe side (a slob grab). With their front hand in the
middle of the board on the toe side (an indy grab). With their front
hand near the front of the board on the heel side (a lien grab). With
their rear hand near the toe side of their back foot (a mute grab),
etc. Aerial surfing is all the rage, borrowing both terminology and
maneuvers from skateboarding. Aerial surfing is what makes up
70 percent of magazine photographs. And Ollie is progressively
aerial, stylish, and out of place because of where he is from, how he
looks, and how he acts.

I slide in line behind him and ask him for the news cruising along
the coconut wireless. He tells me, "Pipeline is pumping right now.
The contest is on and it's firing. And Cheeseburger is snapping at
everybody down at Rockies." The same Cheeseburger that choked
out the mainland kid. "He is wanting to fight every surfer from the
East Coast. Just snapping." I ask if Cheeseburger slapped him and
he responds sheepishly, "Yeah," while looking down.

He also told me that most of the surfboards from the Hurley house
and the O'Neill house had been stolen. Stolen surfboards are not big
news. Reports of theft are, in fact, completely regular North Shore
news. But Cheeseburger losing it on East Coast surfers is mildly

amusing. Ollie shakes his head. "I hate this fucking place." Such a common sentiment for those forced into the circles of hell. Forced to interact in a culture that doesn't suit them. Again, surf culture outside of Hawaii is socially complex but not difficult to navigate for the initiated. And there is rarely any sort of physical reprisal for getting out of line. There is only a sort of tsk-tsk scolding or backstabbing. But here it is all menace and the surfers respond. The previous night, at the Surfer Bar, after I had talked with Joe G. and before Eddie Rothman reminded me of the "fucking Jew" incident, I had seen an amazing South African surfer who, like everyone else, is also forced to interact in this alien land. He told me something so damning that I cannot, in good conscious, name him. He said with a twinkle in his eye that he was going to bomb the Pipeline reef. "Bru, I know all these South African special forces guys and they do all this underwater demolition and I am going to fly them out here and we will scuba dive at night and plant TNT on the section of the reef at Pipeline, that end section, and blow the shit out of it. We will wreck Pipeline, bru, and then all these North Shore monkeys won't have anything anymore. We will take away the only fucking thing that they have." He threw his head back and laughed at the thought.

If Pipeline's reef were ever destroyed it would devastate not only the North Shore, but the surf community as well. It is our icon, our measure, our Holy Land. And all of the other waves on the North Shore, however glorious, however historical, however iconic, bow before the Pipeline. Though many surfers and surf industry participants would also smile through crocodile tears and be eternally pleased that they never have to set foot on the North Shore again. That the damned island within an island could rot without outside interference. The locals would kill each other in *Lord of the Flies* fashion or maybe, who knows, would all turn into hippies. What-

ever they did nobody would know because nobody would look be-
cause, without Pipeline, there would be no reason.

But, for me, again, this black loathing, this destructive hatred of
a place combined with a magnetic compulsion to return each and
every winter, is gold. The North Shore is so hated, passionately, and
so loved, greatly, in equal measure. This brings on a madness. It is
a madness that I feel every time I get off the plane in Honolulu and
it is a madness that abates only when I have been on the mainland
for more than three days. But madness is something. Madness is
adventure. T. E. Lawrence was mad when he wanted to ride across
the Sun's Anvil for Aqaba. Indiana Jones was mad when he infil-
trated the Nazi's Egyptian archaeological dig to get the Staff of Ra.
Uncle Dave was mad crossing the Khyber pass with mules, Stinger
missiles, and Ollie North's blessing. I am mad, every winter, on the
North Shore. And being mad is amazing. It far outshines comfort-
driving toward existential boredom. The North Shore will never be
boring. It will always be an adventure.

Ollie Kurtz asks me, before he leaves, if I have any news and
I tell him that I just spent the morning with Eddie. His eyes go
round. "Whaaat? What in the world were you doing? Did he tell
you about the Billabong house?" I tell him that he did and also
showed me a video of Makua pounding T.J. Ollie can't believe this
coconut-wireless gem. "Whoa." He even stops in the door, un-
affected by the transvestite's longing gaze, soaking in the news.
"Fuuuuuck. How'd you do that?" I tell him that I am older than he,
and wiser, and someday if he stays the course he can be just like
me. He smiles, then says, "And Pipeline is cracking. I think Kolohe
is almost in the water and it is the biggest Pipe I have ever seen.
Kid's gotta be shitting himself. What a fucking morning!" I agree
and go back to my car. It is time to watch some surf contest. It is
time to watch Kolohe Andino.

Kamehameha's traffic comes to a compete stop half a mile from the contest site and I don't feel like sitting it out and so I pull onto the grassy shoulder and park in a giant puddle and hop out without opening the door right like Tom Selleck. The North Shore is truly country so cars can be parked virtually anywhere with little fear of towing. Towing is for town. And I cross through some island scrub to the Ke Nui and begin walking toward Pipeline. The Ke Nui, too, is crowded with kids on bikes and skateboards and tourists holding beach chairs and the surf fan and the stray methamphetamine addict. All making their way toward the event. Word has gone out. Biggest Pipeline opening day ever. Solid twenty-five feet, probably non-Hawaiian. And the genuinely knowledgeable walk shoulder to shoulder with the sadistic voyeurs.

There are so many characters on the North Shore during the season. It is Cannes during the film festival. It is Hollywood Boulevard during the Academy Awards. Every character has a story and most know each other. When I walk around Foodland, the event site, the Ke Nui, Hale'iwa, I hear my name said one thousand times in many accents. "Hey, Chas," "Hi, Chas," "Ho, Chas," "Chaaaaaaaasssss . . ." Every character is here for a reason and they give the North Shore its texture.

I pass a fat moke kid with a dirty face pushing a bicycle with a flat front tire. He is wearing last year's contest T-shirt and it is tattered. He looks at me and is maybe twelve years old and says, "What da fuck you look at haole?" And I tell him to fuck off and hope that he doesn't have a notorious father.

Surf contests are so strange. They are more like test-match cricket than anything else. They take days to finish and are often boring but the flourishes, the rapid exchanges between two good surfers in great waves, may be the best spectacle in any sport. Even better than test-match cricket.

The top tier of competitive surfing is the Association of Surfing Professionals' World Tour, the ASP. It consists of between eleven and twelve events that take place around the globe during the year. The first stop is always on Australia's Gold Coast, moving to Australia's Bells Beach, which is near Melbourne. That is set in stone. And then it can change slightly. This year it moved to Brazil's Rio de Janeiro, South Africa's Jeffreys Bay, Tahiti's Teahupo'o, New York's Long Island, Southern California's Trestles, which is near San Clemente, France's southwest coast, Portugal's Peniche, which is near Lisbon, Northern California's San Francisco, and then Oahu's Banzai Pipeline. The tour always ends at Pipeline.

I pass an eager, young associate editor for *Surfer*. He has just come out of his house, where he is staying, and is juggling a camera and a notepad. His sunglasses fall off of his head and he stoops down to pick them up and then sees me and says, "Chas! Are you heading down to Pipe? I heard it is pumping!" I tell him that I am and we make small talk for a minute. I tell him, too, that I was just hanging out with Eddie just to leave him with something to chew on. Trying to lace my own myth/reality into the North Shore narrative. "With Eddie? Rothman? Fuck!" He asks if I had heard about the Billabong house beating and I tell him that yes I had. His eyes go round like Ollie's. "What the fuck! That was crazy! I heard that Eddie was involved or something!" He is eager, too eager. The eagerness will be slapped out of him soon or choked out of him.

Each event has a title sponsor and the title sponsors for all the World Tour stops are split among just six of the many surf brands: Quiksilver, Billabong, Rip Curl, Hurley, Volcom, and O'Neill.

Hurley, which is owned by Nike, which also just launched its own surf imprint, Nike Surf (which almost as quickly shuttered because it was awful), is the one that matters. Title sponsorship matters so

much, in fact, that a few years ago Jordy Smith, a broad South African with very small nipples that are laughably close together, was the hottest up-and-coming surfer. And all the brands were courting Jordy because his contract with Billabong had expired. Nike courted him and flew him to Portland, Oregon, and made him a rich offer and told him that they would make him the Michael Jordan of surf. His full name is even Jordan Michael Smith. But he turned them down because they didn't sponsor any events and he thought this would be held against him when he started competing. Also Nike is not "core" to the surf community and "core" mattered very much to him. He is South African and sensitive.

In truth the professional surfing system seems ripe for corruption. How does a Rip Curl surfer, for example, not get scored better at a Rip Curl event? And it probably is corrupt but nobody really cares because that is just the way it works and that is just the way it has always worked. Nobody really cares except Eddie Rothman and most Hawaiians, who feel robbed and raped by the brands.

I continue to walk and pass two of the Gudauskas brothers. The third will be surfing in the event later today. The Gudauskases, called the Gu-dangs by most, are an anomaly because they are always outwardly happy when they are in Hawaii. They are from San Clemente, California, and are as white as snow. Literally as snow. And their blonde hair is almost blinding. They are perpetually happy about everything and happy to surf anything. They love to come to Hawaii even though their haole-ness is almost oppressive. They are headed to watch their brother and then they are going to surf Sunset. I honestly don't know how they don't get pounded just for being snow, blinding, and always happy. Maybe they have found the kryptonite. Maybe.

On the World Tour, thirty-two surfers compete against each other

at each event and earn points depending on their placement in the events. The surfer with the most points wins the World Title. Kelly Slater has won it eleven times, which is unheard of in any sport. He is supernaturally possessed and very sensitive. Whenever I ask to speak with him he initially tells me, "No, because you will just make fun of what I wear and write that I'm not sexy enough," which is not true because he is a very handsome man, though he does have a penchant for baggier-than-appropriate denim. After three or four attempts he consents to speak with me and usually speaks openly and honestly but also tries to hypnotize me with his blue blue eyes. He is possessed. But nevertheless, he is the champion and a good champion and a handsome champion. He is unbeatable even at forty. And so for the past decade-plus most surfers on tour shoot for a top-ten finish. A top-ten finish makes the sponsors happy. A middle-of-the-pack finish means the surfer will be allowed to compete on next year's World Tour. A bottom finish means he will be dropped off and have to surf Qualifying Series events.

I pass J-Fred, who looks like he has been up for four nights in a row and is blabbering about losing his wallet and something else I can't understand. He is notoriously fighty and once took on an entire club in Bali. As in, he was fighting every able-bodied man in the club at the same time. I had to interview him once and his girlfriend sat in on it and tried to stop him from saying anything incriminating. It was funny and annoying.

The WQS is the World Qualifying Series and there are many many QS events around the globe each year. They take place everywhere. From Peru to China to Japan to Northern Ireland to the Canary Islands to Brazil. There are many WQS events in Brazil. They each carry a certain amount of stars, from one to six, and the more stars they carry the more points a surfer can earn and the faster he can

land himself on the World Tour. QS events are usually by population centers and in not very good waves, the prize money is not great, and the schedule is grueling so, once qualified for the World Tour, surfers hope to keep off the QS—it's a genuine shit show. Though the top pros will usually surf the six-star-rated events and also surf the Primes, which are the best of the non–World Tour contests.

I pass Michael Oblowitz, a filmmaker who has made a film called *Sea of Darkness* that he refuses to release. It is about the discovery of G-Land by the surfers and the cocaine and the heroin and the jails and later the founding of Quiksilver. But he only screens it at small festivals and for people he knows. He says it is too heavy to release. Too dangerous. He is worried about the blowback from the industry and more important from Hawaiian locals who were, and are, involved in the drug trade and he may be right but he also may be completely paranoid. He is from South Africa too, like Jordy, like Shaun and Michael Tomson, and used to make vampire soft-core porn for Showtime. He is currently making a movie on Sunny Garcia, who is a North Shore star from the 1980s. Sunny is very good friends with Jeremy Flores, the Jeremy Flores who choked out Sterling Spencer for making fun of him not signing an autograph. There is probably a twenty-year age gap between Sunny and Jeremy but they both love fighting and they both love choking others out.

On the North Shore, the Pipeline Masters is the only World Tour event, though the two events before, at Hale'iwa, which is a six-star, and Sunset Beach, which is a Prime, are surfed by all. The surfer with the best scores in all three wins the Triple Crown and the Triple Crown is held in high regard. The Triple Crown is, in fact, held almost as high as the World Title. The surfer who can master Hale'iwa, Sunset, and Pipeline enters the North Shore folklore, even if he is from Australia. Even if he is from Florida. The Triple Crown

always takes place in December. It brings Christmas cheer to an otherwise seasonless island.

I bump into Grenny. He is a surf agent. He has a small roster of surfers and he gets them deals from the brands and helps them with their travel and things of that nature. Grenny is in a bit of trouble right now because he is undercutting the other big agents in the game by charging a 10 percent fee instead of the customary 15 percent. But it is OK because his main competition, agent Blair Marlin, is in worse trouble for bringing Lindsay Lohan to the North Shore. Blair is a very kind man but makes decisions like a surfer, which is to say bad decisions. He claims that Lindsay wanted to see one of his stars, Julian Wilson, but in reality Blair spent most of the time with Lindsay. The two of them were photographed making eyes at each other while sitting on one of the house decks watching the event. Her purse would later get stolen from her Jeep and $10,000 in cash would get stolen from her purse.

The events that comprise the Triple Crown are held in a waiting period of either one week or ten days, depending on the spot. Surfing is dictated by nature. She has to provide the waves and if there are no waves then the surfing itself becomes an act of frustration. Of slopping around in gutless little ankle slappers in front of cheering Chinese. Or Northern Irish. Frustrating. And so contest organizers have either one week or ten days in which to hold the event. They will watch the swell forecasts. They will use science and try to determine the best time to start the contest and aim for a firecracker finish.

I push between two tourists from Canada who can't believe they are on the North Shore and can't believe they get to see the event. They are both in their midforties, male, and wearing maple leaf baseball hats and sports sandals. They clutch small GoPro cameras

Bruce Irons is our demigod. He is our rock 'n' roll. *(Damea Dorsey)*

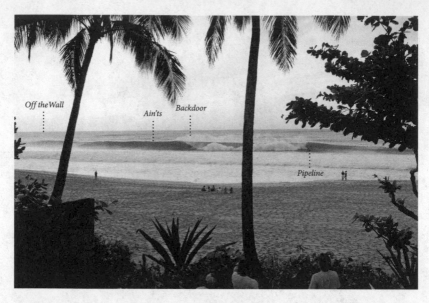

The theater with Pipeline breaking left, Backdoor breaking right, Ain'ts bubbling next to Backdoor, and Off the Wall peeking around the corner. *(Damea Dorsey)*

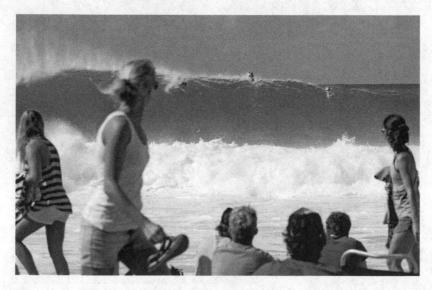

Locals and tourists alike cannot pull away from Mecca.
(Damea Dorsey)

The Volcom A-team house, also known as the "Gerry House." *(Derek Dunfee)*

Pipeline as seen from the deck of the Volcom A-team house. *(Derek Dunfee)*

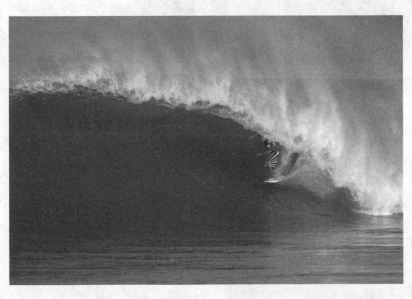

Andy Irons, here at Backdoor, surfing as he lived: raw. *(Damea Dorsey)*

Dustin Barca watches over the madness. *(Derek Dunfee)*

Surfing and drugs. A forever union. *(Derek Dunfee)*

Hamburger steak bowls and ebi rolls. The food order from the Volcom house is a thing of dietary wonder. *(Derek Dunfee)*

Bruce Irons defiantly scrawls over Kaiborg's orders. *(Derek Dunfee)*

Makua and Eddie Rothman looking happy and benign. Looks are always deceiving on the North Shore. *(Justin Jay)*

John John Florence is the young prince of the North Shore. *(Justin Jay)*

Kolohe Andino lives the high life. *(Justin Jay)*

Kai "Kaiborg" Garcia. *(Derek Dunfee)*

Kala Alexander stands in front of his gun. *(Derek Dunfee)*

The Volcom house deck is the place for insiders to be and outsiders to get cracked. *(Derek Dunfee)*

Tai Van Dyke in traditional Hawaiian postures. *(Derek Dunfee)*

in their sweaty hands and take little video clips of everything. The people walking. The island scrub. The houses. Their own sport sandals. Sport sandals are the worst things ever, equal to Crocs and Vibrams in the record books of hideous fashion. But their Canadian excitement is heartwarming so I forgive them their fashion blunder.

Surfers are judged, in the events, on a scale of one to ten by six judges. The judging criteria will shift depending on what a particular wave offers. The Quiksilver Pro on the Gold Coast, for example, will provide good scores for airs and good scores for barrels, because the wave at Snapper Rock provides both. The Hurley Pro at Trestles will provide great scores for airs because that is what Trestles is known for. And on the North Shore, barrels are the only real things judged. If a surfer paddles out at Pipeline and tears the wave apart—really carves and hits the lip and gouges and even throws a little slob, or some other skateboard-named air in, but doesn't slip into a barrel—he will be judged poorly and those on the beach will hoot in derision at his stupidity. Pipeline is a barrel. A gaping barrel. The best, most critical barrel in surfing.

I am finally close to the event and see Neil Ridgway out on the Ke Nui making a call. He looks over at me and says, very sarcastically, "Chas Smith." I say, "Hi, Neil!" while throwing a loose shaka and then he goes back to his call. He is wearing the most clownish sunglasses that I have ever seen. They don't fit his face well but they are far better than his European red beret.

In all the other events around the globe, surfers paddle out against each other in man-on-man heats. They can catch as many waves as they want and their two best are scored and the surfer with the best two-wave total moves on and on and on until he wins the finals and gets chaired up the beach and gets champagne sprayed in his face by the second-place surfer. Getting chaired up the beach is one of the

most embarrassing things in surfing. The victor's friends, usually countrymen, will meet him at the shoreline after his victory and they will prop him on their shoulders and move through the crowd to the podium. Two men carrying one man. And it might look OK except surf events never draw hundreds of thousands of people. They draw hundreds and sometimes thousands. It would look good if a surfer was being carried through an overflowing crowd of adoring fans, throwing roses and blowing kisses and uncontrollably weeping. But at surf events, when a surfer is getting chaired up the beach, sitting on his friends' shoulders, through spread-far-apart beach gawkers, it looks embarrassing. It looks like Christian rock 'n' roll.

I turn into the Ehukai Beach Park, throw another shaka at Dave Prodan, and hear him say, awkwardly, "G'day, Chas" with his Austral-American accent. Dave was half raised in Newport Beach, California, and half raised in Australia and so his accent is a mess. He is now the marketing director for the ASP. Not an enviable position here. And I check the heat draw posted on the large "Billabong Presents the Pipe Masters in Memory of Andy Irons" scaffolding.

Man-on-man heats is the norm for World Title events but on the North Shore the man-on-man format changes. At Hale'iwa and Sunset, surfers compete in four-man heats with the top two going through. At Pipeline they run staggered two-man heats, meaning four surfers are in the water at a time surfing in the man-on-man format. Two heats running at the same time. Hawaiians don't like contests. They get angry when their waves are off-limits because a surfer from Australia is battling a surfer from Florida. And so the contest organizers must run them as quickly as they can. And Eddie sits on his porch and chuckles and says, "Fucken bloodsuckers. Fucken corrupt bloodsuckers."

Eddie hates the ASP. He will curse it any chance he gets. He calls

them "bloodsuckers" and also "cocksuckers." He feels, deeply, that it is a system that serves surfers from California and Australia and punishes surfers from Tahiti, Hawaii, Brazil, and other nonwhite places. He will rant, without provocation, about "Fucken money equals stars and stars equals points. How many fucken organizations are run that way? It's a fucken joke. The ASP is a fucken joke." And what he means is that the brands that sponsor the biggest events can include surfers they want to see on the World Tour as wildcards . . . but I don't really know how that is an advantage because the wildcards usually lose in the first heat and never progress. Except in Hawaii.

Eddie, and others, demand that, here, a full eleven Hawaiians get to surf in the Pipeline Masters and even more Hawaiians in the Hale'iwa and Sunset Beach events. And these Hawaiians always progress. They are men who may have a stiff, statue-like approach to smaller waves in California, Australia, or Europe but on the North Shore, they are untouchable. They have been surfing these waves since they could walk. Being pushed into monsters by their fathers who were pushed into monsters by their fathers who were pushed into monsters by pride and a desire to get weird.

The pros will often grumble, quietly, about the Hawaiian wildcards. The bottom-pro tier is fighting to stay on the tour and they must come to the North Shore and surf terrifying waves and surf them against locals who know every secret of the reef. They lose. And drop off tour and have to go back to Northern Ireland, or Brazil, on the QS circuit and they grumble about fairness. Quietly. They don't want a crack alongside their upcoming Northern Ireland misadventure.

I look at the names and see Marcus Hickman, Kekoa Bacalso, Evan Valiere, Kai Barger, Aamion Goodwin, Shane Dorian, Mason

Ho, Hank Gaskell, and Bruce Irons. All Hawaiian wildcards. And I look and see that Kolohe Andino is surfing in heat number nine and John John Florence is surfing later in the morning. The event is already into heat eight. And this is it. Kolohe versus John John. This is a giant clash, the results of which will bring hoots and maybe a riot.

In this first round they are not surfing against each other but that doesn't matter. They each represent much more. They each represent the future of surfing and on the North Shore, the future of surfing is the only future that matters. Presidents come and go. Regimes change. But surfing, here, is forever.

You Said That You Could Let It Go.
Or, a Contest.

I last left Kolohe at the Target house as the growing swell thundered as his father and his coach discussed strategy. Kolohe, angelically blonde with defined features and straight teeth and blue eyes and well-developed muscles. Kolohe, sponsored by Target. Alongside Target he is also sponsored by Nike, Red Bull, and Oakley. His slate of sponsors is as moneyed as anyone's in surfing. Most professionals ride for endemic brands only. The brands that were begun by surfers themselves, printing T-shirts and hand-stitching canvas boardshorts in their parents' garages and selling them from the backs of their parents' station wagons.

Quiksilver has the best story of all. Missing-toothed Australian Alan Green saw that surfers needed surf-specific trunks and so, in 1970, started making them from double-twisted poplin, a material used mostly for raincoats. They sold well in the beach towns around Melbourne and Sydney and he had a nice, growing business, and then Jeff Hakman arrived.

Hakman was born in California but moved with his family to Oahu when he was twelve. He was a natural, paddling out to giant Waimea at thirteen years old, and soon became the best surfer in the world. Surf historian Matt Warshaw writes in the *Encyclope-*

dia of Surfing, "His mastery was complete and he could ride for hours—sometimes days—without falling off his board." He also became a total drug addict. Talent often trumps addiction, especially for the young, and Hakman won contest after contest even when loaded. He would travel around the world and met a very young Bob McKnight in Indonesia. They became fast friends. McKnight would later go over to G-Land to surf and would meet Mike Boyum and the other lost boys.

Hakman, meanwhile, glassed three ounces of cocaine inside the hollowed-out fins of his surfboard that he planned to trade for heroin, and flew to Australia to compete in the Rip Curl Bells Beach Pro. He won (while loaded), becoming the first non-Australian to accomplish that feat but the only thing in his head was Quiksilver. He had stolen a pair of Quik trunks on an earlier trip to Australia and thought they were the best things on earth (except maybe heroin).

After the event wrapped, everyone went to the victory party. Hakman found Alan Green's table and begged for the license to sell Quiksilver trunks in America. He is quoted in the book *The Mountain and the Wave: The Quiksilver Story* as saying, "Greeny, what do I have to do to make you understand how much I want this license?" Green, drunk, pointed to a cloth doily on the table and responded, "Eat the doily." Hakman did, washing it down with wine, and the license was his.

Hakman called his fast friend Bob McKnight and Quiksilver USA soon dwarfed Australia, and other brands followed suit. Brands that were for surfers and by surfers.

Quiksilver, and Billabong too, have grown into billion-dollar empires and are publicly traded but they are still considered core. They are still considered to sprout from surfing's hallowed spring. But

Target is not core. Nike is not core. They are interlopers and often disparaged for sticking a dirty corporate finger into surfing's hallowed spring.

Surfers are very temperamental about "core." If anything smacks of opportunism, of getting involved in surfing to make a dollar, then surfers recoil—even when the endemic brands do it. Maybe especially when the endemic brands do it. Every so often Costco will get its hands on a brand's goods and put them on the tables amidst the beanbag chairs and tater tot samples and then the brand will be, officially, dead. The brand will be accused of "selling out" and be totally finished.

Nike was so worried about entering the temperamental surf market that it first, very quietly, purchased the core brand Hurley and tested the waters before launching 6.0, which was a hideous mutant and had no visible "swoosh" or any connection to Nike, before launching Nike Surf, which is semiaccepted by surf culture and even semiaccepted on the North Shore. They sponsor Hawaiian Kai Barger.

But Kolohe doesn't care about core. And so his peers call him Corpo—short for corporate—behind his back. Corpo Andino. But he doesn't care at all. He is proud of his blue chips. He is proud to be corpo and even brags about it. Brags that the stickers on his surfboard, representing his sponsors, look like the New York Stock Exchange. He is the future of surfing. He is where surfing is going.

And his surf style is impeccable. Groomed in San Clemente, child of a professional, he learned how to surf to the times. He learned to surf like a modern child throwing all the complicated newfangled airs, the slobs and the mutes and the stalefishes, and he lands them all with amazing consistency. He knows how to surf and he knows how to surf for the magazines and he knows how to surf for the

judges. He is a competitive machine and his father, Dino, has been by his side the whole time.

Kolohe's dad's Christian name is Reinol but he is known only as Dino in the surf community. Dino's father was an emigrant from Moldova who moved his family to the suburban Southern California town of Anaheim. Dino was raised near enough to the beach to hitch rides after school. Through pure hard work and perseverance, he became a decent pro in the late '80s/early '90s, with an exceptionally powerful carve. He would paddle into the wave, long hair flowing behind him, and fly down the line before changing directions on a dime. He had the longest hair. It was his trademark. He would bury the rail of his board beneath the water and send spray toward the heavens before redirecting and continuing on down the line. His powerful style was also, along with luxuriant flowing hair, his trademark and he won a handful of contests on the tour. Enough to make a living. He was fearless as well. He had to be in order to get respect as a middle-class kid from Anaheim. So he'd surf big waves and fight and never back down.

He met a pretty blonde beach girl, married young, had Kolohe in his early twenties, and moved his own family to the Southern California beachside hamlet of San Clemente, which is the location of Trestles, the best wave in California and a World Tour stop.

Trestles is referred to as a "high-performance wave." It breaks over a cobblestoned bottom and forms perfect ramps, ramps like the waves at Rocky Point. Waves that keep a consistent shape with a steeper section at the lip that beg to be danced upon. It never gets over six feet in height and the transition section is perfect for speed, carving, hacks, gouges, and airs. High-performance.

Young Kolohe would follow his dad to Trestles for daily surfs and contests. He remembers walking around the competitor's area as a

four-year-old and being awed by what he saw. He says, "I would just see all these pros and I thought they were gods. I never really thought of becoming a professional surfer myself but I never thought about becoming anything else either. These guys were my heroes and they were all my dad's friends. I'd just walk around and I was probably pretty annoying but it was cool. I was cool."

Kolohe followed the trajectory of most beachy Southern California groms (surf slang for "kids"), getting on a bodyboard as soon as he could walk but soon begging for a surfboard. "My dad gave me one of his and I would go froth around in the shore break. I'd go kill it out there," he says with a mischievous grin. Dino saw the potential and coached and encouraged Kolohe, waking up at the break of day for his own dawn-patrol surf sessions and always bringing Kolohe for a paddle. The two would bob in the water and Dino would give him pointers on how to attack this section of the wave or what to do on that section. Kolohe progressed quickly.

He entered Kolohe in some local National Scholastic Surfing Association contests and soon Kolohe was beating kids in competition over twice his age. And word started to spread about Dino's kid.

Dino, too, began to develop a reputation for being a soccer dad. A pejorative in the perpetually rebellious and ruggedly individual surf world. He'd stand on the beach with Kolohe's extra competition boards and continue to give him pointers and tips between heats. He'd bark at the judges if he felt Kolohe had been robbed of a score. And if Kolohe made a mental error he would bury his head in his hands and say, "What the fuck is he thinking?" He'd deal personally with the surf industry interest in his young son, getting Kolohe his first sponsorship deals, which happened to be Billabong, which happened to be where Dino worked. And he worked at Billabong because they wanted Kolohe so they gave him a job.

He homeschooled him so that he could travel and compete overseas as well as at home. The two would travel everywhere together and they still do even though Kolohe has, just this year, qualified for the World Championship Tour (WCT) and even though Kolohe now also has a personal coach.

Kolohe qualified in record speed. He won WQS competitions in all the little and junky waves because his style and his flair and his ability lent themselves to the judging criteria at those junky waves. He could flair with the best of them in Brazilian beach break.

But this is Kolohe's first full season on the North Shore. Unlike other exceptionally talented groms his age he was kept from the prototypical parental ship-off. Parents trust their exceptional youth to the brands. They send them to the North Shore with team managers and the children are stacked in bunk beds and made to sweep floors and slapped and are pointed out to the water when the waves are biggest and forced to take sets on the head. But Kolohe was sheltered from the brutal dog-eat-dog North Shore because he was a prodigy and his dad never left his side. The hazing, and the slaps, and the choke outs, and the sets on the head were foreign and he was, instead, groomed in Southern California beach break and safer Indonesian reef breaks. Kolohe's own reputation began to develop in the surf community. He is soft. He is a media creation. He can surf fine in safe little waves and do progressive tricks and get his picture in the magazines but there is no way he'll be able to handle North Shore power. There is no way.

Kolohe, vice grip tightening around his throat, has chosen his board and is getting last-minute pointers from his coach and his dad on the steps of the Target house. His face is grey. I have moved down to the Target house too, through the "Billabong Presents the Pipe Masters in Memory of Andy Irons" scaffolding, down the slope

of dead and dying grass to the beach, past the photographers poised to capture every wave, past the Volcom house with a full deck of angry mokes, and past Jamie O'Brien's house, which is, inexplicably, pumping out dubstep, past the Billabong house where Graham Stapelberg got slapped, and up the stairs into the Nike house yard, moving across the Oakley house, where angry Hawaiians are hanging on the rail, glaring, and up to the steps of the Target house deck. The thunder of Pipeline has shaken me during the whole walk. I have never seen it this big. Ever.

Kolohe's face is grey and he is waxing a new pintailed surfboard in the yard and listening, halfheartedly, to the advice from his coach and feeling the same thunder. His face is so grey.

Twelve houses up the beach, back toward Pipeline, John John Florence is sitting on his porch laughing with a surf photographer about a poor Australian World Championship Tour bottom-feeder, Daniel Ross, who only got a 2.84 total score in his early morning heat (2.84 is embarrassingly bad). Pipe is totally massive, but the tide is a bit high and so the waves are hard to judge. Many surfers are getting slammed, free-falling into cavernous barrels that pinch around them and then try to drown them. Those who don't surf Pipe regularly are scratching around the water's surface trying not to look foolish, but even more so, trying not to drown. Or get dredged across the reef. But John John Florence isn't scared. His face isn't grey. He is laughing.

Kolohe Andino, down the beach, is the future of surfing and John John Florence, up the beach, is also the future of surfing but they are two different futures. They are a fork in the road. Kolohe is blue chip, corpo. He is million-dollar Super Bowl television commercials. He is kids in Nebraska buying Nike Surf trunks and wearing them to their local swimming pool. And John John is core. Super core. He is

the first explorers who tackled towering waves at Waimea, Sunset, and Pipeline. He is dingy kids fearlessly paddling out at waves that will crush them because that is what it means to be a surfer.

John John was born on the North Shore and, although he is even whiter than Kolohe and although he was named after John F. Kennedy Jr., he is completely accepted here. He is theirs. He was born in the very house in front of which he now sits, in fact, four lots down from Pipeline itself, and has lived here his entire eighteen years of life. He is blonde too, like Kolohe, but instead of straight hair in a stylish cut he sports a curly mop, which he hides underneath a Monster Energy Drink baseball hat. He is blue-eyed and near six feet tall as well, but their physical similarities end there. John John's features are not fine, his skin not uniform. His face is, in fact, squishy with puffy eyes that droop, smashy nose, and snaggly smile. When he was young he was dreamy. A little grom with a shoulder-length sandy mane and a fearless disposition. He would stand in Pipeline beasts, even as an eight-year-old, but today he looks strange. The island sun has a way of aging those who toil under its glare.

He tugs on his hat with one hand, attempting to block the mid-morning sun from his puffy eyes, while rubbing the salty residue around the seam of his O'Neill boardshorts with the other. His main sponsor is O'Neill and could not be more core. O'Neill was started by a bearded one-eyed surfer in Santa Cruz in the early 1960s. Jack O'Neill reconstituted bulky scuba-diving wetsuits, making them flexible enough to surf Northern California's freezing cold water. T-shirts, jackets, and a full assortment of sportswear soon followed but O'Neill's mission remains as simple as their tagline. First In, Last Out. It is only ever about the surf.

John John is no longer laughing about Daniel Ross's low score but

has gotten up, languidly, and is shuffling toward the sliding door on the side of the house. Getting ready to prepare his own pintails for battle. Kids who have grown up on the islands always seem to move with a sort of defiant slowness. John John, particularly, seems as if he is perpetually fighting sleep. He slides the door and enters the cool interior. His younger brothers Ivan and Nathan are on the couch struggling over a box of skateboard bearings and his mom, Alexandra, is in the kitchen making breakfast. She is a petite blonde with chestnut skin and a fine figure. She has the look of a pretty woman digging her heels in as she slides toward an uncertain future. Island sun is so vicious. She is a strong woman, a successful woman, and calls herself Alex but almost everyone else calls her Mom John.

Alex was born in New Jersey, raised two blocks from the beach. She was the youngest in the family and her two older brothers insisted on watching surf movies and paddling out, when they could, when there wasn't snow on the ground, and emulating what they saw on the screen. "I'd watch too," she says. "I was like, I want to be a girl charging those waves."

And New Jersey surf would never satisfy what she wanted to do so at sixteen she packed up and moved herself to the North Shore. Like Dino, she became a professional, surfing in the handful of contests held across the Hawaiian Islands during the years that were carved out for the women, but unlike Dino's trajectory there is no real money in professional women's surfing like there is no real money in the WNBA. So she settled down with a tradesman in a ramshackle house on the sand at Pipeline and birthed three sons.

Her husband left soon after the third was born, seeking his fortunes back in town but Alex wasn't about to leave. She loved the country lifestyle too much. She and her boys would spend their entire days splashing in the Pacific in front of the house and skateboarding

the cement bowl behind the house. And she would supplement her income by shooting photographs of island beauty.

But surfing took precedence to all. It is claimed, apocryphally perhaps, that John John first stood on a surfboard at six months of age wearing a life vest and riding on his father's board. By five he was surfing alone and by eight he was dropping into throaty barrels at Pipeline. He was treated like a mascot in the lineup. All the older Pipe surfers would hoot him into waves and congratulate him when he'd break a board or bounce off the reef and come up bloody. Alex would watch him, happy that he was having fun but also nervous. She trusted the islands, though. She trusted that the braddahs in the lineup would keep her boy safe. It was around this time that the surf media took notice and pictures of John John, of the little towheaded Monchichi with hair down his back and an almost too mature stance on a board, began appearing in magazines. Nobody could believe this kid could thread the barrel the way he did. Nobody could believe he wasn't afraid of Pipeline and that he surfed with so much style.

Alex will claim that this attention on her eldest son was fine but that she didn't really care either way. She insisted that he and his brothers went to school every day, even when the surf was pumping, even when they begged her to let them paddle out instead of catching the bus to Pupukea Elementary School. She didn't let them watch television and family was the only thing that mattered and as long as her boys were safe and happy and having fun then she was perfectly content. "Yeah, my biggest dream for my kids is that they are happy, healthy, and successful in whatever it is that they choose to do," she often says.

But nothing is ever so simple when prodigious talent displays itself in a youth, and there are stories of Alex working herself into deals

with the brands, demanding that included in the price of sponsoring young John John was a stipend for her, insisting she be paid to travel with him.

She will also claim that she never pushed John John to compete or to be a professional in any way, saying in a recent *Freesurf* magazine interview, "I think that nowadays, a lot of kids are getting pushed to be good at surfing, getting hired coaches and stuff like that, which is lame. My philosophy is that kids should just have fun." But again, nothing is ever so simple and she put a very young John John with the right people. Surfers that were better than mere coaches. Professionals who would paddle John John out to the outer-reef breaks and tutor him, personally, in the arts.

There are always pros hanging about the Florence household. Alex is warm, inviting, and, again, still pretty. Nathan Fletcher is the latest to drink his after-surf beers in the Florence kitchen and also have a relationship with her. Nathan is a legend from a legendary family of surfers. Four generations long, on both maternal and paternal side. He is younger thirties, handsome, amazingly skilled, but a little loopy.

Whatever the case, whether pushed firmly or subtly or not at all, whether helped by Alex's friendly suitors or only driven by his own passion, John John excelled in the competitive landscape, which is rare for those born and raised in Hawaii. Most Hawaiians loathe leaving the islands and therefore refuse the rigorous travel schedule demanded of those who qualify for the WCT. They have perfect waves at home. Why should they leave? John John's loathe of the mainland is no different. He mocks Southern California, is openly derisive of its surfers, who insist on wearing skinny jeans and other accouterments of style, calling them "California barns." Being called a "barn" or "barney" is the same as being called "totally

completely uncool" and is almost as bad as being called a "kook" in surf parlance. But still, through all, he has excelled and, like Kolohe, has qualified for the WCT.

But excellence at a young age in surfing guarantees nothing, except possibly a rehab-worthy drug problem. Being a prodigy is as much a strike against as it is a way forward. And Kolohe and John John are both prodigies.

Both have been in the spotlight since they were children and both are dealing with the shoulder-stooping pressure of being prodigies on the brink of adulthood. The speculation about what they may become is now meaningless. They will either become great, today in the biggest opening day of the Pipeline Masters ever, literally not figuratively, or sink into the annals of surfing's folk history.

The surf industry hedges by betting on both Kolohe and John John. It speaks highly of both. But, truthfully, the surf industry doesn't know shit. By and large, its last good idea was turning cocaine profits into boardshorts. By and large, it has become entirely reactionary, conservative, and petty. There are still some brands that maintain a fine image and make fine products that are both stylistically hip and true to the space. But it is hard when everyone has gone public and boards and chairmen from equity groups have the final say. So most industry brands pull advertisements from magazines for controversial pieces and the most stupidly tame pieces alike. They complain, bitterly, about virtually everything just like a senile old grandpa. An article about sunglasses ran recently on *Surfing Magazine*'s website, for instance, and a small company from Encinitas, California, was not included. A hundred and ten people looked at the story but the company felt so totally shattered that they sent nasty emails to Tony Perez about how unfair everything is and that they buy ads and expect to be included and blah blah blah.

Blah. That is the surf industry. And even betting on both Kolohe and John John may bring only more hurt old feelings.

There was once a surfer named Dave Eggers, like the author. He was likewise a towheaded youth of exceptional talent and as a child he won every competition in his age group. He crushed all. The magazines and media praised him and wondered about the sorts of greatness he would achieve. Would he be the best surfer of all time? Would he become a pop culture icon? He made covers of magazines standing in his bedroom surrounded by a pile of trophies.

Then he started to drink. Then he became addicted to drugs and stopped surfing competitively, later getting diagnosed with schizophrenia. Today Dave Eggers works in a bar in Bombay Beach, a small town on the shores of the Salton Sea in the middle of Southern California's Palm Springs desert. The Salton Sea was created through an accident of engineering. When damning the Colorado River, a breach occurred and the water flooded a below-sea-level portion of the desert. Early real estate tycoons and prospectors felt the lake would become a destination and built resorts around it. But it was unnatural and became saline and everything in and around it died. The tycoons and prospectors moved away, leaving only a shell community living in rusted trailer homes that dream, someday, the Salton Sea will return to its former glory, and Dave Eggers plies them with whiskey.

Kolohe and John John. The California prodigy with the Hawaiian name and the Hawaiian prodigy named after the most Eastern-Seaboard-establishment celebrity ever. They have surfed against each other in various National Scholastic Surfing Association and junior events around the world as they grew, with Kolohe winning more often than not. His polished flare built in Southern California perfectly fit the judging criteria of the minor leagues. He always

knew which tricks would score the highest, knew when to throw
them, and also has a competitive instinct like none other. He loves
to win. He loves to compete. And the waves in the minor leagues are
often subpar. Not the sort of heavy that John John grew up surfing.

John John would agitate at each Kolohe win, at each Kolohe mag-
azine spread, a growing disdain taking root in his heart. He would
salve the sting of losses by knowing that, soon, both of them would
be on the WCT and waves on the WCT are something else entirely.
The WCT is macking Pipeline. The WCT is what is happening this
morning.

John John's disdain of Kolohe, in my opinion, is visceral. His
smashy face shows discomfort when Kolohe's name is even men-
tioned in his company. His uneven skin becomes an equal shade of
red. He will not say, directly, that he dislikes him but I think he does.

Kolohe, on the other hand, feels neither this way nor that about
John John. He thinks his island fashion is amusing. He thinks he
surfs decently, though a bit hunched over on his board. He thinks he
is quiet. He thinks of John John the way that the New York Yankees
think of the Kansas City Royals, which is to say he does not think of
him very much at all. He will dismissively say they are "like brothers"
but I know Kolohe, better than he knows himself, and I know that he
is as competitive as anyone. Kolohe has the arrogance born of preter-
natural gifts and the bright sun of surf industry prophecy shining on
his back. John John is also arrogant but in a different, more Hawaiian
way. He slowly and methodically does exactly what it is that he wants
to do. He doesn't care when surf industry executives tell him this or
that. The disdain for "California barns" is ever present.

And, right now, John John, in his home, has chosen the board
he will ride today and is waxing it sluggishly, without worry. And
Kolohe is standing on the beach, looking ashen.

I am standing next to Kolohe, on the beach, at the water's edge, and joke with him that he doesn't have to paddle out. That I will put on his contest singlet and take the heat for him. Both of us would maybe fare the same. And Pipeline is standing before both of us, hulking. I have never seen it this big. I have never seen it this powerful. He is ready to paddle, trying to time it so that he doesn't get smashed on the way out, and he just looks at me, grey-faced, and says, "Huh?" He doesn't understand. He is in a state of shock.

The moment he is ready to go, the biggest set of the day washes up and even though we are standing well back it washes over Kolohe's bare feet and over my red Vans. If he hasn't already vomited he will probably do it right now. But like a proper warrior he takes a deep breath and sprints toward Armageddon and jumps on his board and begins the frantic paddle.

When Pipeline is big there is a swift current that sucks along the shore. A rock outcropping near shore, just to the left of Backdoor, marks where most surfers begin the paddle out. And they get sucked down the beach so quickly that it is ridiculous. It looks like they are only going sideways and will never make it out. But then they hit a rip current sucking out near the Ehukai Beach Park and are sucked out to sea and then they paddle back to their left to get in position.

Kolohe follows this pattern and is in the lineup with four minutes to go until the beginning of his heat. Jamie O'Brien is currently in the water, in a heat, and his heat will overlap into Kolohe's. They will be in the water, at the same time, for twenty minutes of Kolohe's forty-minute heat.

And Pipeline is pumping. It is massive and the sand is shaking, everything is shaking, with each wave that detonates. Jamie, having grown up here, is making it look simple. He is sliding down waves

four times taller than him. Waves as big as a three-story building. Waves that are breaking onto reef three feet deep. And he is making it look easy and fun. He catches one, air-drops to the bottom section, stalls, stalls, stalls, is covered up by a huge lip, and is spit back into the morning sunshine to roaring applause from the beach. It is his playground. And he is dominating his competition, Dane Reynolds.

Dane, like Kolohe, is a California media darling. He is from Ventura, California, and loves progressive aerial surfing, mustaches, arty doodles, obscure music, analog photography, and beat literature. His favorite book is *The Road to Los Angeles* and his favorite author is John Fante. In the water, though, he is getting embarrassed by Jamie O'Brien. And the North Shore beach is loving the punishment of this cuffed-panted, mustachioed, Mexican-beer-drinking hipster. The night before, at the Surfer Poll awards, Dane begged for Jamie to go easy on him but Jamie is not going easy at all. He is embarrassing him badly.

Kolohe sits on the shoulder, waiting for the horn for his own heat to sound, watching Dane get embarrassed. He himself is lucky not to be surfing against a North Shore local, but his lot is not much better. He is surfing against Laurie Towner, a fearless Australian hellman. "Hellman" is a nomenclature given to any surfer willing to throw himself into any wave at any time. Sharks and currents and reefs and rocks and decapitation and death be damned. Laurie is a hellman. He has dislocated his arm many times, being pounded by giant western and southern Australia surf. And he has put his time in on the North Shore as well. One of his most famous barrel pictures, a giant green mutant covering him up at Off the Wall, right next to Pipeline right next to Backdoor right next to Ain'ts, was snapped by water photographer Hilton Dawe. It was the same swell, the same day, almost the same minute that Pipeline killed Malik Joyeux.

Malik, floating twenty yards away from Laurie that fateful day, was a French Polynesian known for being one of the most fearless and accomplished big-wave riders ever. He charged Teahupo'o, a bone-crushing slab in Tahiti. He won the Billabong XXL Barrel of the Year award in 2003 on, many believe, to be one of the largest waves ever surfed. But Pipeline cares not for pedigree. It cares not for skill. And on a December day in 2005, Malik paddled out and surfed. It was only an eight-foot day, not massive by North Shore standards, and Malik took off deep. He was a goofy foot, and so he was facing the wave, going left. He tried to make the section but the nose of his board sank, right after he popped to his feet, and he lost speed. He tried to make up for it but was too late and the lip pounded him in the head and sent him underwater. The force of the wipeout was so great that it pulled his leash, the strand of rubber that connects a surfer to his board, clean out. And Malik was lost under the water. It took more than fifteen minutes for surfers and lifeguards to find his body down at Pupukea beach break, to the right of Pipeline if standing on the beach and looking out at the ocean. They dragged his limp torso to shore and tried to bring him back to life but their attempts were unsuccessful. A later autopsy revealed that Malik hit his head on his board after he fell, knocking him out. And then he drowned. Malik was no kook. He was good, even great. But Pipeline cares not.

And Kolohe bobs on the shoulder, floating over mountains, watching Jamie O'Brien, who has broken both his legs out here, and looking over at Laurie Towner, who knows, intimately, what Pipeline can do. Then the horn sounds. It is his turn. It is his time.

Laurie scratches, almost immediately, for the first wave. It is a thick Pipeline beast. It would be a classic with a little less water, a little less thickness. But nevertheless, Laurie scratches, paddles with

all his might, and he pops to his feet. It is solid twelve foot, Hawaiian. He drops, backside, facing the beach and grabbing the rail of his board with his right arm and feeling for the wall of the wave with his left. His back (right) leg is cocked and he is centered. Textbook. Kolohe can't see what is happening because he is behind the wave swimming in his own sea of gut-wrenching adrenaline. He is looking for his own wave. Laurie drops to the bottom and tries to dig the inside (left) rail of his board but something happens. He digs too hard and spins out, slightly, and his back foot becomes unstuck and suddenly there he is. At the bottom of a twelve-foot, Hawaiian, Pipe wave lying on top of his board. He slides for a minute and he knows that he is fucked and he *is* fucked. Then the lip comes down on his back. It smashes through him and he disappears behind an avalanche of white. The water patrol on Jet Skis scramble, looking desperately for him. He pops to the surface and waves them over and they help hoist him onto the sled that hangs off the back of the skis. He slowly gets to his knees and then violently punches the sled with his right arm. His left arm dangles sickly at his side. Pipeline has dislocated it and it swings lifelessly.

The Jet Ski spins around and rushes him toward the beach and he walks, hobbles, toward the competitors tent, angry, cradling his sickly, lifeless arm. The event doctors take a look and take it in their hands and pull it away from his body and it slides back into place. He moves it around a bit, gives them a thumbs-up, grabs his board, and rushes back toward the mayhem.

I am close enough to see the grimace on Laurie's face and know, quite personally, the hell of dislocation. I dislocated my arm, first snowboarding and second fighting a mixed-martial-arts bout against an Australian champion for *Stab*. I do anything for a story. My dangling arm totally grossed out both the champion and his

training staff but I popped it back in with a smirk. And third, fourth, fifth, sixth, seventh, eighth all on one passionate night with my woman in Beverly Hills. It was a hot night, and, like Laurie, I gave a thumbs-up and kept going. I intimately appreciate his verve.

Kolohe wouldn't have known what was happening, exactly, but he must have known it was something bad. Pipeline breaks close enough to shore where surfers in the water can see the events on the sand. If he happened to be looking he would have seen Laurie hobbling. And the doctors milling.

Laurie paddles back out to the lineup, getting worked by the waves on the way out, and then catches another beast and falters and gets pounded. He is washed in and his leg is bloody and his other arm dangles sickly. In two waves he has dislocated both of his shoulders and hit the reef.

Kolohe is alone now, not in the water but in his heat, and he will win it no matter what he does because the competition has been punched out of the arena. But this is no consolation because now all eyes are on him, even more so, and there is no place for him to hide. But he also doesn't want to hide because underneath it all he is a competitor. And he pushes down the fear, swallows it deep into his belly, and sees a set feather out over Third Reef. Coming directly for him.

Jamie is still in the water, punishing Dane, embarrassing Dane, and he sees the set and he watches Kolohe turn around and start to dig. Kolohe is going. He is going. It is a giant. The biggest wave of the day, so far, and it swells up behind Kolohe ready to eat him like it ate Laurie. His head is down. Digging. And right when he is about to drop down the skyscraper—fifteen foot, Hawaiian—Jamie screams, "Stall!" This is Jamie's playground. This is his backyard and he has fun out here and he knows that if Kolohe stalls down the face it

will be the barrel of his young life and he will silence every detractor. Stalling is when a surfer slows his momentum, letting the wave overtake him and barrel over him as thickly as possible. Jamie is an expert. And when he stalls he can also instantly speed up and make it out of sections that he has no business making it out of.

Kolohe hears him and tries to stall but this wave is a beast and it crushes him. It buries him in rolling thunder but he escapes without bodily harm, popping to the surface shaking his head and pulling his board back toward him. He has taken a beating and he has survived.

And he paddles back out to the lineup, surfing his heat alone. He takes off on another behemoth and tries to stall and races down the line, getting covered up at the end section and then pinched. But it is enough for a score. And then, before he knows it, his heat is over and he has gotten through and he is alive. This is a mixed blessing because it means he will have to surf again today and the swell is rising.

On the beach he is visibly relieved to be out of the water, and in his post-heat interview he says, "I'm gonna be honest, I was hearing about this swell about four or five days before and I was like, oh my gosh, oh my gosh, I hope it doesn't happen. I hope something goes wrong where they won't run it cuz I'm not too experienced out there, and I have never surfed really-too-big waves and . . . yeah, I was pretty scared and, ummm, I'm stoked to be here and bad luck to Laurie . . . but, also stoked to make it." His two-wave heat total is a 5.27, which is not good but also not the worst of the morning. And he is not that stoked to have made it. He will have to surf again. And the swell is rising.

The day finds its own rhythm and the beach fills as the sun climbs toward noon. I have been awake since dawn and am starting to tire

but Pipe is like coffee and everyone on Oahu knows that epic Pipe is happening. Everyone is coming. And as the tide drops, the swell cleans up. It gains size and its quality improves. The barrels stay open longer. They don't close down and surfers ride the full length of the wave, getting spit out furiously at the end. It is an unreal show and the beach hoots and hollers with every giant barrel, with every head-spinning wipeout. Those watching from the surf house decks speak authoritatively of who is excelling and who is looking foolish. I move up to the Billabong house and Kolohe's performance has mixed reviews. Some are proud that he even paddled into anything. Others, Hawaiians, feel that he got showed up in front of God and Canadians. It is their apocalypse, after all, and they know best.

Then John John is on the beach ready to paddle out for his first heat. He looks free and easy. He hunches down and watches for a moment, taking it in before sprinting into the water and getting sucked down the beach, sucked out to the lineup.

This is not the first event this winter that Kolohe and John John have surfed against each other on the North Shore. They were both in the Reef Hawaiian Pro at Hale'iwa, the first jewel in the Triple Crown, but it was not a good gauge. The surf didn't turn on the way it was supposed to and so the waves were fat under a puffy, fat, clouded sky. But it was good for airs and both Kolohe and John John excelled, though John John made it further than Kolohe. He threw an impressively high, hands-free, full rotation on the inside section and the beach erupted.

They also surfed against each other in the second jewel of the Triple Crown, the Vans World Cup of Surfing at Sunset Beach. The surf turned on for Sunset but it was a maxing swell coming from multiple directions and filled the ocean with chaos. Even Sunset veterans said it was virtually impossible to pick the proper take-

off spot. Kolohe fared poorly but almost anyone would have fared poorly. Except John John. In his first heat he found two barrels and had the highest heat total of the day. He kept surfing, heat after heat, and kept winning and he eventually won the entire contest, getting chaired up the beach and hoisting the large silver cup with a pink lei around his neck and a pink lei on his head. It was a fine win. And Kolohe watched it from the couch of the Target house not caring because Sunset is a strange wave.

Now it is Pipeline and there are no excuses because this is the Billabong Pipe Masters and the surf is on, it is full and perfect, and when John John reaches the lineup it is an equal test on the biggest stage.

He is surfing against Kai Barger, a Hawaiian wildcard from Maui, and he looks calm in the water. He moves into the same spot where he always sits, lining up with the same tree and same reef head that he always uses. And he sits. Calmly. Before whipping around and catching a bomb. He pops to his feet so languidly and slides down the face, sliding his ass down the face to slow his momentum. He is stalling perfectly. Jamie O'Brien would be proud. Both John John and Kolohe are regular footed so they both ride Pipeline backside, facing the beach. And John John slows his momentum and waits and waits and gets covered up by a thick lip. He is deep in the barrel. Very deep. Lost from sight. In his own world. And then the end of the wave pinches shut. Those on the beach feel, for sure, that he will not make it, but then he shoots through and squeezes into the light, standing tall. The beach loses it. He is their hometown hero. On his second wave he gets equally barreled, standing straight up. This is the mark of a Pipeline specialist, standing straight and tall in the tube. Standing still. Not crouching or grabbing or trying to speed through it but setting a clean line and standing as tall as possible.

And John John stands as tall as possible and then comes racing out after the spit. This is also the mark of a Pipeline specialist. Coming out of the barrel even after the vapor has been shot out like a cannon. On his third wave he gets the longest barrel. He is lost from sight for an eternity. And when he finally reemerges he pumps his fist twice toward the shore. Boom boom. More losing it. He receives a ten, a perfect score, and his heat total of 18.07 is the highest of the day so far. Afterward, on the beach, he says, "Yeah, it was really sketchy until I got up into the barrel and then it was fun." It was fun. That is a difference between John John and Kolohe, and Hawaiians and mainlanders, for that matter. They have fun in the maw of death.

I had moved back and forth during the morning from beach to house to beach, trading conversation with various friends and colleagues who had passed my way, but now I want to go to the Billabong house again and maybe see Graham Stapelberg huddled in a corner. I want to see his face in order to more fully understand Eddie and the whole violent North Shore's story. A victim's face speaks volumes. And so I walk down the sand and turn into its yard. I see various Billabong groms milling about and ask if G. is still around. Some say he is. Others say he has left. "But this is his home," I respond. "Wouldn't you know if he was here?" And they shrug their shoulders and then ask if I have heard that Eddie slapped him last night before skulking off. The whole house is still on edge. It has been put off of its typically cocky game.

I walk over to the Nike house to see if Kolohe or Dino are there. This is life on the North Shore. Incremental movements between surf houses, Lei Lei's, Hale'iwa Joe's, Foodland, the Chevron, and back. There can only be so much movement within seven miles. There can only be so much movement on an island.

In the Nike house more young groms are spread out on the leather

couch playing *Call of Duty* on the large television. They have turned off Pipeline coverage for a moment and are enthralled with throwing grenades at each other. I ask them if Kolohe is around and they shrug. Damned shrugging. Always damned shrugging. Why doesn't anyone get to the bottom of anything here? And so I move back over to the Target house. Incremental movements.

On the porch J.D. is sitting and talking with Michael Ho, a North Shore legend. I interrupt and tell J.D. that Target will be sponsoring the Backdoor Shootout next year and he gives me a monologue about how it is not in Target's interest to sponsor events here. They only have one store, in Honolulu, and don't need whatever it is that sponsoring events gives a brand and the only reason they are here is to provide help for Kolohe and Carissa and this and that. I tell him it is fine and well, but Eddie asked if they would be interested and Eddie asking means Eddie telling them they are interested. He doesn't know what to say. Michael guffaws and says, "Ehhhhhhhh, Eddie. He used to haaaaate me. When he was first building his house, the house where he is at now, I used to shoot out his lights with a pellet gun. I live right across the street and would sit on my deck at night after all the construction workers went away and *pow pow pow*. I would shoot them all. One time Eddie wanted to fight me in the street but I told him he'd have to teach me some moves because I don't know any. Hahahahahaha. Eddie . . ." Michael Ho is untouchable. He is Hawaiian royalty. His cousin is Don Ho, who sang "Tiny Bubbles" on a ukulele.

I finally find Dino inside, kneeling on a couch with his face pressed to the window, alternating between the live action on television and the live action in the ocean. He is talking a mile a minute about strategy and where to sit and which waves to go on and which waves look best bending over the horizon. I don't see Kolohe. I ask Dino

when Kolohe is surfing next and without looking away from the television or the window says, "Soon, Chas. Rough, yeah?" And I tell him that I thought Kolohe did all right. That he took a barbarian set on the head and that he got barreled even though he got pinched at the end. I don't say anything about John John or his 18.07. Dino nods and says "Yeah yeah yeah yeah" without thinking. Looking at the television and then out the window.

The swell had grown all morning. It had come in and exploded on the reefs in bigger and bigger sets. Off the Wall was a reign of close-out terror. Third Reef constantly feathered. Backdoor was working, sometimes, but surfers brave enough to charge through the Backdoor were met with nature's sadism on the return paddle to the lineup. When surfers ride Pipe waves they are, again, spit into the channel and their return paddle is relatively easy. But when surfers ride Backdoor they are, again, spit out in front of Ain'ts, next to Off the Wall's reign of closeout terror, and there is no channel. They end on the inside and must try to duck-dive under twenty feet of whitewash mash in three feet of water. Three feet to the reef. And the surfers flail and let their boards shoot toward the sky and try to swim under and often give up, letting themselves be washed in so they can paddle back around the way they started. Into the side-sucking current and into the out-sucking current. Nasty.

Dino asks me about the Billabong house situation and we trade Eddie stories while Kolohe scoots by us on the way to the beach, preparing for his next heat. Dino gives him a word of encouragement. Kolohe's face is not grey anymore but it doesn't look easy. He is surfing next against Dusty Payne. The redhead with a Mormon father. Dusty is already on the sand and Kolohe comes over, standing next him, before kicking at the sand, jumping into the water, and paddling furiously.

Dusty catches the first wave. A Backdoor gem. And gets scored decently for his brazen skill. Kolohe catches the second and gets dumped on his head, certainly getting rag-dolled before emerging, shaking his head, and paddling back into position. Except he is not in the right position and Dino is screaming at the window, "What are you doing, brother? Fuck! Get over! Get over!" Dino calls Kolohe "brother" but Kolohe can't hear him. Dino may as well be screaming from the moon.

Dusty and Kolohe trade waves and Dusty's are always better. He is deeper, on the takeoffs, and gets barreled more deeply and his scores reflect his commitment.

Kolohe gets a nice Pipe wave but doesn't get deep enough. He could have had the barrel of his life but just barely gets covered up instead. Dino keeps screaming, "What the fuck are you thinking, brother? What the fuck. Are. You. *Think*ing?" And then the final horn sounds. Kolohe's two-wave heat total is 6.57 to Dusty's 9.20 and with the loss he is ejected from the Pipeline Masters. His North Shore season is finished.

In instant retrospect it is a mixed bag. He performed well in bad waves at Hale'iwa's Reef Hawaiian Pro. He performed poorly, along with everyone besides John John, at Sunset's Vans World Cup of Surfing. And he performed as expected at Billabong's Pipe Masters, which is to say he performed poorly. The Hawaiians, particularly, trusted that Pipe would show Kolohe up. That it would spotlight the gaping holes in his overall game. It would show that he can surf slop amazingly, but that he can't ride big barrels, heavy barrels, well enough. And the Hawaiians will feel happy that, no matter the hype or the sponsors or the money or the pedigree, Pipeline equalizes. Pipeline distributes the wealth. It will hack down the greatest and the only way the greatest will excel is if they put in the time

like everyone else. Like every other grubby Hawaiian kid with big
dreams. The greatest have to be willing to come, every season, and
sit on the shoulder and then move over and, if they are lucky, get
called into deathly closeout bombs by the Pipe locals. And if they
do that enough they will get called into a good one. And if they ride
that well enough they can exist at the bottom of the Pipeline pack
and get scraps for many, many, many winters in a row.

Kelly Slater, for example, the world's best surfer ever, gets scraps
at Pipeline. But he has also put his time in, willing himself to learn
its nuances and characteristics and peculiarities. He has purchased
a house in Pupukea Heights, above Foodland, and his girlfriend is
partially Hawaiian. He has put his time in and so if he is out in the
water for a heat, and there are no locals to take all of his waves, he
will surf it as well as anyone. But he willed himself there.

. Kolohe comes back into the house undaunted. He shakes his head
good-naturedly, still dripping wet, and says "Fuck, that's heavy"
with a smile on his face. The grey is gone and so is the uneasy and it
is replaced with his typical mischievous grin. He is Kolohe Andino.
He is so arrogant and his arrogance, if he can hold on to it, if it is not
slapped from him by either wave or North Shore local, then he will
someday do fine at Pipeline. He will have to do fine. No surfer ever
becomes a legend without surfing Pipe well.

Then it is John John's turn again. His initial heat performance set
the bar for the day and, in between whispering about Eddie and
the Billabong house, surfers and surf industry types say, "Did you
see the John John heat? Did you see that barrel where he came out
behind the spit? Fucking amazing. That kid rides Pipe so good."
He has. He, all eighteen years old, surfed it better than anyone. He
surfed the biggest opening day on record like it was easy, like it
was fun. Moreover, due to early losses by some of the other com-

petitors, John John has a chance to win the entire Triple Crown. His decent showing at Hale'iwa and his win at Sunset put him in control of his own destiny. All he has to do is win his next heat and he wins the Triple Crown. And if this happens certain corners of the North Shore will explode with party. The heavy corners. The localized corners.

He gathers his red competitor's singlet from the beach-marshal tent and wanders so slowly down to the shoreline. A crazy Japanese woman who sells beer from a stand in the bushes runs toward him and extends her hand. They bump knuckles. And then she throws him a very loose shaka.

He will be surfing against Damien Hobgood, who is from Florida. Damien has a twin brother, C.J., also on tour. The Hobgoods are two of the greatest people on earth. They are good ol' boys, Southern gents, who love huntin', fishin', drivin' their trucks in the mud—called muddin'—and generally whoopin' it up. Surf mixed in with a Deep South redneck sensibility seems strange, on the surface. But it somehow makes sense. It somehow works and works well on the Hobgoods.

Damien is also fearless and on the first wave of the heat he takes off ridiculously deep and gets guillotined by the lip. It hits him in the head and drives him straight into the reef but he comes up laughing because he hunts crocodile in his off time. His second wave is a double barrel. He pulls in, facing the wave since he is a goofy foot, and crouches low, getting completely covered up and spit into another smaller barreling section. He crouches lower and gets spit out of that section as well. The beach politely whistles.

And Damien catches another wave sitting too far inside, too close to the beach, and is launched from his board and takes the full energy of a Pacific storm on his back. And he catches another wave,

getting a solid barrel, adding a meaty cutback onto the end section as an exclamation. It looks like John John will be bettered by a more experienced competitor.

But then John John comes alive. He takes a Backdoor wave, a solid wave, and drags both his hands in the wave's wall to slow his momentum as much as possible. To get barreled as deeply as possible. When Kolohe, and most other competitors today, catch waves they speed through as quickly as they can, trying to make it to the shoulder. Trying to make it to safety. Trying to live. John John is trying to get barreled. He is not trying to live. And he gets spit out to roars from the beach and high scores from the judges.

He takes off on a second Pipe wave, one that stands up so suddenly and fiercely that it looks as if it will pitch him down the face before he has a chance to do anything. But he takes the air-drop in stride, grabs his rail, slows himself down with his ass, and gets barreled, deeply, again. At the end of the wave, where Damien added a meaty cutback as an exclamation, John John launches into a hands-free, full-rotation air. He doesn't land it but the message is clear. This is his wave.

He takes off on a third Pipe wave and the lip pitches over well in front of him. It appears that he has no hope, but he crouches low, pumps his board by pressing down with his feet and then releasing to gain speed, and comes shooting out the barrel moments later to pandemonium on the beach. To, "Did you see *that*? *Wild!*" And he wins the heat with a 19.10 two-wave score. Nine-tenths away from perfection.

On the beach, afterward, his already puffy visage appears even more swollen and it is. During a noncompetitive free surf down the beach, in between his heats, he had been sucked over the falls and had smashed his face on the reef. He smashes his face on the reef

and then paddles out into giant Pipe and throws hands-free, full-rotation airs and tries to slow himself as much as possible to get barreled as much as possible and succeeds. He is on a tear. He is fearless in his element. He is a vision in his element.

To top everything off, he has just won the Triple Crown. In winning his heat, in beating Damien Hobgood, he has locked himself into North Shore lore. He is the youngest winner ever. The Pipe Masters is still running. It will finish tomorrow because the swell is still strong and he has a chance to win that too, but for now, for this moment, he is the best surfer on the North Shore. He reacts to the news on the beach in typical, laconic island style, nodding his head slowly while a smile spreads across his face. Slowly. In his heart he must be thinking about Kolohe Andino and all the hype and fuck him. Fuck the hype. Fuck California. This is the North Shore and this is what matters.

Kolohe Andino hears the news that John John just won the Triple Crown in the Target house while he is packing his bags. Shoving surfboards and dirty Nike boardshorts and Red Bull hats into his board coffin. He and Dino will be on the first flight they can get out. They will be going home to Southern California to catch this same swell in friendlier waters. The swells that hit the North Shore, depending on exact direction, keep moving across the Pacific until they end in California. And Kolohe will have a week of good surf to practice in before leaving at the start of February for Australia's Gold Coast. He is also planning a quick run to Aspen, Colorado, for the X Games. Target puts together a very fancy chalet and Kolohe will get to rub shoulders with other action-sports stars.

When he hears the news that John John has won the Triple Crown and the beach is all atwitter over it he shouldn't care. John John Florence can have the North Shore, for now. He will punish him

around the world, starting in February, starting in Australia. That is what Kolohe Andino would be thinking. He will be more consistent than John John and his airs will have a higher level of difficulty and his surfing will be flawless. He knows that he has to improve here on the North Shore. He knows that he will have to, one of these days, put on a memorable performance at Pipeline but it is not going to be today and it is not going to be tomorrow because he will fly to California instead of waking at the break of dawn and paddling out to Pipe before the event and taking some scraps on the head and starting to establish himself. In his heart he should be thinking fuck John John. Fuck the North Shore. Fuck the aggressive, chest-pounding, fighty, slappy, intimidating bullshit. And he will fly home to Southern California.

In late January, Kolohe will go to Aspen and rub shoulders in the chalet and have two drivers and seven butlers and three chefs at his beck and call. It will be the same time that the six-star Volcom Pipeline Pro is running on the North Shore. The surf will be huge, again, and the event will even be called off the first day because it is too big to surf with even a semblance of safety. John John will win. He will beat Jamie O'Brien on a last-second Backdoor wave and many will call it the best heat, ever, in professional surfing.

Two futures. One is corpo and the other is core. The corporate future means more money and more visibility but also giant cultural missteps. Any time Ford, for example, puts surfing in a commercial it is completely embarrassing. All the subtle cues, like the way a board is waxed, or when the leash is applied, are totally off. The core future means surfing stays where it is. An insular activity for a privileged few with no real people paying attention.

I don't know which future is better but I love Kolohe Andino and his style very, very much, and John John Florence surfs without fear,

which is awe-inspiring. Maybe the future will be a mash of stylish and fearless. Who knows? Maybe Ford will hire proper consultants and get the cues right and maybe the big, core surf brands will all have to file Chapter 11. Quiksilver is being investigated by its own investors for waste of corporate assets. Billabong is in a world of leveraged hurt. Maybe that is the mash right there. Ford, Coke, Pepto-Bismol getting the look of surf right and Quiksilver, Billabong, Rip Curl getting mired in traditional American business scandal.

I Found a Wallet. Or, Back to Town.

had moved, incrementally, back to the Billabong house, once more, in search of Graham, and he is either hiding under his covers or flying back to California and nobody is saying anything, insisting on only shrugging. He is nowhere. And so I give up on him. Fuck him, anyhow. He still owes me an interview. He can rot.

And, incrementally, I am starting to burn with island fever. Island fever is not unique to Hawaii. It can strike on any island. Its symptoms include wanting to get in a car and drive in a straight line for one thousand miles, feeling nauseated by the smell of coconut, hating palm trees. I decide to escape to my heart's true home, Waikiki, for an early afternoon cocktail. Those who live on the North Shore treat Waikiki like it is on a different planet but, really, it is forty minutes away. That is a minor Southern California commute so I wander up the Ke Nui back to my white convertible. My chariot.

The drive is uneventful and I start to breathe easier past the Dole Plantation. Eddie, Graham, Kolohe, John John, Pipeline, Kala, cracks, kicks, dislocated arms, death by slap, myth, reality, myth, reality, myth, reality, myth, reality all recede, for a moment, and the thoughts of a frosty piña colada begin to consume, even though the smell of coconut nauseates. Hair of the dog, I suppose.

I drive and let my mind wander until the valet of the Moana Surf-rider hotel is opening my door and welcoming me with aloha. He is a young Hawaiian with friendly eyes. Waikiki is so friendly. There is no negative energy at all. Sweetness and light. Respite. I used to be a valet until I got fired for drag-racing Ferraris on the Pacific Coast Highway with my brother. I used to drive a submarine at Disney-land until I got fired for calling in sick with tuberculosis.

The Moana Surfrider is historic and gorgeous. It is a mash of Eu-ropean, Southern Gothic, and Hawaiian-plantation styles, with a classic 1970s wing because nothing in Hawaii is respected unless it has something that feels like fat Elvis. It glows white in the midday sun and is only five stories but towers into the imagination.

I walk past the giant porticos into the cool, white, and natural-wood lobby. Fans spin ever so slowly. The languid fan is one of the best parts about the tropics. I want Scarlett O'Hara to come down the stairs but a newlywed Japanese couple appears instead. When the Japanese get married in Hawaii they stay in their wedding clothes for a full seventy-two hours. They shuffle around, bride and groom, followed by a lensman, and smile like their dreams have come true because their dreams have come true. They are married! In Hawaii! There are many pictures to take of the alive happiness.

I see a chunky midwestern couple giggling at them. What in the world do midwesterners eat? Why are they all chunky? I have never been to the Midwest.

And Hawaii is so damn fucking weird. It is the rare place, like Las Vegas, where totally opposing cultures enjoy the same exact things. In Vegas they all enjoy losing lots of money. Here, they all drink fruity cocktails and sit on chaise lounges in the sun and buy aloha shirts.

I move out to the expansive deck, sitting in a teak chair overlook-

ing the South Shore. A giant banyan tree is in the middle of the property. It must be four hundred years old and gives Waikiki a sense of historical permanence, like it has been here for all time. I am approached by a friendly Filipino waiter and he tells me about the specials with his special accent but I don't want food. I order a piña colada. I used to be a waiter until I got fired for being too slow. I had my father drive me back to the restaurant, that night, and I threw my wadded-up uniform at the door with a note inside that read, "Go to hell!"

It is warmer here, not oddly cold like the North Shore, and feels free. It feels untroubled. All of Waikiki used to be the private play-ground of Hawaiian royals. They would surf, splash, sometimes choke each other out, and roast pigs.

King Kamehameha the Great unified all of the islands in 1810 and his grandson, King Kamehameha III, moved the unified cap-ital from Maui to Honolulu in 1845. And the royals set up shop in Waikiki, which means "spouting fresh water" in Hawaiian.

Diamond Head, the extinct volcano, floats directly to the east, and the whitest sand spreads out for three miles to the west. Waikiki is enviable and, as much as the Japanese and midwesterners want it today, rich American sugarcane-plantation owners wanted it in the mid-1800s. There had been a crisis in Hawaii's royal line. King Kamehameha V did not name an heir to the throne and King Lu-nalilo, second cousin to King Kamehameha V, was elected by the people. King Lunalilo died the next year, also without naming an heir, and this time the people rioted. Wild in the streets. British and American troops stormed the island to bring peace but mostly to ensure the property of the white plantation owners who had been coming to Hawaii for fifty years.

Before dying, King Lunalilo was forced, by powerful Americans

with powerful business interests on the islands, to sign a consti-
tution that stripped the rights of native Hawaiians and gave most
everything to the white community. He ruled, powerless, until his
death, when the last Hawaiian royal ascended to the throne.

Queen Lili'uokalani came to power in 1891, right in time for the
end of the Hawaiian world. In 1893 the queen tried to sort out an-
other, more favorable constitution but a group of white business
leaders outflanked her and got Hawaii annexed by the United States
instead. It did not become a state for another sixty years because
statehood guaranteed the rights of minorities. The people were me-
thodically fucked during that pre-statehood window and Hawaiian
culture was beat almost beyond recognition.

In 1959, President Dwight D. Eisenhower signed the Hawaii Ad-
mission Act and da North Shore (plus the Big Island, Kauai, Maui,
the rest of Oahu, etc.) became the fiftieth star on the American flag.
Later, in 1993, President Bill Clinton signed the Apology Resolution,
in which the United States apologized for the overthrow. It is the only
time in history that the United States has done anything like this.

My waiter returns with a totally delicious piña colada in a perfect
piña colada glass. The coconut and pineapple are so pleasing. The
rum so fine. And I feel bad for Hawaiians, I do. I am no bleeding
heart, but they really have been fucked and now the Hawaiians on
the North Shore, and a Jew from Philadelphia, fuck new generations
of white interlopers, forcing them to live scared every waking, and
sleeping, moment they are here. This seems like an overly simplified
fifth-grade conclusion to a massively complex social, cultural, eco-
nomic situation but sometimes, sometimes, fifth graders are smart
and sometimes they are right. I used to teach fifth grade until I got
fired for playing dodgeball with my class for three hours a day.

And, like when I left Eddie Rothman's compound, I go back to

wondering about the meaning of all this is. What the fuck am I trying to discover again? What makes this shithole tick and why do I love it so goddamn much? Why cannot I for the life of me just leave danger behind? What did Charlie Marlow learn, or hear, or understand in the middle of Africa? The cinematic Martin Sheen version heard fat-as-sin Marlon Brando's Colonel Kurtz mumble, semi-incoherently, about kids inoculated with polio having their arms hacked off. "A pile of little arms," he said before adding that the men who did the hacking, "were not monsters, these were men . . . trained cadres. These men who fought with their hearts, who had families, who had children, who were filled with love . . . but they had the strength . . . the strength . . . to do that. If I had ten divisions of those men, then our troubles here would be over very quickly. You have to have men who are moral . . . and at the same time who are able to utilize their primordial instincts to kill without feeling . . . without passion . . . without judgment . . . without judgment! Because it's judgment that defeats us." Hmmmm. I'm always judging this fucking North Shore when I am here. I am judging the bad fashion, architecture, food, grinding violence, the sometimes ridiculous ideal of respect, funny accents. I just referred to it as a "shithole" after all and it is many things but it is not that. I should just stop. Yeah, this really is paradise. Not the paradise tourists think they are seeing but a paradise where man is more fully realized than our pampered, coddled West. A paradise with a solid crack as part of it. Maybe? Or maybe not. Maybe this cinematic Chas Marlow has finally been fully consumed by the ambiguity, the fine mist of salty, humid air. My goodness gracious. This piña colada is so totally amazingly delicious!

I Let the Bad Ones In and the Good Ones Go.
Or, He Wasn't Here for a Long Time;
He Was Here for a Good Time.

My waiter returns, again, twenty minutes later with longing eyes, assuming that I will reorder another piña colada, because it really is amazingly delicious, and that I will stay awhile. There aren't many customers today and I am not Japanese, which means I tip well, but I have another longing in my heart. I feel the urge to go back to the North Shore to see and feel more and so I pay, bid adieu to peace, and drive back north. I think dark thoughts mixed with frivolous ones as my white convertible top retracts, electronically.

All the while, on the North Shore, Bruce Irons has been drinking Heineken, called "da green ones," and watching Pipeline heats from his penthouse deck of the Volcom A-team house, called the "Gerry house" because Gerry Lopez used to own it. The same Gerry Lopez that was fitted with a colostomy bag, angering Eddie. The same Gerry who is nicknamed Mr. Pipeline. Gerry lives in Bend, Oregon, these days, because he prefers snowboarding and maybe the North Shore straight burned him out.

Bruce hoots loudly and pounds yet another green one and hoots loudly again. His boy won the Triple Crown. His North Shore boy.

His John John. And there will be a party tonight. Bruce Irons is not from the North Shore himself, but he is part of the fabric here like few others. He is Andy Iron's brother, who the contest is in memory of. He is a demigod.

Bruce and his older brother Andy were born on the garden isle of Kauai. Their father, Phil, like many fathers, had moved there to surf and revel in paradise. He felt he was living the dream. The sun shone every day. The temperature never rose above eighty-five degrees and never dropped below seventy. So many older white men move to Hawaii and feel they are living the dream. It is a disease bound in horrible aloha shirts, perpetual shorts, and old, ratty slippahs. And a disdain for anyone who doesn't view them as highly evolved. Who'd want to put on pants? Fuck that. Fuck pants.

But Phil's dream was marred by the existential reality of divorce, a nasty divorce, and he moved his two young children into a termite-eaten plantation-worker shack. They didn't care. It was directly across the street from Pinetrees. A very good reef break.

So Bruce and Andy grew up surfing in front of their house. Every day they would come home from school and they would surf. They each had a natural style, a flair, a fearlessness that was instantly recognized by the Kauai locals, hardened mokes living on the sparse northern shore. These two wild boys were adopted as mascots but soon outgrew mascot status and then the locals got in line to be in their entourage. Bruce and Andy called the shots and mostly Andy.

Each was truly wild. Andy was sixteen months older than Bruce, with a strong jaw and handsome face. His long brown hair, when he was a child, would get sun bleached and he was the very picture of surf sexy. Handsome and, unlike John John, grown-up handsome. Not cute blonde little bunny. He was exceptional in the water. He surfed so fluidly and so powerfully that people knew he was des-

tined for greatness. He also had the worst attitude ever. The people knew talent plus a horrible attitude meant he was going places. Reef McIntosh, fellow Kauaian, with him since the second grade, said, "I always knew he would be what he grew into. Even as a little kid I knew he was gonna be a legend. He never held back and he could do anything. From shitty Huntington to Waimea, he wasn't a one-trick pony. He could do it all."

Kaiborg, though slightly older, also watched Andy and said, "I remember watching him as a little little kid surfing Pinetrees. You could always see that he had it. Fucken hood-rat ripper. Surfing was different for him. Wasn't mechanical. Fucken Picasso in the water. Einstein. He looked at the ocean different."

There are many professional surfers but few that have an instantly identifiable style and Andy had that from the moment he first began. He was instantly identifiable from the land, or in the water. He surfed like a man possessed by style. Arms behind the back, back arched, looking at the watery roof of giant barrels. He would drop into the biggest waves and keep his body so still and stand up so straight. On smaller days he would hit the lip and fly, so high, into the air effortlessly. He was also a very powerful surfer and power is rarely beautiful but Andy Irons made it so. He surfed his personality. He surfed without limit or care.

He grew up fast and started winning contests. Bruce would follow Andy's lead and win contests too. Bruce and Andy started to battle. More than just battle in the water but battle on land. Knock-down-drag-outs. Big, nuclear, no-holds-barred attacks. Fred Patacchia, a North Shore local and standout, remembers the wildness and the horrible attitude. He said, "It was the first time I thought, 'This guy is radical.' It was, like, a junior pro event and I had known Andy and Bruce for a while but this must have been one of the first events or something. It was at V-Land. And Bruce was beating him in the

final and had this little barrel and Andy purposefully tried to get in his way. He, like, bailed his board and tried to hit Bruce in the barrel but he still made it out and won. And you know Bruce, he rubbed it in. Andy chased him around V-Land for a minute and then we all left and as we were leaving I saw Andy's trophy jammed in a tree. I thought, 'Holy shit, this guy's on another level.' He wouldn't take losing. Didn't accept it. Wasn't in his vocabulary . . . to see him get rid of his trophy . . . I would have been stoked just to have any trophy but second place wasn't good enough for him."

Andy won an event at Pipeline when he was seventeen. He won at Teahupo'o later that year and established himself as someone to watch. Billabong signed him to a large deal and he was living the dream. Ready to conquer the world. Ready to smash Kelly Slater's bald face.

Kelly Slater has been the dominant figure in surfing for two decades. He is a winner with those eleven titles and, more, he is the closest thing our totally curious community has to a legitimate star besides Laird Hamilton, who is not considered part of our community at all. Laird is considered a waterman, which is different than a surfer. A waterman spends time on the water. He fishes and stand-up paddleboards and windsurfs and swims and maybe surfs too but a waterman is not a surfer and Laird is definitely not a surfer. He has a hideous wide stance that is superugly.

Kelly was on *Baywatch*. He dated Pamela Anderson and Gisele Bündchen and Bar Refaeli and Cameron Diaz. He dates the same women as Leonardo DiCaprio. And he is a winner. Unbeatable. Kelly won so much that in the late 1990s he became bored of winning and so he quit for three years before he became bored of red carpet events and came back to professional surfing and started winning right away.

And so Andy made the World Tour during Kelly's rebirth and

struggled initially against the might of Kelly and the rigors of inter-
national travel and a very specific judging criteria. Again, Hawai-
ians often struggle on the tour. They love their island and when they
are out in the world they only dream of returning home to their
island. They can't imagine anything better than a mai tai and a palm
tree and no pants and temperate weather. Hawaiians are shocked to
think that not every person would move to Hawaii if they could.
They, in fact, don't believe it. They believe the only thing holding
the world back is money. If all financial resources were equally dis-
tributed, Hawaiians believe that seven billion people would move to
Hawaii. And they love their island's waves. They love the power and
force and it is difficult for them to surf smaller beach breaks. Not
difficult, skill-wise, but difficult care-wise.

Andy struggled for two seasons, almost falling off, back to the
vainglories of the QS, when something snapped. His hatred became
focused and yes: hatred. Hatred between top-level surfers is rare.
They all travel together, always, and surf together and at best become
best friends but at worst become indifferent to each other but Andy
hated Kelly. He hated him way more than John John hates Kolohe.

C. J. Hobgood, good ol' boy twin of Damien and world champion
in one of Kelly's retirement years, witnessed the venom. He said,
"Andy was the first person who came along that hated Slater. He
hated everything about him and I know hate is a strong word but
he really hated Kelly." Their rivalry became the best. Kelly was the
white knight. He lived clean, surfed very professionally, worked out,
and even wore white wetsuits. Andy was black. He wore black and
did not live clean. He partied like the world was going to end. I wit-
nessed many of his benders. Cocaine and booze-fueled ragers that
would go on for days. He would get surly when raging and get loud
and fight and be bad. The dark knight. But he also started to win. To

beat the unbeatable Kelly Slater. And he stole the World Championship crown from Kelly three times. Andy Irons. Three-time world champion. And the more he won the more he partied. Celebrations. Mad, burn it all down, down, down to the ground bangers. Tom Dosland, Maui surfer, underground charger, remembered Andy partying, saying, "Because he was always winning. That guy would go the gnarliest. His benders were legendary. He'd party and then charge the next morning . . . I mean, his whole trip . . . a real rock star life." Kaiborg adds, "That's just how we were raised on Kauai. Win and earn your right to have a good time. When you get older you realize better to treat yourself to a Pepsi . . . but we were young. It's a reward thing."

Bruce, on a slightly different path, signed with Volcom and developed the reputation of a little hellion. A little arrogant shit who would do whatever he wanted and say whatever he wanted. Cocky. He competed from time to time but did not emphasize victories and prowess in the same way his brother did. He did what he wanted to do. Surf fans loved Bruce's devil-may-care attitude and, even today, he is one of the most popular figures in our world. His deal with Volcom included a large stock option and when the company went public a handful of years later he made a rumored ten million dollars.

He, too, made the tour but hate and victory and beating Kelly was not his bag. Party was his bag and he would match Andy rail for rail, shot for shot. Bruce and Andy would fight and heckle each other but there was something brotherly lovely about their bouts. And about their partying. And their surfing. They would drop into the biggest waves on the North Shore with arrogant sneers on their faces. They were surf writ large.

But the party started to take a toll on Andy and so did the constant judgment. The surf world, again, is small and insular and the

best pros are always underneath the microscope, and Andy Irons was sensitive, extremely sensitive, which is rough when combined with a white-hot spotlight perpetually burning. C. J. Hobgood knew the feeling. "I'd always said being a professional surfer is sick, but you are definitely signing up for a job where you're gonna be judged. You're judged during your heats but also outside of the water you're getting judged. You're always being judged, which might have been real hard for Andy." Kaiborg added, "All eyes were on him for his good days and his bad days. People always want the dirt and that took it out of him. It took it out of all of us. When he was doing good he was on a pedestal and when he was doing bad people just . . . it's real hypocritical. You've got to be strong and Andy . . ." Here Kaiborg pauses long and thoughtful. Fighting for the words. "Andy didn't roll with the punches." And Freddy Patacchia saw. "People either wanted him to be winning or they wanted a controversy with his lifestyle. That got to him, being judged all the time. He was a pretty insecure guy. He always looked up to Kelly and he'd seriously ask me, Borg, his brother, 'Fuck, am I a kook?'"

Eventually Billabong forced him into a star-studded rehab facility, where he met Lindsay Lohan. Blair Marlin was Andy's manager and so he met Lindsay Lohan too and then took her to the North Shore and then she got her things stolen. Andy got clean for a minute but relapsed and his surfing suffered and he started slipping toward the bottom of the pack. Still, he was marketable and magnetic and he got married to a beautiful woman and she got pregnant with a son. He decided to clean up, for reals, but also decided that one last tear was in order. It started in Portugal, on tour, where he was bending, and then he followed the tour to Puerto Rico, where he became so sick, most say from withdrawals, that he left back toward Kauai. But he stopped in Miami, first, because it was Halloween, and he went wild. More bending. And then flew to Dallas, where he got off

the plane, checked into a hotel room, and died late at night and by himself.

The official cause of death was a heart attack with a secondary cause of acute intoxication. He was thirty-three years old.

His death rocked the surfing world. We were all implicit. We all watched him party and partied with him but he was also an adult, making his own decisions. But still. It hurt. It really broke our heart and it shattered his brother Bruce's heart. There was a very well-attended paddle-out ceremony in Kauai. When surfers die their friends paddle out on surfboards and sit in a large circle out at sea. On a boat in the middle of the circle stood Bruce and Andy's beautiful wife, who had just given birth to a beautiful son, Andy Axel, and the tears flowed.

The surf industry did its best to cover up the causes of death to the outside world. Official word, initially, from his main sponsor Billabong, was that he had contracted dengue fever in Puerto Rico and had died from it en route home. Then the people did the research and it was quickly discovered that dying from dengue fever in the industrialized world is extremely rare so Billabong had to step away from their initial statement. Embarrassing. Andy's widow then proceeded to delay the autopsy and toxicity report for as long as it could be delayed and the questions became loud.

The surf media, meanwhile, went totally quiet, refusing to touch the story even though Andy Irons was one of our biggest stars and the story was one of the biggest to ever hit the surf world. Our stars sometimes drown while surfing and they sometimes get thrown in jail but they never die in the prime of their lives, in hotel beds, in Dallas, Texas.

The nonendemic media sniffed around. TMZ did a story and it was the front page of many major newspapers, though Billabong and the surf industry's intransigence made it difficult to get any

real information at all. *Outside* magazine published a long, tawdry, preachy exposé about the wall of surf industry silence and its compliance in Andy's death but the piece was only self-serving. No surf brands advertise in *Outside*. So easy to take the moral high ground when nothing is at stake. And *Outside*'s story made me livid. I wrote my own piece, lambasting them and praising the silence of the surf industry, claiming that we are a family and we don't air our dirty laundry in public. The story was another internal sensation with surf fans chewing my head right off. Typical comments told me that I was an ass-kissing coward. They would scream, "Go pop some more pills with the rest of the 'holier than thou' crowd . . ." before telling me that I am the worst surf writer of all time and also, for good measure, suck dick.

The surf fans were a little bit right. I was holding the truth, close to my paisley Etro vest, because I would have lost everybody their jobs at *Surfing Magazine* had I written it. Billabong would have screamed, "Au revoir, assholes!" pulling all their advertisements, and *Surfing*'s obituary would have read, "*Surfing Magazine*. Born: 1964. Died: 2010. Cause of death: Chas Smith is a dick." But I also thought, "This whole story is too cinematic for the magazines. Yes. It is a book. It is *this* book (and then a movie)!"

Again, we were all implicit in Andy's death. Billabong sent him to rehab but there were always more people to party with. We like to party.

Bruce likes to party too. He always stays in the penthouse of the Volcom A-team house and it is nice with wide-open views of Pipeline. It is the best room on all of the North Shore. And he stood there, on his balcony, watching John John. Watching his princedom. Standing under the giant black-and-white stone.

He Came from the South of Sweden,
He Spoke Just Like a Dane. Or, V-Co.

Volcom's logo, the Stone, is eponymous with heavy North Shore. It looks a bit like a three-dimensional gem shaded half black and half white. The Stone sticker was the one that Kai Otton saw before he smashed his face on the reef and would not get angry at or fight against. The one that scarred Marcus Sander's soul. The Stone and the North Shore have become one.

Volcom was started by Richard Woolcott and Tucker Hall in 1991. They had both been surf industry insiders but saw how stale things were getting and so they started their own company, in Newport Beach, with the tagline "Youth Against Establishment." It was an instant success, though sales lagged at first. But success is more than sales. Success, in surf or any youth culture hipness, is buzz, heat, and Volcom was hot from minute one. The brand was hot. The brand was now. The kids were bored of Billabong and Quiksilver and the establishment surf brands. Surf had been around long enough so parents and grandparents were wearing it. The kids wanted new. The kids wanted the Stone.

Even though they formulated the idea of Volcom on a snowboard trip, Woolcott and Hall were surfers, first and foremost, and Woolcott had always been fascinated by the North Shore milieu. As soon

as Volcom could afford it, they set up a seasonal surf house and hired Kaiborg to run the show.

Woolcott met Kai Garcia before he was known as Kaiborg, during summer vacations to Kauai when he worked for Quiksilver. "He used to sponsor my brother so he basically . . . after he did *Black and White* [a famous surf film] with Kelly Slater he used to come and stay with us and, like, unwind, and he started telling me, 'Hey, man, I'm gonna start my own company blah blah blah and I'm gonna call it Volcom. I'm over Quiksilver,'" Kaiborg said. "And I told him, 'Brah, you're fucken high. Don't leave.' But he was like, 'No, I'm gonna do it and if it ever goes through I want you guys to be a part of it.' And I was like, 'Yeah, you're high. Just stay with Quiksilver,' because back then Quiksilver was it. But he ended up doing . . . he ended up leaving and he called me in 1992 and was like, 'Heeeeeey, what's up? Got the company going and blah blah blah and I want you on board.' I was like, 'Oh yeah? OK.' And he was like, 'I'll give you eight hundred bucks a month.' And I fucken jumped through the ceiling, brah. I was like, 'Really? Holy shit.' That was unheard of. I didn't even know that was possible back then. And so we did it."

Volcom's reputation for ferocity on the North Shore was inherent in the brand from the beginning. Woolcott ensured this by hiring men like Kaiborg to run the show and by sponsoring surfers with a penchant for violence. Whether having this ferocity around made Woolcott feel protected—he is an extremely short man—or whether it was purely a marketing ploy, it was only a matter of time before the ferocity grew out of control. It is now an ever-present North Shore apparition. And always centered in the Volcom houses.

At first, the Volcom house was a mere rental near Rocky Point, but Kaiborg and the crew tore it up so badly that they were banned and sent to a purgatory near Velzyland called the V-Land Colony.

And the Volcom crew rotted there for some years before moving to another house by Ted's Bakery before buying a house right in front of Pipeline. *The* house. The one that is famous today. Later Volcom bought Gerry Lopez's house next door and the A-team, or Volcom's best riders, moved in there, but the original is the legend.

You Are Not Invisible Now, You Just Don't Exist.
Or, Surf Houses: an Interlude.

The Billabong house, where Eddie did his slapping; the Rip Curl house, where I got choked right out; the Target house, where fear rolled through Kolohe, pre-Pipeline heat; the Nike house, where chefs cook private dinners and the diners never go to the Volcom house; the Quiksilver house, which used to have a trampoline in the front yard; the *Surfing Magazine* house, which moves around but always gets robbed; the Body Glove house, which is way too far away from the action; the Globe Suite, which is in Honolulu. All of the brands, or any of the brands that care to be respected in the surf world, maintain houses on the North Shore. Some hold the houses for a matter of weeks and use them to entertain clients or simply to claim that they had a house on the North Shore. Some own the houses year-round and gain the added credibility of a year-round presence and the added expense of year-round protection.

The houses are where meaningful things happen and they are all exclusive in their own way. Young fans wander by the houses that front Pipeline, Backdoor, Off the Wall, and crank their necks toward the yards. Their heroes are up there. There, heroes are waxing boards or hooting for their friends in the water, or playing video games, or racking rails, or bedding girls freshly dragged up

from the same beach. None of these young fans, though, would dare think about walking up the stairs to those houses and mingling. Not that they couldn't, theoretically. There are no doormen or bouncers but each house exudes a vibe of exclusivity and privilege. A heavy vibe.

The professional surfers and surf industry insiders themselves will pop from house to house, occasionally, and definitely if a non-Volcom house is throwing a party, but will most often stay in their own sponsor's sphere. The possibility of getting cracked is always present and always foremost in head and heart. It doubles once one steps onto the Ke Nui, triples at Foodland, quadruples in the water, and quintuples anywhere near Volcom.

The houses all share certain rules. The highest-paid/best surfers are treated with kid gloves and can do whatever they wish, even being given their own houses for only them. The groms should be seen but not heard. No uninvited, non–surf industry guests. A bucket of water to rinse feet somewhere near the stairs to the beach. Very ugly looks given to those who do not rinse their feet, even from groms. Very ugly looks given to overindulgence of beer from the fridge. Respect given to all Hawaiians who enter. Shit talking given to all Hawaiians who leave.

The houses are where life on the North Shore takes its domestic shape and I feel fine in most of them, though I did not always remember to wipe the sand from my feet and got in trouble. I have also written bad things about many surfers but am used to their dagger glares so don't care. I approach them and make small talk like I did with Kai Otton unless they are Hawaiian and then I try to pretend that I don't know who they are or what is happening while continuing to be the sort of gregarious asshole who wears pink button-ups and skinny pants. It is a wild game but it works, or has worked, and

is, anyhow, more akin to my natural state of being than wearing
baggy boardshorts, slippahs, and being scared.

The houses can be fun, they can be boring, they are always hot-
beds of information, and sometimes hotbeds of venereal disease.
They used to have more venereal disease but many of the top pros
have recently married and their wives travel with them, not trusting
their devious surfing husbands, and the wives keep the less-than-
exemplary girls far far away. But, again, this only happens at the
houses where the top pros stay, the A-team houses, and these are
all comfortable but boring. Billabong's A-team house looks like a
giant wave. It has a blue roof that curls over the side walkway that is
supposed to look like getting barreled. Tacky and not where Eddie
did his slapping but if he ever feels any aesthetic angst he can go and
slap the architect and interior designer.

The best brands, or most respected brands, are closest to Pipe-
line. Others spread across the Seven Mile Miracle from Hale'iwa to
Sunset. Body Glove is near Sunset and, God bless them, they used
to be a fine brand. They used to produce gold-standard wetsuits and
sponsor great surfers. When I was twelve years old I went to the
Southern California second-rate amusement park Knott's Berry
Farm with my family and I saw a Body Glove watch in the window
of a shop and I begged my parents for it. They said no and so I cried.
They still said no. It was not a proud moment in my life but that is
what Body Glove used to mean. I loved it. I loved their yellow and
black hand logo. But, in truth, the watch was in a window at Knott's
Berry Farm. A second-rate amusement park. Body Glove had sold
out when I was twelve and so, even today, they are relegated to a
house near Sunset. Though I must say, they mix a very wonderful
martini at the Body Glove house. The best martini I have ever tasted
on the North Shore or anywhere in the Hawaiian island chain.

All the houses, even though they do not brand themselves with

logos or signs, are well known to those who need to know. Everyone knows where the Hurley house is and if some iced-out moke wants to steal surfboards from the Hurley team then he knows exactly where to go. This is not news. Theft on the North Shore is de rigueur. Once, at the *Surfing Magazine* house, all of the camera equipment was stolen. Every camera body, every lens. The photographers are smart, though. They insure it all before they leave the mainland, but still. It is a hassle and it is a headache. Hawaiian theft got Captain Cook killed. Hawaiian theft would get a pesky, inquisitive photographer killed. And so it is much easier to insure and when it goes missing ask no questions.

The houses are exclusive and they are meaningful and two houses are the most exclusive and the most meaningful. Two houses are directly in front of Pipeline. Two houses stick giant logos on their roofs so everyone knows where they are yet nothing ever gets stolen. The two Volcom houses.

The original Volcom house is the legend. Their A-team house is nicer but the original is the stuff of myth/reality. Approached from the sand, it looks like an A-framed black hole. The energy of that many parties, that many beatings, that much trouble, radiates out. It is not a nice house. It is classically North Shore and smells of salt, decomposition, dirt, and, sniffing very strongly, hurt feelings, blood, and tears.

Approached from the Ke Nui, it looks like a plywood den of iniquity. A random stack of architectural who-gives-a-fuck. The paint colors don't match. A dystopian assortment of vehicles are jammed into a very much too small parking area. There are haphazard Volcom stickers stuck many places. Going through the door, on the Ke Nui side, one enters the dungeon and this is where first-time North Shore groms begin their North Shore experience.

The dungeon is windowless. There are bunk beds stacked next

to each other like a bad jail. There are nude girl posters on the wall, which can be seen with the one hanging lightbulb, if it is on. It smells like young testosterone and pain. It smells like a middle school locker room.

And picture, for one moment, the youthful Southern California surf talent. He lives in a million-dollar house near the beach because his father works in investment banking and his mother works in corporate law and, really, the only way anyone gets exceptionally great at surfing is if he lives on the beach, which is always expensive. Mexicans cut his grass. Brown men with submissive attitudes. He goes to a fancy white person school, or is homeschooled because surf is more important than geometry or grammar, and is the most popular kid in his class, or town, because he rips. He gets all the waves at his home break. He travels to exotic locations because his father works in investment banking and his mother works in corporate law. They have the money to spoil their son. And so they spoil their son. They are never home. He rules the roost. He throws parties. Sometimes Kristin Cavallari shows up and sometimes Lauren Conrad shows up. He has everything. And then he gets sponsored by Volcom, which makes him very stoked and even more popular. And then he is shipped off to the North Shore.

Well what the fuck? He finds himself in a literal dungeon and he finds himself being harassed and humiliated by brown men who look like the brown men who cut his parents' yard. And he finds himself on the very bottom of a complex social structure.

Volcom breaks even the most spoiled youth and breaks them quickly. Groms in the dungeon must clean up. They must do the dishes and sweep the porches and wake up very early and work out in the park with Kaiborg and then paddle out at Pipe and drop into the biggest bombs without even thinking, without even pausing. If

they pause, they will be done and not back on the North Shore and not sponsored anymore. His life may still be charmed—his father is an investment banker and his mother works in corporate law—but he will always know he was a pussy by the North Shore's standard and it will haunt him until he dies.

The dungeon at the Volcom house is as hideous and horrible as one can imagine, or at least as I had imagined. And the groms are supposed to be stoked on it. They are supposed to feel they are living the dream. What? A free bed thirty short steps away from Pipeline? Free food? Access to the heaviest locals in surfing's Mecca? But it is genuinely rough and only the most hardened spoiled blonde children survive.

And if they survive they someday move upstairs to the main house. The living room is Spartan, and directly adjoins the kitchen. An old refrigerator keeps da green ones cool. A Formica counter always feels sticky. Rotten couches. A sliding glass door that leads out to a deck with another rotten green leather couch on cinder blocks, a broken UFC punching bag, and hundreds of surfboards set on rail between the deck railings.

This deck, and the yard directly in front of it that faces Pipeline, has hosted countless parties. The wildest parties. The most aggressive parties. Volcom parties. And all of it resonates out from the wood, the cinder, the leather, the fiberglass. Everything feels dark and painful at the Volcom house.

And Bruce Irons stands and watches it all from his penthouse deck at the Gerry house. High and untouchable. He is a prince here and nobody will tell him what to do while Kaiborg sits on the rotten green couch of the original Volcom house and cracks his knuckles. Kaiborg gargantuan and menacing. Kaiborg as scary as anything on the North Shore. As scary as even Eddie Rothman.

And Now Your World Is Here, Watch It Disappear.
Or, Kai Garcia Is a Zen Thug.
Or, Full Consumption.

have arrived back on the North Shore, fresh from Honolulu and a piña colada, momentary respite, and a revelation that maybe this is all really and truly paradise. That is the violence and commitment to violence by wave and men that makes it such. I have passed all the familiar landmarks and I am ready to get my head fucking cracked as a personal ablution. I always imagined that I wanted peace and tranquility and a garden and Saint Bernard. But I am defective. I have had traditional peace. I have owned a wonderful little prewar house in hipster Eagle Rock, Los Angeles, with the wife that I hated, and we had a Saint Bernard and I would come home from near-death Middle East experiences and think, "Never again." I would rub my Saint on his big fluffy head and think, "I have done enough." But three weeks later I would be thinking about adventure and five weeks later I would be on an adventure, running from Arabs holding rifles. Sweating. Cursing. Damn me. Damn my own degenerate heart. But maybe not. Maybe this is all the way, the truth, the life. Whatever. Even today I want to go climb Mount Everest to prove that it is not very difficult and the people that I love very much do not want me to but I will anyhow because I cannot stop.

And so I passed Waimea, I passed Foodland, and I passed the Billabong house before slamming my car onto the shoulder in front of Sunset Beach Elementary School and thinking about an adventure with Kaiborg. I needed his story. He told me, once, when we talked about Andy Irons, that whatever I needed he would give me. I wanted to push this further. To see if there is more to feel on the North Shore. To see if I can fall even further down the rabbity hole. To see if I can get further consumed, as if I am not consumed enough already. I had turned the radio from Top 40 to a Hawaiian station and Israel Kamakawiwo'ole, or Bruddah Iz to da locals, is singing a ukulele cover. "Somewhere over the rainbow, way up high, and the dreams that you dream of once in a lullaby . . ."

The contest had just ended for the day and would commence again early tomorrow morning but there were parties to be had and the road was full with fans and surfers trying to decide what to do. What their next steps should be. I push through them toward the small sand trail and stood between the two Volcom houses. Their gates flank me like zombies who would eat my brains. I decide to go into the original house gate. I pull the lock and enter and feel cold and not well.

I cannot see Kaiborg but do see a derelict sitting on the deck hooting at the surfers in the water. Anytime a contest ends, tens, maybe hundreds, of surfers huddle on the shoulder until the final horn and then they scramble to the peak, trying to catch the first wave of the postcontest day. Today there are maybe fifty surfers scrambling around, dropping in, getting spit out. And the derelict hoots them. "Whooooooohooooo!" I ask him where Kaiborg is and he responds in two syllables, " 'A' house," without looking my way. He is not Hawaiian but old enough to be the sort of non-Hawaiian clown grandfathered in. He is wearing shorts. And so I leave, kicking a Coors

can into the bush before opening the gate back to the sandy path
and through the A-team house gate.

The A-team house feels different, nicer, but it is still dark. Its deck
is not rotted. Its grass is not trampled to an early death. There are no
couches on cinder blocks. I approach and spot a broom and scratch
at my feet furiously before moving from grass to wood. I make sure
there are no specs of sand this time.

Dean Morrison is sitting on the porch, nursing a beer. He is the
smallest Gold Coast surfer, of Maori descent, and cute but also loves
his drink. He once used to surf on the World Championship Tour
but no longer. He still loves his drink and has been accused of being
a bit of a cheater. Once, during last year's Pipe Masters, he surfed a
heat against Damien Hobgood and it was a real scrappy, close heat.
Toward the end Damien had priority and a great wave came toward
him and he paddled for it. Inexplicably he slipped and went over
the falls, awkwardly. It would have been a great wave and Damien
might have won but, instead, Dean won. Back on shore Damien
found the head judge and started barking about how Dean had ac-
tually tugged his leash, sending him over the falls. A dirty move.

And now he nurses his beer on the Volcom A-team house deck. I
ask him if Kaiborg is around and he says, "Yeah, he's inside sleep-
ing. Go wake him up." I may be many things but I am not totally
oblivious. Still, it is tempting. I look through the sliding glass door
and see Kaiborg asleep, a sleeping giant, and it feels like being at a
zoo and wanting to stick a troublemaking hand into the tiger's cage.
I resist, though, and sit next to Dean instead, and watch Pipe fire
and watch the sun slip farther down the sky. It is still too cold but
the sunset will be gorgeous for sure. Sunsets on the North Shore are
almost always gorgeous.

After fifteen minutes Kaiborg stumbles out onto the porch,

scratching his stomach and stretching. He looks out toward Pipe for a long time. He arches his back. He is a giant of a man. As big as a house. Arms like Toyota Land Cruisers. He towers above me because I am sitting next to Dean but he would tower above me even if I was standing. Even though I am slightly taller. And, looking up, Kaiborg blocks the sky. He is all I can see. He is a specimen. He is handsome like a Roman gladiator. "Kai," I say in my friendly voice, and my friendly voice always grates my ears because my nose has been broken so many times that my friendly voice sounds like a nasal Muppet. "Do you have a minute to talk?" I only like my voice at three a.m. after one pack of Camel Reds and five whiskey sodas. He studies me with freshly woken eyes and then responds, "Hoooo, Chas, yeah brah, let's go over to the other house." I am climbing Everest just to do it. Just because I can't stop. I am entering into the real possibility of big trouble for the sake of getting into big trouble, or maybe to serve my ablution, but I also need to hear more and I don't know exactly what. I need to feel more. Eddie and Kaiborg in the same wicked day is a real double-down. How can simply talking to another man be so bad? Because this is the North Shore. And asking personal questions is worse.

I follow him through both gates, brushing my feet like a fiend again, before joining him on the cinder block couch.

We both watch the waves, quietly, for a few moments. We watch an unknown surfer get barreled and spit out. We watch a haole paddle awkwardly in the way of a Hawaiian and there will definitely be blood spilt before the sun sets completely. I ask Kaiborg about how it used to be on the North Shore. He looks at me and his voice answers. It is not like Eddie's. It is not a guttural mess but instead sort of sweet, inflected with the islands. "Ahhhhhh, how do you say . . . those were caveman days. Paleolithic. A trip, brah. This is our

spot, our place . . ." he says, referring to the rampant territorial-
ism of surf and of the North Shore. "We'd learn from our uncles,
who would paddle out and beat the shit out of people and then
they'd tell us to beat them up. And we thought that was normal.
We didn't know anything else, you know? Sad to say but it's just
how it was. Not how it is anymore." Bullshit. Bull fucking shit. The
past is always and forever seen as harder, rougher, deadlier, tougher.
Grandparents talk about walking to school uphill both ways. Par-
ents talk about the exorbitant cost of shoes and things today. The
past is always seen through a different filter and events can take on
greater, rougher, better, worse connotations. I was not on the North
Shore in those early days. But, truthfully, I have seen more fear in
the eyes on the North Shore than anywhere on earth. I can't imag-
ine more fear than there is today. Kaiborg is wrong. He is accentu-
ating history and minimizing the present. But there is no fucking
way I will tell him he is wrong and so I merely respond, "Yeah?
Seems pretty rough to me still, I mean . . ." And he looks over at
me, all two hundred fifty muscled pounds of him, and says, "No no
no. It's so different now. Back then there was nobody even around,
not near the amount of people that are here today. What we did . . .
It was just straight territorial trip. It was . . . back then we thought
it was all cool and right on, this is what we do cuz we didn't know
any better, but now that I'm older and look back on it I'm like, whoa.
Wow." I still think bull fucking shit. I believe, full well, that Kai-
borg doesn't crack as many heads today as he used to but that is
only because he has done Malcolm Gladwell's ten thousand hours.
Malcolm Gladwell quoted neurologist Daniel Levin, in his book
Outliers: "The emerging picture from such studies is that ten thou-
sand hours of practice is required with being a world-class expert
in anything." Kaiborg has cracked the metaphorical ten thousand

heads and now nobody will mess with him. Or very, very few people will mess with him. Word on the coconut wireless is that Kai and Eddie have beef. That they don't like each other. And also there is another at the Volcom house, Tai Van Dyke, who is looking to take over as big man and run Kaiborg off. Kaiborg used to party. He used to go as wild as anyone. Wilder than maybe everyone, excluding Andy and Bruce. But he has since cleaned up, completely. He doesn't even drink anymore, and this frustrates some. It frustrates Bruce and so Bruce is on a mission to replace his old great friend with another dark party animal, Tai Van Dyke. Bruce does not hide his contempt, nor his ambition. Kaiborg has a whiteboard where he writes the workout schedule for the groms. After John John won the Triple Crown, Bruce marched downstairs and scrubbed out the workout schedule and wrote, "Big fucking rager tonight," signing underneath in his own scrawl, "BRUCE IRONS." A proper affront to the power structure at the Volcom houses. Derek Dunfee, a big-wave surfer from La Jolla, California, sponsored by Volcom, who has done many tour of duties, later told me, "I have never felt it that way at all, that unhinged. Literally. I had my bags packed the entire time I stayed there in case shit really went down. I've never done that before but it felt like all-out war was imminent at any moment and I was ready to fucking bail."

The North Shore has always been rough. It is rough today, and it was rough when Kaiborg first started coming. I ask him when, in fact, he did come first and he answers, "I started coming to the North Shore when I was sixteen. First trip stayed with Marvin Foster. I came with my brother and, like I said, those were the kind of people we looked up to. We looked up to the kind of people that most people don't look up to. And it was the exact same thing we got thrown in over here like it was over there. But over here we had

to prove ourself even more." Over there is Kauai, where he grew up and where he learned to pound and crack and surf. Marvin Foster was one of the toughest men to ever wander the North Shore. He was a genuine star in the 1980s, one of Quiksilver's prized surfers, charging every oversized swell, but he also got into the drug trade, spending eighteen months in prison in the early 1990s on a weapons charge. He also, later, landed on Hawaii's top-ten-most-wanted list. Marvin Foster died by hanging himself from a tree in 2010. This was Kaiborg's moral compass.

But how does it all work? What happens? How does a sixteen-year-old Kauai kid come to the North Shore and become a legend? What did Kaiborg do to prove himself? And so I ask as the sun slides farther and farther down the sky, which continues to fire. Which continues to look like a painting. Kaiborg looks at the sun and lets out a long and low "Pssssssssshhhhhhhhhht" before pausing long. How to answer? "Just doing all the wrong things. You know. 'Doing the work,' as they like to say now. Doing the dirt for everyone. Like they said, 'Go lick that guy.' You gotta do it." It sounds, to me, like hell. It sounds, to me, like jail and so I ask, "Was it like jail?" And his voice goes very high in response, his head kicks back, and he locks his fingers behind his head. A small smile creeps over his face. "It wasn't . . . it wasn't . . . it wasn't like jail or anything like that because it was all we knew. You know? Like now that I'm older and everything . . . it's basically like, I don't live in the past, but I don't shut the door on it either. When I see people out in the water now or whatever, hey, I'll start character assassinating but then I'll check myself and go, 'Hey, these guys are just out here to have a good time too.' I ain't telling nobody to beat it. I ain't telling . . . I don't yell at nobody in the water I don't . . ." He trails off, thinking more. Thinking about his past and what it meant to him and what it means to him. "And

that's all from where I was to where I am. And now I don't say any-
thing. I do my trip and that's it. I'm not the most friendly guy in the
water but I'm not loudmouthing off or, you know, I'm just out there
to get my waves, get my daily reprieve and come in all happy. But,
you know, sometimes you gotta put that vibe off out in the water
because some people take your kindness for weakness and they'll
start hustling you and, fuck that, brah, you know . . . I don't know
if it's like, self-entitlement or, whatever, but I've put my time in and
I'm cherry-picking. I'm not a little kid paddling for every wave. I'm
waiting for mine and when they come to me, if you're behind me,
that's your problem. I'm going. I'm not going to yell at you, or what-
ever, just don't drop in on me. And everybody knows the deal."

No person would ever drop in on Kaiborg, full stop. He is huge
and one does not have to be intimately aware of any regional hierar-
chy to know a huge man is not to be toyed with.

But still, how long does it take for a man, an outsider for that
matter, to climb to the top of the North Shore's very specific, very
rough, hierarchy? Eddie came from Philadelphia and climbed to the
top in a matter of years. Kaiborg, though, is different. "You're always
climbing 'til today." And then he chuckles because he is not climbing
and maybe he never was. "Nahhh, honestly I can't say when or what
but I've never really had a problem because I've always been with all
the crew. I've never been on the short end of the stick, basically. And
what that develops, when you start to turn into a young man, is a
lot of fucken unwarranted pride and ego. And it's ugly. That whole
mind-frame is just . . . so wrong. That . . . but hey. It's life. If you don't
know any better and . . . basically we all come from broken homes,
the whole shit, so we don't know the ways like everybody around us,
since we were like five, so . . . you're a product of your environment
no matter what. And as you get older, you start learning. The key is

to try and break the cycle and not repeat it with where you are with the kids under you because . . . it's just a shitty fucken thing."

Kaiborg's introspection is intriguing. He is here, on the cinder-block-raised couch, in his fiefdom, talking about breaking cycles of violence and the ugliness of ego and being a product of an environment. His fiefdom. It is Eddie's kingdom, but Kaiborg rules the one thing that matters most. He rules Pipeline. This is not what I expected at all. I expected bravado or harsh vibing or a slap or aggressive platitudes about respect and such. But he seems so Zen and what he is saying seems genuine. Or maybe I have been totally and completely consumed and everything I hear on the island is now completely reasonable. I tell him he is a Zen thug and he laughs. "You know, it's all simple. I see guys come and go left and right and it's bad. You've got to appreciate everything. You've got to enjoy the ride until it's the end. You've got to wiggle and waggle and try and make a career out of surfing or being here, you know, but the bottom line is that you've got to stay grateful and happy. There's so much worse things in life you could be doing than sitting here talking to me. We're blessed to do what we do. It's just . . . appreciate and stay grateful and, like the kids, I try to instill in all these kids to give them a little structure in life. You know, clean up after themselves. To go do the work when the waves are flat, cuz the waves aren't good all the time. That's when you train. Making good choices in life. It's all that stuff. Try to live clean. Watch out for all the fucken hanger-oners and all the bad choices that they make real easily. But only they can do it. Alls I can do is show them here's the path, hopefully you stay on it, and if they stray off of it, hopefully they can get right back on it."

Such a Zen thug but even if he is a Zen thug, even if he is enlight-ened, even if I am not seeing clearly, I know that he is still the Kai-

borg of myth/reality legend and that he is greatly feared. Kaiborg stories and Eddie stories are told with equal amounts of petrified eyes and quavering voices. He is still considered a monster and I tell him that and, again, he lets out a long and low "Psssssshhhhhhht" before continuing, "I don't like that at all. But. You know what . . . Ffffff. I created it and that's why I'm changing it now. I've never been the most open and friendly guy but you know now I'm trying to like . . . this year I told myself, try to tell everybody hi. I'll be on the bike path walking down, or on the back road, and guys will see me coming and they'll be putting their head down and getting all squirrely and I'll be like, 'What's up?' and they'll be like, 'Whoooaaa.' And I'll be like . . . ffff, whatever. But you know, it's life. You live and learn. You gotta go through the process and it's a process and I wanted that . . . of course I wanted that mystique at some point, but then you're over it and it doesn't just end when you're over it. I'll probably always have it, but whatever. It serves me well cuz when I speak up they better listen. Hey, I'm not perfect. I still have my, you know, my inner demons like everybody but at least I recognize it now and I try to keep them down and don't overreact and fly off the handle." He laughs loudly. "I don't want to be perceived like that anymore, though. I'm a father and a husband and basically . . . I do what I say, and say what I mean. Alls we have in our life is our word. Everything else is fucking bullshit."

The wisdom continues to pour. The enlightenment of Kai "Kaiborg" Garcia. And it may be even greater than the enlightenment of Siddhartha Gautama "Buddha" himself because of the distance traveled. Buddha moved from spoiled rich child to enlightened one, which is a great climb, but Kaiborg moved from monster in one of the heaviest places on earth to . . . I don't even know. To something far greater. Wisdom. And I am feeeeeling it, baby. "Ahhhh yeah, it's

hard to make a change in your life. Super hard. Really hard. We're creatures of habit. This guy told me a year ago, 'You're gonna have to change one thing about your life,' and I really look up to that guy, and I was like, 'Oh yeah? What's that?' and he was all, 'Everything.' And I was all, 'Fffffuuuuuuuuuu.' But he was right. You know. I did. And I'm trying to change everything. It's not easy but I'm working on it, you know? The bottom line is we're imperfect and it's progress, not perfection, so if you make a little progress every day, you know, you're doing OK. At the end of my day, I'll sit down and think about my day and be brutally honest with myself, be like, 'OK, how could I have made my day better? How could I have made people better around me?' We all have our moments, but as long as I sit down there and reflect every day then I can wake up and try and make a little progress the next day. Day by day. One foot over another. It's hard to grasp but when you start getting it, you start getting it. You start seeing what life is about, not just existing through life—you start living again. You're not all blinded. You start looking at the ocean and the rainbows and you start seeing the leaves falling off the trees. You know, stuff like that. I don't know. I could be fine this year and I could flip the switch next year, you know? You just never know." Fuck sacred fig trees. Kaiborg found enlightenment under a palm.

The sun is all the way beneath the earth's rim and the sky is on fire. It is all the colors of red and we both pause to look at it. It is, truly, paradise. But at the same time it is always truly hell. And since I am feeling all metaphysical I ask him about the hell, about Eddie and the politics of a place outside the law. I tell him that word on the Ke Nui is that Eddie and him are not on friendly terms. He stretches again and speaks, "Ahhhh we're fine. We're all one family. Just, everyone is on their different path. You know, I'm kinda looking for

enlightenment. Just staying levelheaded. Hey, we all get along. We all argue and bicker and shit, but that's part of it. But at the end of the day, we all got each other's back. And the North Shore politics? You know what . . . I love this place, and politics? I could give a f— a rat's ass, you know. I'm powerless over people, places, and things. If that guy is an asshole out there, hey, you know what, I'm not gonna worry about him. I can't change him. I'll let him wallow in his own shit. Just don't bring it. Boundaries, you know? I've got my boundaries. Don't, you know . . . stay out of my boundaries and it's all good. I don't care what you're doing, running around being an asshole, whatever. That's your trip. I just mind my own business now." And I am feeling all warm and in love. He is an apologist for everything that is the North Shore. He is also validating my own personal asshole trip by not judging it. Beautiful. Love. Warm. Deluded? I don't care anymore. Getting to the bottom of a story—selling out Eddie, Kaiborg, the North Shore—had been swallowed by a general feeling that I belong here.

At that moment an older, eccentric local talking jibberish comes crashing through the Volcom house gate and into the yard. He is dripping wet, just having gotten out of the water, and is jabbering about how Pipe almost crushed him but he got fully barreled and *whoosh!* And *bam!* And *pow!* Kaiborg laughs at him and says, "We're more grassroots over here. We're more core. We have all of the local surfers come hang out here, you know what I mean? Nike down the road and Quiksilver, they have their guys and they all stay in their little bubble. They're all bubble-ized. Over here we got guys like"— and he gestures over to the older, eccentric local—"Donnie don't go hang out at Quiksilver. You know what I mean? We got every fucken creature walking around here. We keep it real. It's how we were all raised and we're not fucken exclusive or . . . we're not better and no

less than anyone. It's pretty much open arms over here." And it is pretty much totally not but that is the way that Kaiborg feels and so I just guffaw, slightly, and tug on my pink shirtsleeve and continue to look at the fire-red sky.

The gate opens again and a young Volcom grom comes through and nods, submissively, in Kaiborg's direction before scooting out of sight. Kaiborg doesn't notice him but I do and ask him about the process of being a grom in the house. Standard lines about being a family and cleaning up and the dungeon and working out and living the dream because of the free bed thirty short steps away from Pipe, free food, access, and never having to fear getting beaten up in the water. But I still want to know how that came to be. How did these houses come to rule? Kaiborg listens to my question and then looks at me and then answers, "Look at me. I'm six two, two forty, you know. Surfers are fucken what? Five eight, one fifty? It's like . . . plus I've trained my whole life. I'm not a normal guy, you know, so. The groms are here, they're part of it, and they know better. If you go out there and drop in on a guy blatantly, or whatever, you're gonna get your head slapped. But it's mellow now. Everybody knows where they belong. It's not like the old days."

The old days. The old rough days, which to men like Kaiborg are over and we are all living in the soft present, and to men like Graham Stapelberg are not over because he is getting his face slapped right off, and to men like me are not over because the North Shore is scarier than any war zone. The past is always amplified but I will say that the North Shore exists in perpetual violence and it always has. Maybe the violence looked or felt different in the past but it is not less today. Only different and only realized differently.

The fire reds are turning into powder blues and darker blues. Pipeline is still thundering, shaking the Volcom deck, which shakes

the cinder blocks, which shakes the couch. The contest will be run-
ning again tomorrow. *Booom!* And Kaiborg is gazing out and is not
talking to me anymore but talking to Poseidon. "That's a heavy wave.
This place is scary." I ask him if it still scares him and he responds
honestly, "Ahhhh yeah. I want nothing to do with it." And he says
this even though he surfs Pipe every big swell. "Hey, we change. She
don't. We get older and slower. She does not let up. Every time . . .
there's a bunch of times when I been out there and I'm like, fuck . . ."
He lets his thought trail off as another wave explodes. "That's what
she does out here." *Booom!*

I pull myself off the couch and we shake hands and I leave him
sitting there, looking out at Pipe. A Zen thug. I didn't serve my
ablution on the couch today, but I believe he will still knock my
head completely off if he needs to, or wants to, someday. He has
been training in jujitsu for eighteen years. He has trained under the
greatest mixed-martial-arts Brazilian master, Royce Gracie. He has
fought in the octagon, or modern version of gladiator battle, many
times. He is six foot two, two hundred forty pounds but seems like
Gerard Butler's King Leonidas in the film *300*.

Let's Go to the Beach, Each,
Let's Go Get a Wave.
Or, Let's Do This One Last Time.

stand on the Ke Nui for a moment and debate what to do next. I could go to Lei Lei's and have cocktails with my friends and enemies. I could go to one of the houses and get bored. I could sit on the beach and think noble violent thoughts. I could smoke a cigarette but after sitting with Kaiborg I don't really feel like it. I want to be reformed. I am reformed. My cinematic-adventure Didionian, selling-out recklessness is slipping. Slipping. Slip.

It is growing darker by the second. A light rain is beginning to fall. I feel reborn. I belong. And then I see Bede Durbidge coming toward me, dripping wet, wearing the worst Fox boardshorts ever. They are so tacky and even extend beyond his knees. Fox is a motorcycle brand but also sponsors surfers. I pull a Parliament out of my pink button-up pocket and light it and he glares at me when passing. I am who I am, I suppose. My revelations never last long. My reformations always get erased because, try as I might, I cannot change. I cannot change my disruptive pull. And it is dark.

Night on the North Shore feels safer than day, to some extent, even though it feels thick. The shadows overcome and there are not many streetlights and evil men might be lurking in those shadows

but it also gives me a place to lurk, unobtrusively. And so I post up underneath a banyan with roots that go into eternity and continue to debate about what I want to do. It is almost peaceful. I wander back down the Ke Nui toward Off the Wall, turn down the sandy path toward the beach, and see a good young Australian filmmaker packing up his gear. "Ahhhhhh, Chas," he greets me, "how crazy was Surfer Poll last night? Fuck me . . . I didn't sleep at all. Somebody gave me a big bag of toot and I did the whole thing by myself and was just going mental." Australians call cocaine "toot." I laugh at him and laugh mostly because he is a filmmaker, which means he would have had to have been on the beach, under the tropical sun, all day long with a cocaine hangover. Life is its own punishment. He asks me if I'd seen Wheels and I tell him that I haven't and didn't even know he was here. "Wheels" is Sam McIntosh and Sam McIntosh is the very pretty and very young publisher of *Stab*. He is fit. He is blonde. He is young, by publisher standards, maybe thirty-five. He used to be a model and I think he still does model for Corona beer but is too embarrassed to tell anyone. "Yeah, mate. He's here. He was just out surfing Pipe." Sam has a death wish, I believe, because he is very pretty. He is forever proving himself in deadly surf. He also never ever calls me because he is petrified of what I may write. He lets Derek deal with me, exclusively.

And just then Sam comes up the beach, wet, pretty. "Ahhhhh, Chas." Australians always say, "Ahhhhh, Chas," and it is always three octaves higher than normal and always happy. Hawaiians always say, "Hooooo, Chas," and it is always three octaves lower than their normal high girl voices. Sam is happy. Not to see me but because he had just bagged an epic barrel courtesy of Bruce Irons. Bruce had left his penthouse deck and his green ones sometime before the sun had set and paddled out to Pipe. It is an amazing feat that surfers

can surf so well while out of their minds, not necessarily that Bruce was out of his mind in the water, but I have seen surfers wildly out of their minds in the water. Once, in Western Australia, I was covering the Margaret River event and up drove Chris Ward, five minutes before his heat, in a dead-bug-smeared car. Chris Ward is a San Clemente folktale for going on benders and surfing well. I asked him what the deal was with all the bugs and he told me he felt like driving to Margaret River from Melbourne. That is a 3,680-kilometer journey. His eyes were red and insane and he won his heat.

This evening, though, a maybe-out-of-his-mind Bruce floated next to Sam and when a massive set appeared on the dark horizon he shouted him in. To get shouted into a legitimate Pipeline wave by a demigod is worth a smile. To survive that wave, and surf it well, is worth much more. It is worth an ethereal glow and Sam is glowing ethereally. We make small talk about the Billabong house incident and the day of competition and Kolohe and John John. We laugh, he nervously. And then I ask him if he is going to go to John John's Triple Crown rager, courtesy of Bruce Irons. He shakes his head no. "No no no way. Nike has a great chef and I am going to have some dinner up there. I try and stay out of the way as much as possible over here." He will let Bruce call him into a wave but he will not be caught dead surrounded by a houseful of Hawaiian heavies. I tell him that I am going and he shakes his head again. "Ahhhhh, Chas," but this time it is tinged with pity and sorrow and a little pain. He shares my compulsion for destruction but in a different way. He throws himself off the ledge of deadly waves. I fraternize with deadly people. He has physical skill. I have an unwarranted belief in my own charm. We throw shakas, mine is very loose, and he leaves with the filmmaker.

I sit on the beach. I can't see Pipeline anymore, the wave. All I see

is a dark horizon and dark sand and dark. I sit for an hour until I am stiff. I don't do yoga but I should. The beach has emptied entirely. I am surrounded by thunder.

After the hour I get up, brush the sand from my skinny jeans, and hobble back up the sandy path, back onto the Ke Nui. I don't know if I am really going to go to John John's rager. I feel it is my duty but I also love to shirk duty. But I figure walking by the Volcom house one more time can't hurt. I mean, it can totally hurt. I might get punched, but I might get punched anywhere so whatever. I walk and turn down the other sandy path that cuts between the two Volcom houses and pause outside the gate, debating. By the sounds of it, there is no rager yet. I hear subtle reggae and conversation. I stand and then feel a meaty paw pushing on my back. "Get in there, Chas." I turn around and see Michael Ho pushing me toward the gate and I laugh and open it and go through even though I really don't want to. I am exhausted. The fine mist is evaporating and now I am only existentially exhausted.

Even though I was just here it feels different. As I suspected, it is not a rager yet, but the deck is completely full and completely full of only North Shore heavies. I see Eddie Rothman and his son Makua. I see Kala and Dustin and Bruce and Kalani Boy Chapman and on and on and on. Names with many vowels. There is not one blonde head besides John John, who doesn't count, and Dusty Payne, whose hair is really red. There is not one true mainland haole. And this was a horrible idea but I am here and so walk up to the deck, again, and see a cooler and feel that a beer in hand will make me look less awkward.

I move toward the cooler and right when I am opening it a giant foot slams down on the lid, drilling it shut. I look up, slowly, and see Kaiborg, sitting on the rail. His face is stone, and then it lightens.

"Ho, Chas. Have a beer." And he smiles but it is not a warm smile. I do not belong here right now and he may be enlightened and he may be Zen but there is an order to things here, and I am out of order and I suddenly do not want to serve any violent ablution.

I take one and thank him and the beer in hand does not make me look any less awkward. I nod at Eddie and he nods back. Dustin stares. Others ignore. I sit on the railing, near Kaiborg, and watch and drink and know that I am very out of place. Getting slapped in the Volcom house with the men I spent this North Shore day with would be a fitting end but it would also be so totally pointless. I am too exhausted to make conversation. I am too exhausted to try. I have been worn out.

And I am caught in an internal limbo. If I get slapped I will feel like a cliché. Like I did it just to do it. If I don't get slapped I will feel like I didn't push it as far as I needed. That I let my own very recently renewed cinematic adventure narrative down.

Once, in Yemen, before the Lebanese war adventure, my best friend Josh and I were riding motorcycles across the country just to do it. Just because we covered wars and bad places and we had heard that Yemen may be breaking down, marching toward a civil war. This was years before it actually did break down but we were avant-garde in our Middle East sensibility. We felt changing winds. We wanted to cover it.

We were warned not to go into a town named Marib. They hate Westerners there worse than anything. They hate Westerners even worse than they hate their own government, which they hate enough to regularly rise up against and kill its national troops. It is an Al-Qaeda den. And we had to go there.

As soon as we swung into the outskirts of the city, Josh's spark plug went bad. We stopped to swap it out and a mob descended. "Where are you from? Where are you from?" Josh said, "Lebanon." Leba-

non has some blondes and even some blue-eyeds and no Yemeni in Marib has ever been to Lebanon so it seemed like a fitting lie. They weren't buying it, so they marched over to me and started asking, "Where are you from?" And I, too, said, "Lebanon." "Where in Lebanon?" "Beirut." This seemed to pacify them for the moment: They have seen Lebanese television. They have seen the blondes and blue-eyeds. So they started to help with the spark plug. I made small talk about the wonders of Lebanese music videos until the bike started running again. Back on the road.

Out of nowhere, a truck was suddenly on top of me. The passenger was yelling out the window, "Where are you from?" All this "where are you from" business is an attempt to suss out if you're American. In Marib that means a guaranteed kidnapping. I gave him an ugly look and he raced forward to try to bash Josh off the road, trying to kill him. We were going about a hundred and twenty kilometers per hour at the time. Josh somehow controlled a slide on the dusty shoulder and pulled behind the truck. The driver slammed on his breaks to try and smash our gorgeous faces to his tailgate, then sped up again. I don't know how this would have ended if we hadn't run into the checkpoint for Marib proper. The truck backed off and turned down a side road.

There are always checkpoints in and out of Yemeni towns. This particular one looked like a *Mad Max* barracks, all built up with gunship trucks, homemade corrugated armor, and a bare-bones military detachment.

One time, the Yemeni government kidnapped ten sheiks from Marib and held them hostage. Another time government troops entered the town looking for senior Al-Qaeda members and the townspeople opened fire on them. They hate the government. They hate Westerners.

When Josh and I rode up, the soldiers froze. They didn't know

what the hell we were doing but could see that ugly attention was around the corner. There were six of them versus a few thousand armed townspeople in a very small square city block. Yemen is the most heavily armed country on earth, per capita.

Then my bike ran out of gas.

Fuck.

Breathing.

Heavily.

The situation escalated quickly after that as more people came out of the corrugated woodwork and encroached upon the scene. Mobs always exacerbate delicate situations. The soldiers began screaming at everyone to back away, but nobody moved. Their eyes had the dull angry glaze of a dog who's fought too many battles. A group of men in the back of a truck broke out a brand new HD movie camera and started filming us. They didn't have smiles on their bearded faces. The soldiers kept screaming and the people kept not moving. A setting sun cast a bloody glow on the scene while the weather had turned weirdly hot, or maybe I had just noticed it.

And here it all was. A town with a history of firing on government troops, supporting Al-Qaeda, and tasting the sharp end of American missiles, plus an unnaturally warm evening and an increasingly menacing crowd. On top of everything, word had trickled in from the outskirts that we may not actually be Lebanese. A kid was shouting "They're American! They're American!" from across the street. The mob grew.

In my personal experience, if there is one man holding a gun to your head, reason is still in play. If there is a whole town that is going to go nuts then hope diminishes. All someone has to do is pop their gum too loudly and it is over. Josh and I tried to look cool on our motorbikes, making Arabic small talk with those brave enough to

get in the future line of fire. It probably didn't look cool that I was sweating like a fat car salesman.

After what seemed an eternity someone brought up a canister of gas and we left. That was it. Drove quietly through town as everyone stopped what they were doing and ogled. I half expected to get shot off my bike somewhere in the middle of this and realized, when we made it through, how tiring it had all been. My muscles were sore from flexing in an unconscious attempt to deflect potential bullets. I don't think it would have worked. And why did we go to Marib? Because it was there. Because we were warned not to. Because I would have sold myself out if I had not gone. Because, at the end of the scene, I could get on an Emirates flight and go back home.

And back on the North Shore, back on the Volcom house porch. Back. I sit and look around and am paralyzed by my narrative limbo. Well fuck it. Fuck going deeper and deeper and deeper. It is time to stop. I ain't covering wars no more. I am covering surf. And even though the North Shore has scared me more than any Middle Eastern war zone, and even though I have been choked out, and even though and even though, I am still doing the softest thing ever. I am partying and drinking and staying out late with a cute girl and surfing and drinking and looking at palm trees swaying in the wind and feeling salt water on my skin. I am writing about that. I have the best tan. I have a very good haircut. I have the best skinny jeans. I write fluff called Trash Prose. I am on the best cinematic adventure ever.

So I leave.

For one moment I have stopped my degenerate get-in-to-the-worst-of-all-situations heart from drowning me. I know the North Shore scene never wraps and that it can follow me back to Los Angeles but for one night, this night, I will dodge my inevitable end. I push through the gate and leave, out into the night. Out into the cool.

And I am still breathing heavily.

And I am exhausted.

A day here is exhausting. A day here is a lifetime of stress. Hawaii. Oahu. The North Shore. Surf. How did it ever become a holiday destination? How did it ever become the coolest thing on earth? Because it is beautiful and the water is warm. Because it is always the same temperature, or roughly the same. Because the sand feels perfect against half-naked, tanned skin. Because tans are always better than pale. Because coconut and pineapple make for fine cocktails. Because nothing except sex beats getting barreled. Because even in my unchecked judgment there is something magical about it. I have been fully consumed. I have taken the pharmakon. Kaiborg had barked to me, just before I pushed through the gate, "Hey, Chas . . . look at all this." And he extended a granite statue of an arm out toward the ocean. "We're isolated. We're two thousand miles away. We have our own little trip. Our own little . . . we're different. We're not following the codes of anybody. We're our own tribe. And it's different." In an increasingly monochromatic world the North Shore's Technicolor living is for sure different. It is paradise. It is hell. It is alive. It is alive.

A jacked-up pickup roars by with four gigantic mokes in the bed. A ratty Hawaiian teenage ice head in an "A.I. Forever" T-shirt with torn sleeves asks me for a cigarette. A.I. stands for Andy Irons. I tell him to fuck off.

Burn Them Bridges Down to the Ground Because I Won't Be Coming This Way Again. Or, a Postscript.

flew back to Oahu three days after finishing this book, a week after it had gone public, through the surf world, that I was writing one about the North Shore. I had been invited by a magazine that I had never heard of to go pig hunting with men I had never met. It smelled, vaguely, like a setup. Like they would take me deep into the bush and then say, in their girlishly high voices, "Soooooo, Chas Smith. You writing one book about da North Shore, eh? Let us see it, brah," and then proceed to pound me and watch, over my bloody shoulder, while I changed every detail of this story. My woman was worried and even more worried that I packed red Vans as my pig-hunting shoes. "You are going to get out there and not be able to run away," she said. But there is no running on Oahu, not even running back to the mainland, and I had to go. Whatever happened it would be a cinematic adventure. My degenerate heart had come back in full even fuller, more robust, than it had been in the Middle East and Africa. It beats dark.

And so I flew, again, and landed, again, and felt depressed again. I come back and back and back no matter what or how I feel. I cannot get away from this bloody, volcanic land.

I posted up in Waikiki in a hideous equestrian-themed hotel next to the Hilton Hawaiian Village and called my pig-hunting contact. His voice was not girlishly high. It was low and sounded like throat cancer. "Meet at my house at four forty-five a.m. I'm on the east side." The weather was cold again.

And so, the next morning I woke up at three forty-five a.m., drank a cup of Hawaiian coffee, smoked a Parliament—fucking Parliaments—on my equestrian-themed balcony, and prepared myself for the end.

The drive to my pig-hunting contact's house, over the mountain and east to the Pacific, was uneventful. It was a different road, one not taken to get to the North Shore, and so one I had never been on. There were tunnels. I drove and thought and found his house and parked. The sun was far from up. Pig hunting happens early.

I could see through his open garage all the accouterment of pain. Punching bags, barbells, fingerless boxing gloves, and a kennel of hunting dogs yapping with excitement. And then he came out the door. He had a completely shaved head, tattooed neck to finger, wearing camouflage pants, a black T-shirt that read "Defend Hawaii," and baseball cleats. He was six four and pure massive muscle. A mound of muscle, which is not rare here. His name was Mike Malone. He shook my hand, wrapping it in his muscle paw. We made small talk about pigs and dogs and writing. The dogs, he told me, were a mix of pit bull, Rhodesian ridgeback, bird dog, and hound. I told him I was writing a book about the North Shore, all the characters, all the stories. If I was going to get popped in the bush I wanted it to be legitimate. He looked at me with very blue eyes and said, "Yeah?" I could see a silver tooth glimmer as he smiled. He was handsome.

We drove to the pig-hunting grounds with two of his friends and

their dogs. The sun wasn't up yet but I could see the Pacific and see the stark geography of Oahu's east side. The cliffs are steeper here and totally green. They look like God's best work on earth. One of his friends, nicknamed the Hollywood Hunter, had the permit to eradicate pigs on the Kualoa Ranch lands. This is where they film many television shows and movies. We walked past the still-standing set for *Journey to the Center of the Earth*. There was a sign pointing to where *Jurassic Park* was filmed and another sign pointing to where *50 First Dates* was filmed, as if anyone cares. It was one of the most beautiful places I had ever seen. I was in a movie in a movie! And then we set the dogs loose in a canyon. They scrambled away in search of pig.

We didn't talk much and listened for the dog barks, finally hearing them at the top of a high ridge. We scaled it, me in red Vans, slipping and sliding and grabbing for vines in order to keep from tumbling downward. It was so tropical. Huge mosquitos ate me whenever I paused. Wild guava trees and mango trees mixed with strange prehistoric palms. At the top we found the dogs sitting proudly by a dead boar. They had given it a flat tire, meaning they chewed its front armpits until it could no longer run. The Hollywood Hunter said the boar had had a heart attack. He was called the Hollywood Hunter because he hunts this movie-set land. He told me on the climb up that once, while he was hunting, Nicki Minaj was filming a music video and his dogs found a pig and went crazy. Nicki's people were not happy about the disruption. He laughed. "Whatevers, brah. This is Hawaii."

He cut off this boar's balls, gutted him, and hung the guts on a tree. I insisted on carrying the dead boar carcass down the cliff. He smiled and tied the front leg to the back leg on both left and right sides and then hoisted him onto my back like a backpack. I grabbed

his dead snout with one hand, per instruction. His blood ran down my back and it earned their respect.

We ate lunch in a small restaurant perched over the ocean and then I drove back to Honolulu, walking down to the Hilton Hawaiian Village. A pasty-white college boy, with a fine layer of chub, floating in the hotel's strange lagoon said to his darker friend, "Look, I'm floating without even trying. I don't think people can drown in the ocean." His friend mumbled something inaudible. Then he said, "I love it so much here I never want to leave. Let's stay in this water until four thirty a.m." His friend mumbled, inaudibly, again.

I left, continuing on to a nearby mall because the scent of my red Vans was revolting. I found a Gucci store and there were many Japanese taking advantage of the fair dollar-to-yen rate. I saw a pair of red Gucci high-tops that I had been lusting over and bought them. The shop girl asked about the state of my Vans and I told her I had been pig hunting. Her eyes went wide. She asked me about the nuances of pig hunting and asked how I liked Oahu and I told her, "I hate it and I love it. I can't get away from it no matter how hard I try. It is violent, it is great, and I can't stop." I told her I was writing a book about the North Shore. "You know," she said, "there are spirits here. Many, many, many spirits and they demand that fortunes made on the island stay on the island. I have been trying to leave since I got here but I can't because this is where I made my money."

This disturbed me greatly and I went to the airport to fly home to California, my California, thinking about Hawaii's, and more specifically the North Shore's, damned magical, magnetic draw. On the flight, as I lost the three-hour time difference and the sun set too rapidly, I discovered another Joan Didion quote somewhere over

the ocean. This one was not about selling somebody out. This one, instead, read, "A place belongs forever to whoever claims it hardest, remembers it most obsessively, wrenches it from itself, shapes it, renders it, loves it so radically that he remakes it in his image."

Well fuck me. Fuck me.

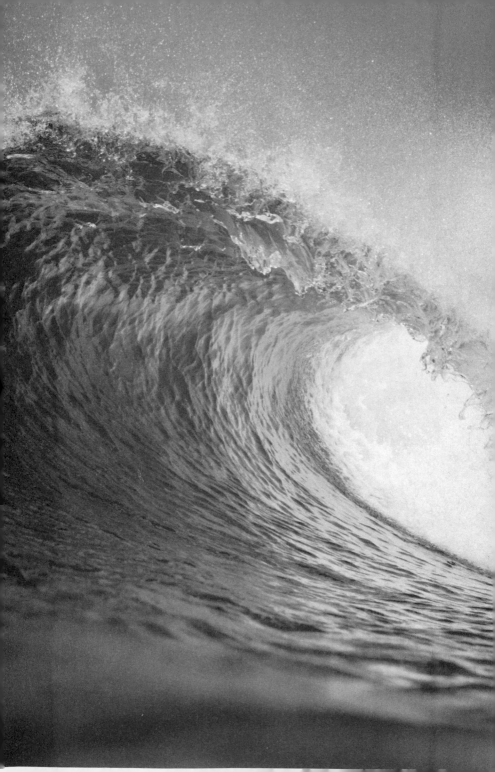

ACKNOWLEDGMENTS

Endless gratitude to: Ma and Pa, Denise Oswald, Derek Rielly, Ava Rose, Hemingway, Josh Winters, Nate Train, Dayten Likness, Joe G., Brodie Carr, Paul Evans, Taylor Paul, Tony Perez, Ryan Harbage, Justin Manask, Cory Lake, Emily Smith, Scott Hulet, Jen Danska, Paige Clay, Travis Ferre, Kari Van Way, Pete Taras, Shane Sakkeus, Matt Warshaw, and Uncle Dave.

INDEX